CHRISTIAN SYMBOLS

Christian Symbols

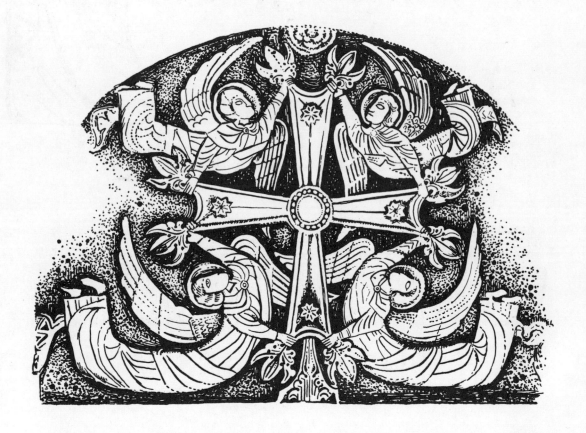

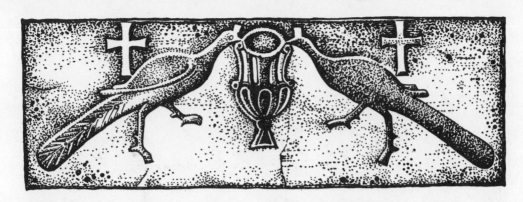

Ancient & Modern
a Handbook for Students

Heather Child
and Dorothy Colles

CHARLES SCRIBNER'S SONS
NEW YORK

Facing: *Christ in Majesty*: detail from the gold jewelled cover of the Codex Aureus of St Emmeram now in Munich Library. This magnificent work comes from the Court workshops of Charles the Bald, one of the grandest of Carolingian Emperors, and was made about 870. The delicate panels on either side show the Evangelists at work on their Gospels accompanied by their Emblems. The narrative scenes show the Woman taken in Adultery, Christ and the Moneylenders in the Temple, the Healing of the Leper and the Healing of the Blind Man. The overlapping circles of the mandorla and the swirling drapery of the figure of Christ combine to evoke a linear rhythm of exceptional vitality.

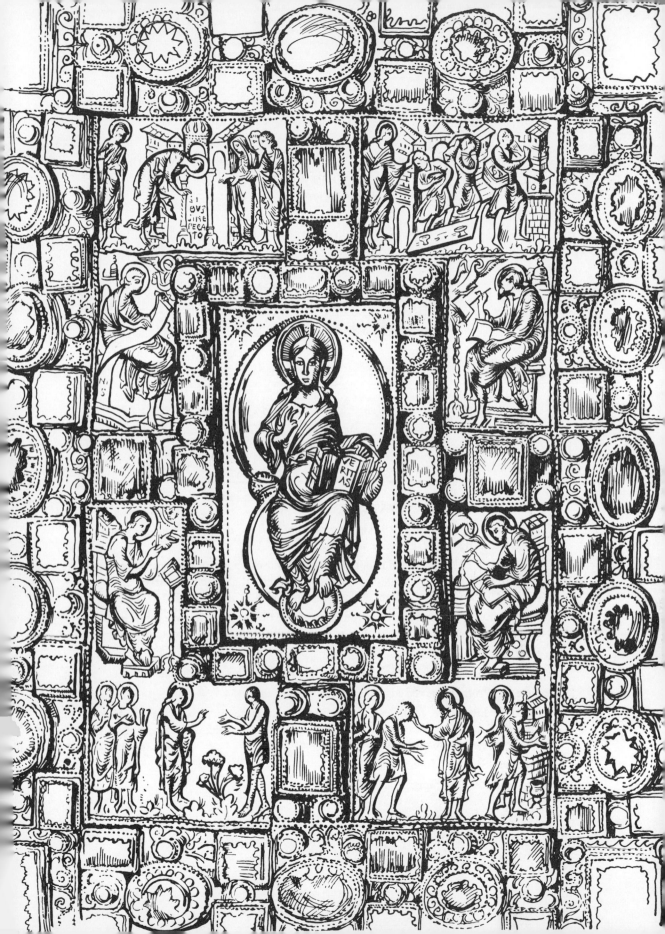

The other drawings in the opening pages are as follows:

Half-title: Angel drawing a curtain: from a relief by Tino di Camiano for the monument to the Bishop of Florence who died in 1321.

Title page: Left: The exaltation of the Cross from the carving on the tympanum of the eleventh century church of Nikordsminda in Georgia. Right, above: Carved marble slab in Grado Cathedral. Right, below: Stone carving in the Cathedral at Aquileia.

Page ix: Eve, the cause of all the trouble . . . One of the modern stone gargoyles on the Chapter House at Southwell Minster designed in 1960 by B. H. Dowland.

Page xiv: St Peter, Moissac.

Page xv: St Cristina: detail from a fourteenth century window at Koenigsfelden.

Page xix: From the carved edge of a seventh century altar.

Page xxi: Entry into Jerusalem: detail from the sixth century ivory diptych from Etchmiadzin now at Yerevan. Animation is conveyed by rising diagonals especially that from rear hoof to the pricked ears of the ass.

Page xvii: St Mark's Lion: Grado.

Page xviii: 'Artist at work' from the catacombs.

Contents

Contents

Contents

List of Illustrations

PLATES

List of Illustrations

Acknowledgements

The authors are grateful to all those who have provided material for the illustrations, especially to Diana Ashcroft, Dr Ellen Macnamara, Kim Allen, Tim Daniell, Roger Jones and Dr James Overton. Our thanks are due to the authorities in churches and museums for permission to draw and take photographs of works of art in their care; to the Provost and Chapter of Blackburn Cathedral, the Dean and Chapter of Chichester Cathedral, the Provost and Chapter of Coventry Cathedral, the Dean and Chapter of Westminster Abbey, and to the British Museum and the Victoria and Albert Museum.

We would like to thank the many craftsmen who have lent photographs of their works; and in particular the Rev. John Perry, Corpus Christi College, London, for reading the manuscript and for his helpful suggestions. We are indebted to the staff of the Victoria and Albert Museum Library, St Deiniol's Library at Hawarden and the London Library for their assistance. Professor D. M. Lang kindly translated the Georgian inscription for us on Plate 6.

Photographs were also provided by the following: Courtauld Institute 1; Society of Antiquaries 2c, 17a; The Times 3b; Fitzwilliam Museum 4a; Stanley Travers, Llandaff 7a; Provost of Blackburn Cathedral 7b; National Monuments Record 8b, 11a; British Museum 8c, 9c, 9f, 25a; Tunisian Embassy 9a; King's College Photographic Department, Newcastle 12a; O. Böhm, Venice 13, 29a; Dean and Chapter of Westminster Abbey 14a, 31c; Pierpont Morgan Library 15a; Bodleian Library 18a; Architects Journal 22; Architectural Press Review 24a; Bayer, Staatsbibliotek Munich 28a; Goldsmiths Company 30b, 31d; P. W. & L. Thompson, Coventry 32c.

Sources of Quotations

p. 2 William Langland, *The Vision of Piers Plowman*, newly rendered into modern English by Henry W. Wells, with an introduction by Neville Coghill, Sheed and Ward, London and New York, 1935, p. xvi.

p. 27 *The Earliest English Poems*, tr. Michael Alexander, Penguin Classics, London and Baltimore, 1966, p. 106.

pp. 48–9 *The Vision of Piers Plowman*, ed. cit., p. 231.

p. 67 Emile Mâle, *The Gothic Image*, tr. Dora Hussey, Collins, London, 1961, p. 133.

p. 80 William Langland, *Piers the Plowman*, tr. J. F. Goodridge, Penguin Classics, London and Baltimore, 1959, pp. 225–6.

pp. 96–7 Gilbert Cope, *Symbolism in the Bible and the Church*, SCM Press, London, 1959, p. 169.

pp. 130–1 M. D. Anderson, *The Imagery of British Churches*, John Murray, London, 1955, p. 138.

p. 150 A. Napoleon Didron, *Christian Iconography*, tr. E. J. Millington and M. Stokes, London, 1896, pp. 114, 123 and 136.

pp. 212–3 Gervase Mathew, *Byzantine Aesthetics*, John Murray, London, 1963, p. 39.

p. 220 Didron, *Christian Iconography*, pp. 407–8.

Definitions

The English language is exceptionally rich in synonyms. There are many words connected with the understanding of meanings, the dictionary definitions of which shade into one another, and these may be used with delicate precision to define the elusive idea of symbolism expressed in visible forms. A choice of relevant definitions from the many variations given in the *Shorter Oxford Dictionary* are set out below:

SYMBOL: something that stands for, represents or denotes something else, not by exact resemblance but by vague suggestion. An object representing something sacred.

ALLEGORY: speaking otherwise than one seems to speak. Description of a subject under the guise of some other subject of aptly suggestive description.

PARABLE: allegory, proverb. A comparison, a similitude; any saying or narration in which something is expressed in terms of something else. A fictitious narrative . . . by which moral or spiritual relations are typically set forth.

SIGN: a mark or device having some special meaning or import attached to it. Something displayed as an emblem or token. A device borne on a banner, shield, etc.

IMAGE: to represent by an image; to figure, portray, delineate. To symbolize.

EMBLEM: a thing put on. A drawing or picture expressing a moral fable or allegory . . . A figured object used symbolically as a badge.

ATTRIBUTE: a quality ascribed to any person or thing. A conventional symbol added to identify the person represented.

ICONOGRAPHY: 'Pedigree of Pictorial themes' (from the ODCC).

Perhaps William Blake has written the best of all definitions of a symbol:

> 'To see a World in a Grain of Sand,
> And a Heaven in a Wild Flower,
> Hold Infinity in the palm of your hand,
> And Eternity in an hour.'

Note on the Line Drawings

The purpose of the line drawings in this book, which is written and illustrated by artists, is to show the use and variety of Christian symbols. By translating certain carvings and craft works into drawings it is hoped that the underlying design of the object and its symbols may come across more clearly to the reader.

In the process of drawing an object it is absorbed in a richer way than merely *looking*, it distils the design and much may be learnt about composition, rhythm and vitality. All fine work depends on its design and no bold details can give strength to a weak composition; majesty of effect depends on rightness of proportions. The drawings in Romanesque manuscripts, for example, can hold their own with the great tympana of the cathedrals of the time, their monumental quality is based on relationships within the design to the whole. A drawing from an object is itself a new work, as well as a reminder of the original. The discipline of accurate descriptive drawings is challenging and exhilarating as those students will find who make their own collections on the extensive travels which are such a feature of their life today.

It should be stressed that there is no substitute for actually looking at original works of art. Chartres and Canterbury, Ravenna, Rome and Istanbul may all be visited in sumptuously illustrated books. But seeing them for oneself is a different order of experience; it 'goes home to the eyes', expands the mind and germinates in the imagination long afterwards.

[xviii]

Introduction

This book is about the use of visual Christian symbols in the service of the Church. It is a subject which started with the very beginnings of simple Christian communities and it grew and developed in the same way as the early Church; the faith and its symbols being aspects of the same activity. The simple emblems used in the first three hundred years of Christianity gradually gave way to a richer, more complex range of explanatory art, the elaborate web of allegory and meaning developed by early writers of theology was passed on by them to artists and masons who translated them into visual form. The panorama of Christian art comprehends the working lifetime of generations of outstanding carvers, painters, mosaicists and craftsmen. For many centuries the Church was their principal patron and it is not possible to understand the development of Western art without some knowledge of the history of Christianity. This vast subject has given rise to many scholarly and well-illustrated books on all aspects of art history, its periods, styles and countries.

On the title-page of this book it is described as a handbook for students and it is hoped that it may also be a quarry for visual ideas for craftsmen, designers and teachers interested in the subject of Christian symbolism but daunted at the extent of the specialist literature. The pursuit of visual symbols and their meanings can add interest to the sightseeing of holidaymakers and so increase the enjoyment of travel. The line drawings may encourage amateur artists to make their own designs for work in the Church such as kneelers, banners and hangings. The book may also be helpful to ordinands and in general provoke discussion, encourage observation of existing works of craftsmanship and even engender fresh ideas about the place of symbols and their use in Christian art and imagery.

The use of symbols in Christian art offers so wide a field of choice that it has obviously been necessary to limit the selection of illustrations. We have confined ourselves to examples from the decorative and applied crafts such as carving in stone, wood and ivory; mosaic decoration on walls and floors; stained-glass windows and engraved glass; manuscripts; ecclesiastical embroidery; work in precious metals, enamels and the like. The whole subject of architecture and the symbolism

of the plan and structure of churches is outside our scope; so also is the vast subject of religious painting in the form of easel pictures, altar pieces and works for private patrons.

The line drawings and the halftone illustrations have been chosen from the crafts of Eastern and Western Christendom. The comparison and contrast of the same subject treated in different styles can be particularly illuminating. The varied renderings of the Crucifixion on Plates 2 and 3 illustrate this point. The chronology of the illustrations needs some explanation, they range in time from the early simplicity of the catacombs in the third and fourth centuries to the richness and variety of Gothic in the twelfth and thirteenth, with some later exceptions. Then we have deliberately leapt across about six hundred years to our own day to illustrate the work of artists in the twentieth century. Although the art of those six hundred years is full of interest and produced great works, the use of symbols declined. The artists of the Renaissance had other preoccupations; the coming of the Reformation was to sweep away much that was of value in Western art. The whitewashing of the churches not only obliterated wall paintings, in the way that iconoclasts destroyed the statues, but the old habits of thinking in allegories and symbols went as well.

In the earlier centuries the freshness of the ideas had not yet become fixed in static visual forms. Examples from the so-called Dark Ages for instance, combine vigour of design with intensity of feeling, itself augmented by naïveté of technique, and this roughness appeals to a certain element in our thinking today. The skilful Byzantines on the other hand, with their technical mastery, make a different appeal through their unsurpassed gift for rendering the symbolism of the spiritual world in colour and shape. The writings of preachers and poets of a given period will add depth to one's understanding of the work of artists of the time. The English quotations from Byzantine texts given in the books of Philip Sherard and Gervase Mathew for example are most valuable. To read the Anglo-Saxon poem 'The Dream of the Rood', for instance, will enhance the pleasure of looking at illuminated manuscripts of the period.

By the time of High Gothic the form and usage of symbols of Christian art had become stylized and the patterns of iconography firmly laid down. Later Christian art is much concerned with man's mastery in rendering appearances. Technical expertise became formidable and an end in itself. The developing Renaissance spirit led to an increased joy and delight in man and his own powers. The exploration of nature and the advance of scientific enquiry focused attention on the physical world, in contrast to the God-centred world of the Romanesque. The making of symbols was over.

There has been talk recently of a new symbolism for our own age, no easy task but a fine endeavour. The effort to simplify ideas enough to make them symbols will increase clarity of imagination and thought. Private symbols are a contradiction in terms, they should be a visual language between like-minded people. There is great scope for the Church to become re-aware of the power and value of imagery. Public 'images' are assiduously cultivated by large firms, corporations and even governmental institutions. The strength of any message today is judged by the majority in terms of its visual impact. The 'media is the message' type of thinking has affected all kinds of communications. There could be greater attention given to the visible expression of Christian truth. What direct symbols have we for Joy, for Prayer, for the Love of God, for the love of one's neighbour, for the Beatitudes, the Trinity and for Life after Death?

Although architects, theologians and some intellectual artists have gone on record as thinking all the old symbols of the faith to be irrelevant to our technological age, it is probable that most ordinary people still derive more support and insight from visual symbolism than from words. If all the figurative decoration is left out and the churches are bare their feeling-faith is chilled and impoverished. While much Church art is not of high imaginative quality there could be time, money and effort spent to raise the level rather than abolishing all opportunity. Man lives all his life within a rich variety of symbols derived from his work, his culture and his dreams. Cars and computers, lunar modules, space-vehicles and satellites, sport and television throw up a living symbolism of their own and it would be extraordinary for Christian thought to exclude so potent a groundwork in its perennial mission to bring to men the Gospel of the love of God.

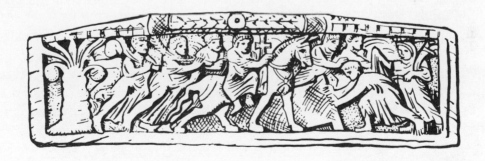

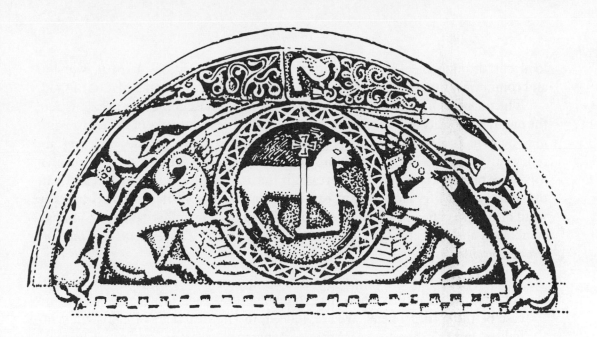

Symbolism

The Power of Symbolism

THE THEME of this book is to try to demonstrate that there is in visual symbolism a power to communicate ideas and feelings, especially those which lie beyond the net of language and logic. Experience as artists has led us to think that symbolism works on several levels of acceptance at once. It can come to the eye as a visual image, it can come to the mind as an intellectual parallel between two ideas, but its true value is when it flowers in the spirit in a sudden uprush of richer understanding.

The symbolism of visionary writers such as Dante or William Blake makes great demands on the intellect and mental capacities. For many people the power of words – or of music – surpass the symbolic power of visual forms. In the process of reading, or of listening to music or of watching drama the mind is more deeply involved; many people simply do not give comparable time and intensity to their *looking* at pictures and sculpture. But for some temperaments it is not too great a claim to say that visual symbolism truly offers windows into Reality for those who will

1. *The Agnus Dei* encircled with fabulous beasts. The symbolic eagle of St John and winged ox of St Luke support the disc with the symbol of the Lamb of God. From the Norman tympanum on the church at Aston in Herefordshire.

look out through them, and it is after all the whole purpose of ritual, worship and community prayer that man should forget himself in the contemplation of God.

The purpose of this compilation of old and modern examples is to demonstrate the enduring vitality of Christian symbols which express the roots of the faith. Faith may be seen as a tree. A living tree depends on its roots for its life, its leaves are renewed each year. Most generations of the tree of faith tend to think their own leaves are of major importance, whereas it is the unity of the tree, both root and leaf, that sustains its life. However, in nature a tree stripped of its summer leaves by wind or fire may die in spite of sound roots. Does our long inheritance of Christian symbolism and imagery stand in peril? Carl Jung says in *The Archetypes of the Collective Unconscious*:

> It would seem to me far better to confess strong-mindedly to the spiritual poverty of a want of symbols than to feign a possession of which we can in no case be the spiritual heirs. We are, indeed, the rightful heirs of Christian symbolism, but this inheritance we have somehow squandered.

A quotation from Nevill Coghill's introduction to *The Vision of Piers Plowman* defines the position in the twentieth century:

> a total falling away in the use and understanding of Allegory has come about; that whole system of poetic thinking has virtually disappeared. Allegory is not a mere trick of writing, a device to twist simple stories into moral shapes; it is not even excogitated in separate pieces and then assembled like a motorcar; it is the form of thought and poetry that arises from the deep intuition of the seamless coat of the Universe. Man is in the image of God, Nature is the instrument of God; one Divine Mind created, sustains, informs, and is everywhere capable of interpretation, because nothing is that does not proceed from and express it. Experience in such a Universe is full of meanings, for lesser things are microcosms of greater, and meditation will bring the understanding of one problem to light by the looking glass of another. This gift of transferred and simultaneous thinking has something of the qualities of metaphor and parable; the manifest meaning is a type of secondary meanings, which in the end are seen to be the richer, the more important.

If we take the Agnus Dei – the Lamb of God – as an example, it is obvious that on one level this is just a carving or depiction of a lamb balancing a cross on one of its front hooves. For those who recall that St John the Baptist said 'Behold the Lamb of God that takes away the sins of the world!' the image can be seen as another way

of depicting Jesus. Then for those who have read the Old Testament the Jewish idea of the lamb as a sacrificial animal will be added to the picture. The ideas of gentleness and purity, of innocence, whiteness, simplicity and freshness; all the attributes which have become associated with lambs, will attach themselves to the image, bringing us to the difficult concept of the totally sinless sacrificial victim offered as an expiation of another's guilt. The originally simple carving has become a substitute for: a depiction of Jesus; an innocent creature; a destined victim; a bearer of others' sins. Yet it is also a sign of the triumph of the Cross and therefore of Resurrection. It has become a symbol, which is more than an emblem or a token, although the lamb may still be worn as a talisman or used as a seal or be the device of the Lamb and Flag on an inn-sign. In this view a symbol may be likened to a stone thrown into a lake with the rings of associated ideas extending outward in wider and wider arcs. So with the symbol of the Lamb, it may flower into a single powerful concept in one person's mind, whereas another may find it linked not only to the visual ideas described but the aspect of Jesus as the Good Shepherd, or with the parable of the lost sheep, or with the twenty-third Psalm. A true symbol should encourage the growing points of feeling and thought, and should remain dynamic and flexible.

The question of the validity today of the simple pastoral symbols of the earliest arts of the Church is one thing, and the relevance of the elaborate iconography that grew up in the Middle Ages is another more remote subject. Whereas it may be pleasant or convenient for the craftsman to use stars and vines, ears of wheat, doves and lambs in the vocabulary of forms and ornament with which he builds up his design, it is a controversial question whether he should use such figures as Moses, Jonah, or David as examples from the Old Testament of Salvation stories.

We lose much by discarding the wealth of character and drama in these dynamic stories. Even if they are no longer thought of as literally true they are a witness to the belief of generations in the interaction of God and his creatures. Noah and the ark; David and Goliath; Daniel in the lions' den; they are splendid subjects for artists, and their very simplicity would make them translate into the bold spareness of modern design.

Too much emphasis on tranquillity in the interior design of churches can be soporific; as life is a struggle outside the walls so images of conflict within the church may well reinforce courage and fortitude. It is not without significance that many people today prefer the rugged grandeur of Romanesque art to the flowing elegance and harmony of High Gothic. Christian art should communicate vitality as well as balance and rhythm. Since the Devil was banished from popular visual

[3]

imaginings there have not been potent images of sin and danger, of evil powers in wait for the soul. Nor can one imagine how in today's terms they could be re-created. But if imaginative energy were poured into the Old Testament stories they could well stand as metaphors to speak to our condition. This is perhaps more a plea to theologians than designers. It is not much good an artist simmering with ideas for a window of the Children in the Fiery Furnace, if he is never going to be given a chance by the Church to make it. Those audiences who were moved and stimulated in the sixties by Benjamin Britten's musical parables of 'The Burning Fiery Furnace' and 'The Prodigal Son' will recall how apt they seem for our questions today – questions of tolerance for racial minorities or problems for parents of adolescent children going to the big city for the first time.

The Task of the Artist

The problem for the artist and the theologian working together for the Church today is to find a visual language appropriate to their activities. There are so many variations in modern art, in style and idiom; from the extreme abstractionists who would have all church art non-representational, to the conservatives on the other hand who find all change in the arts unsettling and have little sympathy with the insights of younger designers. Between these two positions there should be room for a rich variety of expression using the materials of the many crafts.

New ideas about the Liturgy have led to structural rearrangements within the buildings and given opportunities for original work in decoration and furnishing of the new churches. Such commissions are easier for the craftsman than planning work for ancient foundations which are often crowded with the memorials of earlier periods and with liturgical objects that witness the devoted skill of their makers but which may be remote from our liking now. One cannot invent a religious symbolism,

2. (facing). *The theme of Confronted Birds as a symbol.* These three variations show peacocks, standing for immortality of the soul, confronting the Tree of Life, the Fountain of Life, and the Chalice of the Eucharist. Left: Peacocks and doves from a twelfth century South Italian walnut pillar, now in the Victoria and Albert Museum. Right: Peacocks and parrots drinking from the stylized Fount of Life; from a carved marble panel set in the facade of St Mark's, Venice. In the great painting of 1396 of St Mark's by Gentile Bellini, this slab is shown gilded. Below: Peacocks drinking from the cantharus of the Eucharist: detail from the sarcophagus at Pavia of Theodota who died in 720. This example shows the Lombard flair for asymmetrical space-filling.

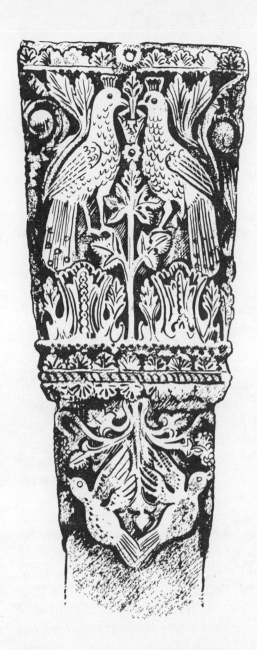

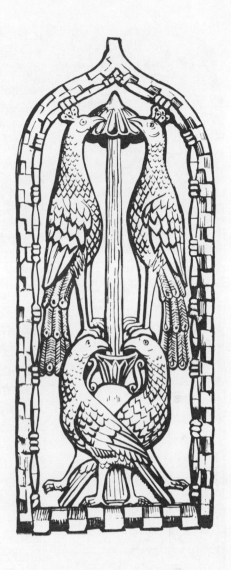

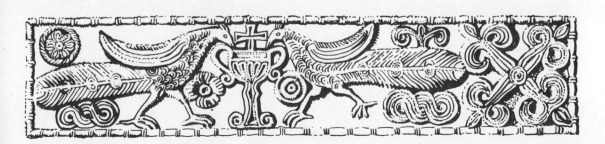

it has to grow from the complex interaction of life and belief and thus becomes a language without words linking those of the same culture. The earliest symbols have recently been called 'primitive Christian hieroglyphs' as though to label them a merely antiquarian and obsolete means of communication. But for some people these visual forms link us with the Christians of their origins; so we need not feel unidentified newcomers on the page of our century – we are part of the immense continuing procession of those, both in and out of the Church, to whom the life of Christ has been a Light.

It is heartening to imagine that the things we make in our own day may help to illuminate Christianity for those who come after us and show them our particular vision of Truth. The symbolism of early Christianity is entirely pastoral; water and wine; bread and oil; wood and stone; stars and wind; fish and birds; fruiting plants and domestic animals. How far removed these images seem from the urban life of dense cities. Yet city dwellers still long for their idea of the country and pack weekend roads with cars and caravans heading for the hills and the sea, in the process so often devastating the country peace they come to find. Conservation has become a popular word. We are beginning to grasp the damage thoughtless pollution can inflict on a rural environment and coming to value nature more highly because it is endangered. The deep significance of symbols from nature is strengthened by this fresh awareness of their vulnerability to actions of men and the delicacy of balance of the interdependence of all living things. The 'crown of thorns' starfish which is currently devastating the hard coral and thus the whole marine ecology of the Great Barrier Reef of Australia, and many Pacific islands, is a poignant and frightening symbol for the destructive aspects of much in our world civilization now. Man's

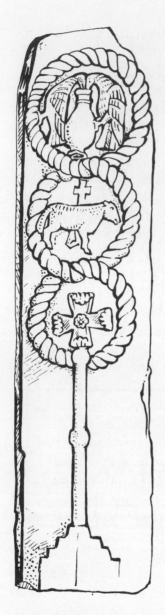

3. *The Agnus Dei* between a foliated cross and two doves drinking from a vase: from an eleventh-century tomb slab at Bishopstone, Sussex.

relationship with nature truly reflects man's relationship with his own kind and his relationship with God.

It is true that there are certain aspects of medieval symbolism that are outmoded. The unreal natural history of the bestiaries is obviously out of place today. We know that harts do not chase serpents and snuff them up their noses. But this knowledge does not destroy the beauty of the hart as an image of thirst for the Divine – or invalidate the medieval concept of the hart casting his antlers as we should cast our pride. The same goes for pelicans; we know they do not feed their young with their own blood, or that lions revive stillborn cubs with breath after three days. These images of Resurrection may well be obsolete. However, it seems unnecessary to deny designers the beauty and panoply of peacocks; they symbolized immortality for the Byzantines and the annual renewal of their sumptuous tails, as many-eyed as the beasts of Revelation, is symbol enough. The Chi-Rho, the sacred Monogram, and the variety of forms of the cross are surely valid now as ever they were, particularly perhaps the Eastern concept of the flowering or leaved cross.

The value of tradition in the arts, as of symbols in the Church, has been questioned by many. It is said that art as a whole has grown away from a need for tradition and can be independent of the restraints of the past, which are seen as a dead hand holding back the originality of the present. In the same way the old symbols are thought to be no longer relevant to our technological times and the modern approach is to jettison them as so much lumber. This attitude is reinforced by the current obsession with novelty of effect and the prestige of fashion. In fact, what is usually rejected by young people are those styles and forms in the twenty years preceding their own training. On going much further back in the past it is possible to see not only forms and techniques that speak directly to our appreciation, but fresh ways of expressing both the visible natural world and that other world of ideas so far removed from our own. The prehistoric marble figurines of Cycladic goddesses, for example, look so contemporary in spirit it is hard to realize that they are ancient artifacts. It is common knowledge that so resourceful an artist as Picasso could fruitfully absorb influences from the art of such widely differing sources as classical Greece and equatorial Africa. It has been pointed out that this tendency to range among the styles of art develops and sharpens the critical faculty in art-students at the expense of their own creativity. Certainly the language of symbols is primarily concerned with ideas and not with means of expression. Too much preoccupation with style weakens the significance of any religious art.

The current international obsession with manner appears as one reflection of a

widespread loss of the meaningful life, which has coincided with the rise of competitive materialism. Much of the present discontent with symbolism in the decoration of churches probably stems from a rejection of the ideas of the Gothic revival in England in the last century. This mistaken use of tradition vitiated much fine craftsmanship. It inhibited originality and saddled the Church with a backward-looking image in the eyes of both artists and the public, and this image and attitude has carried over into our own time. As a patron of the living arts today the Churches have been reluctant and timorous. However, since the end of the Second World War new architecture and particularly fresh developments in the Liturgy have brought a 'wind of change'. There have been heartening opportunities for the work of designers and craftsmen in new churches, particularly in France and Germany. Some of the thousands of people that flocked to see Coventry Cathedral said they were drawn as much by the range of adventurous modern art and architecture as by the drama of the rebuilding after bombing. The meaning of much of the symbolism at Coventry, however, requires literary explanation, especially in the great stained-glass windows on each side of the nave. The artists employed a particular and private symbolism of colour to express the intention of these windows. This brings us back to the earlier comment on the difficulty for designers and craftsmen to find a valid contemporary visual language of emblems or symbols for use in their work.

The earth seen from cameras on the moon has given many people a fresh vision of our planet, and it is probable that the techniques of space research may yield other results that germinate in new symbols – earthly images which carry an inner charge of spiritual meaning. It has been said by Dr Gilbert Cope that new ideas on church decoration might be founded on structures revealed by the microscope, the telescope and other scientific discoveries; the lives of modern Christian heroes and the labours of the Cities might replace the labours of the Months.

Photographic exploration in the field of vibrations by Dr Hans Jenny has revealed a new world made visible, a world of order, coherence and abstract beauty from which authentic new symbols might emerge to fortify the soul on its pilgrimage through life.

The discoveries of psychologists in the last fifty years have opened up a wider understanding of the nature of mens' minds and the common pattern of mental structures. For some this has reduced the stature of man and changed him into an animal with predictable patterns of instinct and behaviour based entirely on self-interest and self-preservation. Although a Christian would not subscribe to such a poor view of humanity, nevertheless the current general opinion tends to colour much contemporary thinking. Perhaps this is why the writings of Jung have had so

much effect on writers and artists of our time. His concepts of the archetypes and of the collective unconscious, of the racial memories and the reservoir of psyche common to all the race – offers a mystery instead of the glare of sex and self-interest. There is room in his rich imagery of the mind for myths to grow and flower and for symbols to transmute simple forms into complex and elaborate chains of meaning. He appears to leave the poet his intuition and the artist his prophetic images.

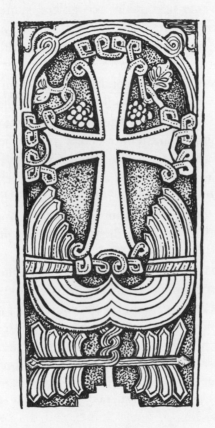

3a. Detail from a Khatchk'ar

The Cross

The Sign of the Cross

THE CROSS is still the one universally recognized symbol of Christianity. It is essentially a sign of Christ, representing his Passion and his Church, and speaking of Christianity to men of all faiths everywhere in the world, but this was not always so. In the first three centuries AD the cross was not openly used as a Christian symbol, for the early believers looked beyond the Crucifixion to the Resurrection and the emphasis was not on the cross of suffering and humiliation but on the Promise of Life with Christ here in the world and hereafter in the life beyond the grave.

The early persecutions in Rome led to secrecy and to the use of allusive symbols. Clement of Alexandria in the second century left written instructions to his fellow believers to use on their seal-stones such devices as the dove, the fish, the ship flying before the wind, or the marine anchor; these peaceful images being meaningful to the Christian but not incriminating if found in times of active persecution. Depictions of the Good Shepherd and the Chi-Rho to signify Christ are also found on seal-stones of a very early date.

In the lifetime of Jesus crucifixion was used as a cruel form of public capital punishment: full of horror for spectators and thus a presumed deterrent to revolutionaries. The death and resurrection of Jesus conferred a new and vast significance on this sign of ultimate humiliation.

One of the earliest known representations of the crucifixion, said to be of the second century, is a derisory graffito found in Rome. A tiny third-century gemstone from Constanza which is now in the British Museum, shows the figure of Christ standing symbolically with his arms outstretched against the cross amid a group of figures.

In its simplest form the cross is made by two straight lines intersecting at right angles. As a decorative unit it has a long pre-Christian history, being found in both Eastern and Western cultures; in the form of the swastika it was a popular ornament in Greek art and Roman floor mosaics preserve an interesting range of types. Although the sign was probably used privately in their worship by the small groups

of early Christians it was not until the reign of Constantine that the cross was publicly displayed and became the accepted symbol of the Christian faith. The threat of discovery and arrest which hung over Christian communities in the Roman Empire encouraged the use of allusion to express religious ideas and held back the growth of a representational Christian art until after the so-called Peace of the Church in AD 312.

The events which led to the widespread and enthusiastic use of the cross have a legendary character as reported in the writings which have come down to us. According to Eusebius, Bishop of Caesarea and the 'Father of Church History', the Emperor Constantine asleep in his tent on the eve of battle saw in a dream a luminous cross in the heavens bearing the words *In hoc signo vinces* – 'In this sign conquer'. By command of the Emperor the sign was placed on the imperial standard and under this banner Constantine won a conclusive victory over his rival Maxentius at the Milvian Bridge on October 27, 312.

From that military success the sacred monogram became the sign of victory and was widely recognized as meaning salvation in the name of Christ. It is found carved on sarcophagi, on coins, in mosaics and throughout the whole range of Christian art. In the repertory of craftsmen today it is still a favourite symbol.

Eusebius, who died in 340, gives a detailed account of the form of the device which Constantine ordered to be placed on a wreath at the top of the standard or labarum, and from the crossbar of which a jewelled banner hung down. The same device was painted on the shields and helmets of his soldiers. It was a monogram formed by the first two letters of the Greek word for Christ; the X and the P interwoven or combined. Although the monogram-cross has developed various forms at different times, basically it is composed of the Chi and Rho, the first two letters of the Greek world *ΧΡΙΣΤΟΣ* meaning 'Christ the anointed'. Some variants of this sacred monogram are shown on page 13.

Complex and decorative monograms of Byzantine emperors and bishops are found in the decoration of the buildings they erected. They may even be mistaken for versions of the Chi Rho by the unwary traveller, as the cross is usually part of the design.

The Invention of the Cross

St Helena, the mother of Constantine, when already a great age, set out in 326 to travel from Rome to Jerusalem to find and venerate the places made holy by association

4. *Various forms of the Chi-Rho monogram* illustrating the changes that took place in the symbol between the time of Constantine and the sixth century.

a. The earliest and best known form of the monogram; it is a simple combination of *P* placed over *X*, the Chi and the Rho, the first two letters of the Greek word meaning Christ.

b. This form was introduced soon after; both styles are found on coins of Constantine's reign. When the letters are used alone and not as a monogram they should read *XP* and not *PX*.

c. A later form of monogram, being a combination of a and b.

d and e. These are alternative forms of the monogram. d. can be interpreted as the Greek initials of Jesus Christ, the *I* and *X* being interwoven and in Greek the letter I being the same as J in English.

e. The two crosses superimposed make a wheel or a star.

f. The Greek *P* has become more like a Roman R. The use of a circle to enclose the Chi-Rho or cross is widespread. The circle may be purely ornamental or composed of laurel leaves, olive or palm branches representing the wreath of victory through Christ, or a crown of glory.

g. The tail of the letter has been dropped and the *P* has become a simplified hook like a bishop's crozier.

h. A combination of the Chi-Rho and IHS monograms.

i and j. These are decorative variations of the Chi Rho monogram.

k. The Greek word *IXΘΥΣ* meaning FISH can be made into an acrostic thus:

I	I	Ieus	: Jesus
X	Ch	Christos	: Christ
Θ	Th	Theou	: God's
Υ	U	Uios	: Son
Σ	S	Soter	: Saviour

l and m. These show the underlying design of the great Chi-Rho pages from two of the early Celtic manuscripts: l. the Lindisfarne Gospels, AD 700; m. the Book of Kells, eighth century.

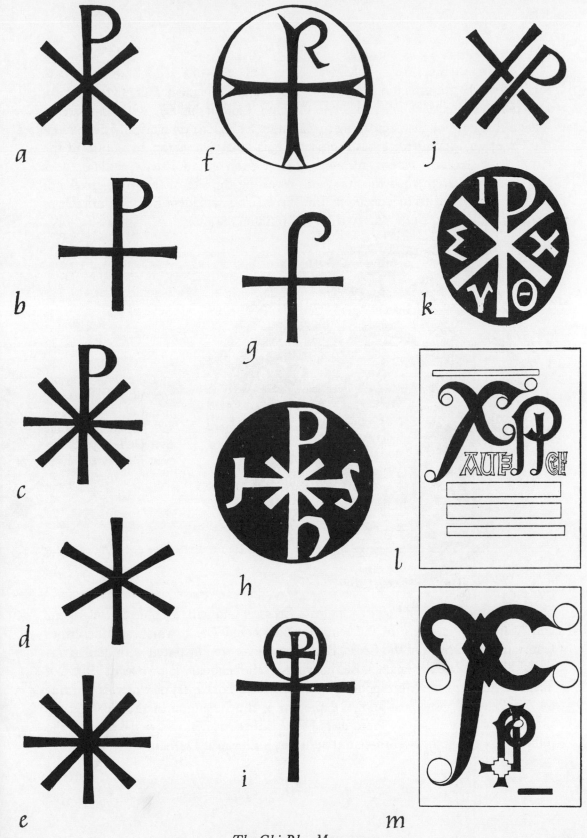

4. *The Chi Rho Monogram*

with events in the Life of Christ. During her stay this redoubtable old lady founded the basilicas on the Mount of Olives and at Bethlehem. Her contemporary, Eusebius has described her journey to the Holy Land in his *Life of Constantine*. It was on this journey that, according to tradition, St Helena dramatically discovered the Cross on which Christ was crucified. This is known as the Invention of the Cross, from the Latin *inventio* meaning to come upon or find. Briefly, the story goes that St Helena frightened the Jews into revealing the site of the three crosses of Golgotha, long buried in a deep pit. The True Cross was identified by a miracle of healing, and subsequently a martyrium was built on the site.

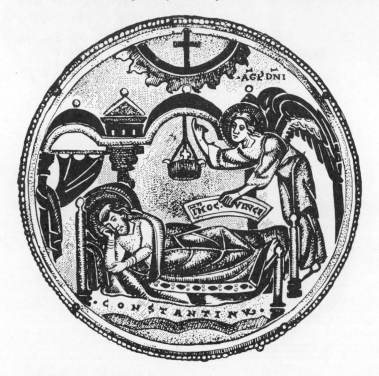

5. *Constantine's Dream*: from the twelfth century roundel in coloured enamels on copper on the Stavelot Triptych. Pierpont Morgan Library.

The story of the finding of the True Cross is told with graphic Saxon vigour and overwhelming piety in the tenth-century poem *Elena*, which also describes Constantine's Dream of the Cross. Both these texts are illustrated with deft narrative skill in the circular enamels on the wings of the reliquary known as the Stavelot Triptych, now in the Metropolitan Museum, New York, part of which is illustrated on Plate 16. The best-known depiction of the Invention of the Cross is the fifteenth-century fresco by Piero della Francesca at Arezzo; less well-known is the refined carving on the twelfth-century cross at Kelloe near Durham.

Whether this attractive legend has a foundation of truth or not, it is a fact that the belief in the finding of the True Cross increased the devotion of the faithful and dramatically stimulated the use of the cross as a symbol in art. Under Constantine it had become the acknowledged sign of faith in Christ. In the fourth and fifth centuries Christians not only ceased to fear persecution by the State, but they also came out into the sunshine of imperial favour and legal rights. Christian artists were able to discard the cautious allusive imagery. The cross as symbol of their faith could be used in sumptuous splendour of gold and jewels. In our times the use of precious metals and materials in church ornament is widely criticized as a misuse of wealth which could otherwise be spent to alleviate suffering. However, it is necessary to recall that other, poorer centuries than our own saw this flamboyant use of material richness as an expression of honour paid to the Son of God. The enrichment of their churches was a form of reverence which we should respect.

The Anchor Cross

The early Christians saw in the marine anchor an allegorical and disguised form of the Cross; variations of the anchor are shown on page 17. The words of St Paul to the Hebrews: 'We have this as a sure and steadfast anchor of the soul, a hope that enters into the inner shrine', caused the pagan emblem of hope to take on the deeper meaning of a heavenly hope anchored to the Cross of Christ. The anchor is found with the related emblems of the fish and the dove on seal-stones and in the catacombs. The sign of the Trident, also a cruciform device and found in the catacombs later than the anchor, was not so widely used.

Alpha and Omega

'I am the Alpha and Omega, says the Lord God, who is and who was and who is to come, the Almighty.' This majestic image comes from the Book of Revelation and also the declaration 'I am the Alpha and the Omega, the first and the last the beginning and the end.' These two letters, the first and last of the Greek alphabet, have long been used as Christian signs of the omnipotence of God and are found with images of Christ and in association with the Chi–Rho and the Cross. In

metal-work the letters are often hung from the crossbar; in mosaic they are placed each side of the upright or between the arms of the saltire cross. The mysterious 'Omega Point' of Teilhard de Chardin extends the use of the symbol to our own times.

The Sign of the Cross

BASIC FORMS

From the great range of shape and style of the cross in Christian art some of the more pictorial usages are illustrated here together with the essential basic form of the sign. The many versions with four arms resolve themselves into the two main types of the Latin and Greek Cross. Before the schism between the East and West these types were not specifically confined to the Greek or Latin Church, they were common to both, but gradually the first became more favoured by the Church in the West and the other by the Church in the East. Both Latin and Greek Crosses profoundly influenced the symbolism of the architectural plans and styles of church building.

THE LATIN CROSS In the Latin form the upright shaft is longer than the transverse branch, which is usually placed about two-thirds of the way up the vertical. It is believed that the historical cross of Christ's Passion and suffering was a *crux immissa*, which had the upright extending above the transom. In form it resembles a man standing with his arms outstretched. The Latin Cross is the one generally depicted on Christian monuments in the West and is probably the most widespread form in use today.

THE GREEK CROSS In the Greek form or *crux quadrata*, the transverse branch divides the upright shaft into equal parts so that all the arms are of equal length.

ST ANDREW'S CROSS This, the *crux decussata*, derives its name from the Latin numeral X; in heraldry it is termed the cross saltire. According to tradition the Apostle Andrew was martyred on a cross in the form of the letter X, and this cross figures prominently in the heraldry of Scotland, whose Patron Saint he is.

THE TAU CROSS The *crux commissa*, or St Anthony's Cross, was the sign made by the Israelites on their doorposts at the Exodus as well as the sign on which Moses raised the Brazen Serpent. Called the Tau because of its resemblance to the Greek letter T, it is the emblem of St Anthony of Egypt and is also used as the head

6. *Variations of the Anchor Cross* (*top row*), and some early forms of the Alpha and Omega in association with the Tau Cross and Chi Rho.

of pastoral staves for the actual or symbolic support of ecclesiastics in the Orthodox Church.

THE ANSATED CROSS In Egyptian hieroglyphics the ankh is the symbol of life. It resembles a tau cross with a loop and was used by the Copts, the Egyptian Christians. This ansated form is linked with the belief that the Cross is the Tree of Life.

THE PAPAL CROSS The Latin cross with three horizontal arms, each slightly longer than the one above, is known as the Papal Cross and this form is used in Papal processions.

THE PATRIARCHAL CROSS This has two horizontal arms, the upper one shorter than the lower. This style of cross is seen in early Byzantine art and is sometimes wrongly called the Cross of Lorraine. The upper cross bar stands for the panel of the inscription fastened to the upright by order of Pontius Pilate at the time of the Crucifixion.

THE CROSS OF LORRAINE This has two horizontal bars, a short one near the top and a longer one, which is nearer to the base of the cross than the bar in the Patriarchal Cross; it is this which distinguishes between these two forms.

THE EASTERN OR RUSSIAN CROSS This has three crossbars, the upper one representing the inscription and the lower, slanting one near to the foot of the cross representing the *suppedaneum*, or support for the feet.

THE CRUCIFIX This is a term used to denote a Latin cross bearing the image of the crucified Christ. Apart from public use on or above the altar in cathedrals and churches, it is one of the most universal of private devotional images among believers.

THE CRUCIFIXION is the term used for depictions of the historical event of Christ's death. These range from elaborate evocations of the scene, such as Tintoretto's mighty canvas in the Scuola di San Rocco at Venice, to the simplest memorial of the First Good Friday. The subject may be rendered with anguished emotion, or serene tranquillity symbolizing the acceptance by Christ of his Father's will. This is one of the central subjects of Christian art and has challenged the power and perception of the finest artists in each age. Plates 2 and 3 show some examples.

THE PASSION CROSS This is sometimes depicted as raised on three steps and is then termed in heraldry the cross of Calvary. It is illustrated on page 41.

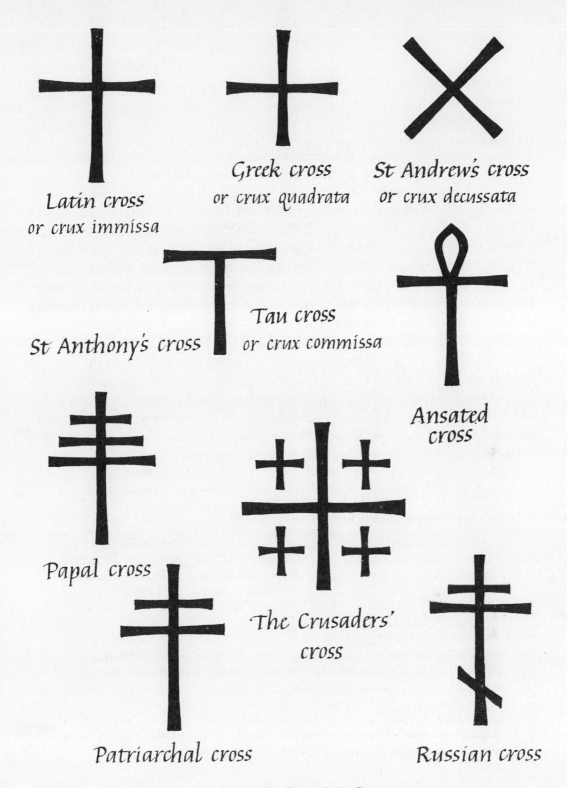

Latin cross
or crux immissa

Greek cross
or crux quadrata

St Andrew's cross
or crux decussata

St Anthony's cross

Tau cross
or crux commissa

Ansated
cross

Papal cross

The Crusaders'
cross

Patriarchal cross

Russian cross

7. *The Sign of the Cross*

The Monogram of Christ

Sacred monograms composed of initial letters and abbreviations of Greek and Latin words have been used inventively from the early days of Christian art. Outstanding examples are the Chi-Rho pages in the Irish and Northumbrian manuscripts of the seventh to the ninth centuries, notably the Lindisfarne Gospels, the Gospels of St Gall and the Book of Kells. The XPI monogram is a contraction for 'Christi' and proclaims '*Christi autem generatio sic erat*' from St Matthew's Gospel. T. D. Kendrick writes: 'The emphasis by ornament becomes so gloriously and extravagantly a salutation that the Great Monogram dominates the whole page.' Diagrams of the underlying design of these great Chi-Rho pages which announce the birth of Christ are shown on page 13.

The Chi-Rho monogram was later replaced by the capitals IC XC, IHC and IHS; in each case the monogram was composed of the first and last, or the first two and last letters of the Greek words for Jesus Christ. A fifth-century mosaic in the Archbishop's chapel at Ravenna shows four angels on the vault supporting a disc which bears the letters IX: this is an early form of the monogram made by superimposing the initials of the Greek name for Christ. Here in a flaming glory of light the sacred monogram is substituted for the human figure of Jesus.

8 (*facing*). *The Monogram of Christ.*

Top left and top right: The Monogram may be composed of the first and last, or the first, second and last letters of the Greek word *IHΣOYΣ* (Jesus) and *XPIΣTOΣ* (Christ). In Byzantine art the figure of Christ is almost always identified by the use of one of the abbreviations: *XΣ, XPΣ,* or *IΣ*. More familiar in the west is the IHC or IHS which took the place of the XP Monogram, this monogram is an abbreviation for the word *IHΣOYΣ* (Jesus); in the Greek alphabet *Σ* is the capital form, s the lower case form, of our letter S. Above the monogram the abbreviation is indicated by a bar or dash placed over the letters; an upright from the H may be prolonged to form a cross with the bar. A cross may be flanked by the monogram *IΣ XΣ* together with the inscription *NIKA* or *NIKH* meaning 'Jesus Christ the Conqueror'. Top centre: Cruciform designs from the so-called 'Carpet Pages' in Irish manuscripts. Centre: Three Orbs. Below: The Cross and Circle flanked by the swastika – or fylfot cross – derived from the pagan sun-wheel. The swastika is tainted today by its use as a Nazi emblem, but it was an obvious form of cross in previous periods and capable of many variations.

ihc

IHS

IC XC
NI KA

[21]

The Cross

As the knowledge of Greek declined and the use of the IHS became more wide-spread other meanings were attributed to the monogram and it was sometimes taken to stand for the Latin: *Jesus Hominum Salvator*, 'Jesus Saviour of Men'. The IHS monogram is still in use today especially in ecclesiastical embroidery. It is capable of a satisfying symmetry and balance as a unit in design, but it is on record as being mistaken at least once for the initials of the artist!

The Celtic Form of the Cross

The Celtic monuments of the early Christian period in Great Britain and Ireland, with their variety of crosses and wealth of ornament and iconography, can be a source of inspiration to the contemporary designer.

These Celtic monuments are of two kinds: pillar-stones and sculptured stones. The pillar-stones which belong to the period between paganism and early Christianity date from approximately AD 400–700, they are unhewn monoliths standing erect and the Chi-Rho, Alpha and Omega and crosses may be found incised on them, with inscriptions in Latin or Ogham.

The sculptured stones which superseded the inscribed pillar-stones in the seventh century are shaped in the form of a cross, or a gravestone. These are carved with characteristic Celtic ornament such as interlacing, spiral and key patterns, conventional animals also interlaced, and figure subjects. Sometimes they are carved with inscriptions in Irish minuscules, Scandinavian runes, or Saxon uncials. The object of the symbolism in the grave slabs was to express the hope of a future life with Christ and to mark the burial place of the deceased.

The splendid sculptured Celtic crosses which include the Irish High Crosses, date from the ninth to the eleventh centuries; they are covered with elaborate carvings, now much worn, showing scenes from the Scriptures. The purpose of the iconography on the high crosses was to instruct and there is no other European country with sculptural work of this quality at so early a date. The typical Celtic form of cross at the top of the shaft consists of a circle of stone connecting the arms, which may be pierced. On page 23 are drawings from incised slabs and the High Cross at Monasterboice is reproduced on Plate 2.

Varying shapes of the Cross are used as the controlling factor in the layout of the remarkable cruciform pages found in early Irish and Northumbrian illuminated manuscripts, as shown on page 21. On these so-called 'carpet pages' both the cross

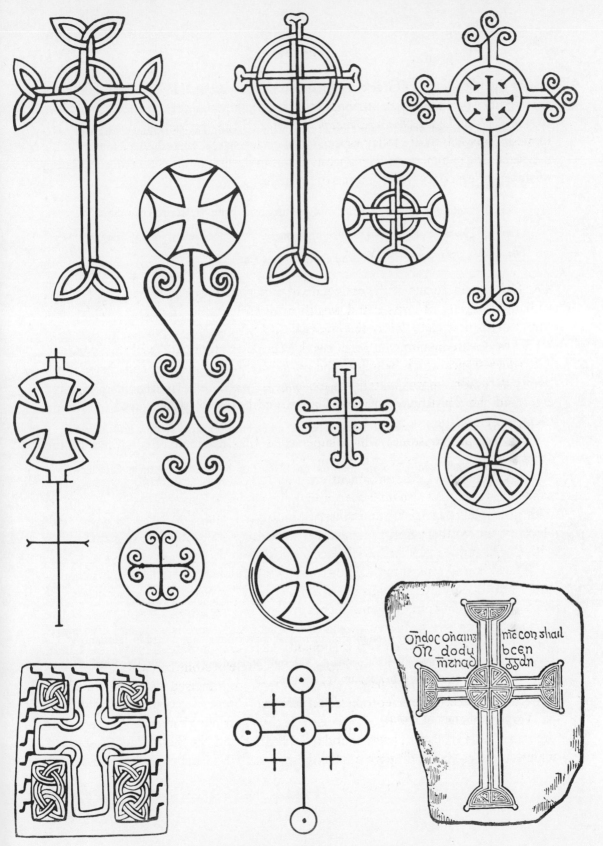

9. *Early Celtic crosses from incised slabs*

10. *Designs in Metal*

Some of these silhouettes show crosses allied with circles and could stimulate ideas for tiles, embroidery and the like; the tones can be counterchanged with considerable effect.

Top row:

Left: Byzantine bronze cross of the tenth century from Nauplia, Corinth Museum.

Centre: Horse brass. English nineteenth century. Typical of many similar designs.

Right: Swedish medieval iron candleholder from Hälland.

Middle row:

Left: Bronze candelabrum disc from Cortyna in Crete, now in Heraklion Museum. Sixth or seventh century AD. The candles fitted into the four holes in the corners.

Centre: Abyssinian brass processional cross, nineteenth century. Victoria and Albert Museum.

Right: French wrought iron door mount. Eleventh or twelfth century. Cloisters Museum, New York.

Bottom row:

Left: Swedish medieval wrought iron memorial cross from a churchyard in Jamtland.

Centre: Ornamental Swedish pendant. The traditional design uses the Tau form of cross and the Ave Maria monogram as pendants.

Right: Bronze Monogram Cross with Alpha and Omega in pendant form. Fifth century AD, now in Vienna.

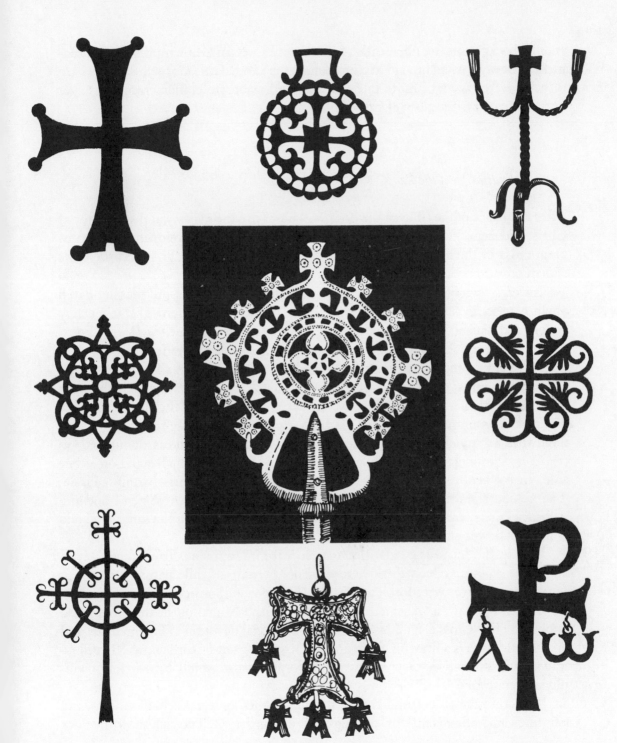

and the background are filled with a tightly woven web of Celtic interlace and orna-
ment. The style could be said to culminate in the Lindisfarne Gospels and it is hard
to believe that work of more intricate skill and elaborate craftsmanship has ever
been dedicated to the glory of God.

The Exaltation of the Cross

After the Peace of the Church the desire to emphasize the majesty and splendour of
Christ and exalt the Cross as a symbol of Triumph grew and developed; the crypto-
gram cross of the catacombs became the monogram cross of Christ and the chief
sign of salvation.

An early symbolic representation of the glory of Christ is the mosaic, dated
about AD 400, in the Baptistry of Soter, Naples. The chrismon cross set in a starry
sphere and flanked by Alpha and Omega, is crowned by the *Dextera Dei* holding a
wreath of victory. Another of those radiant examples of the exaltation of the cross is
the fifth-century mosaic in the cupola of Galla Placidia, Ravenna. The golden cross
is set in the midst of more than eight hundred gold mosaic stars which shimmer
from the depth of a midnight blue sky, and seem to spin around the glowing symbol
of Christ's assumption into glory. At Sant' Apollinare in Classe the whole apse is
filled with a symbolic mosaic of the Transfiguration. The scene is dominated by
the Cross standing for Christ while the figures of Moses and Elijah stand on either
side. In the centre of the huge gemmed cross is a head of Christ within a circle.
The golden star-studded sphere behind is ringed with a crown of gems and the
Apostles Peter, James and John, are represented below the Cross as three symbolic
lambs in a flower-strewn leafy meadow.

During the Iconoclast rule which lasted with intermissions from about 725 to
842 great crosses such as these were officially permitted while naturalistic repre-
sentations of Christ were forbidden by the Orthodox authorities in Constantinople.

September 14th is observed as the Feast of the Exaltation of the Cross, also
known as Holy Cross Day. This is a subject of special devotion in Georgian art and
on the title page is a drawing from one of the carvings at Nikordsminda that illus-
trates the passionate ecstasy with which Georgian artists could convey this meta-
physical concept.

The cross shown as studded with precious stones appears early in mosaics and
paintings and subsequently in carvings and illuminations. The richest of precious

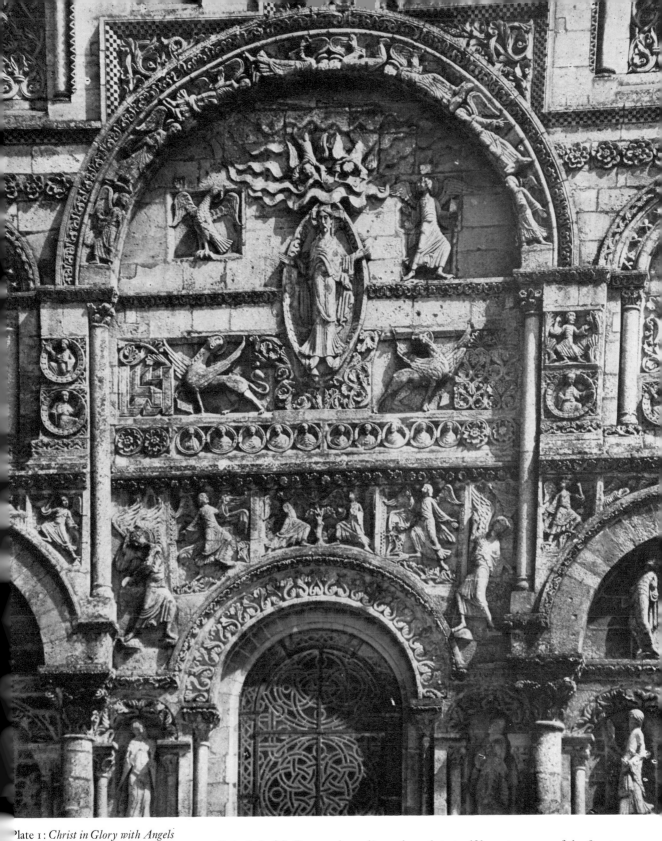

Plate 1: *Christ in Glory with Angels*

Part of the great facade of the Romanesque Cathedral of St Peter at Angoulême, eleventh to twelfth century, one of the finest sculptural compositions of the period in France. The surge of angels below unites with angels soaring round the arch above to frame the figure of Christ in the mandorla which is supported on the Tree of Life. The four Living Creatures, symbols of the Gospel Makers and also of St John's vision in the Book of Revelation, yearn with characteristic intensity to their Lord. The balance between architectural stability and figure sculpture of ecstatic feeling is handled with assurance. The whole composition has a sense of joyous praise and delight in worship.

(Photograph Cruikshank, Courtauld Institute)

Plate 2: *The Crucifixion: Russian, Irish and Gothic examples*

Top left: Russian brass Crucifix, possibly eighteenth or nineteenth century. This stylized representation of the Crucifixion demonstrates the long continuity of Byzantine iconography. Great numbers of these personal devotional objects were made in Russia before the Revolution, but the conservative style makes dating difficult. In this example the figure of God the Father emerging from clouds is seen at the top, with the orb in his left hand and his right raised in benediction. Below is the dove of the Holy Spirit between diving angels holding napkins; and cherubim with six wings. The figure of the Saviour is flanked by the figures of St John and Longinus on his left and his Mother and Mary Magdalen on his right. The feet are nailed separately, in accord with the Eastern tradition; the lance and reed are shown each side of the body; below is the skull of Adam within the mound of Golgotha, illustrating the poetic belief that Christ was crucified on the spot where Adam was buried and that his redeeming blood ran down to the skull. The decorative raised letters are used for abbreviated titles of Christ and the engraved letters along the arms of the cross for the names of the other figures and for quotations from the liturgy.

Right: The Irish High Cross of Muiredach at Monasterboice. This early tenth century cross is about eighteen feet high, carved in stone with scenes from the Passion and Resurrection. The typical Irish bosses surrounding the figure of Christ echo the shape of the heads in the groups of figures; angels support the head of Christ in their hands while on either side appear the lance and sponge bearer. The circle linking the arms of the cross is characteristic of Celtic design. (*Photograph Kim Allen*)

Below: The seal of Anthony Bek, Bishop of Durham from 1284 to 1311, made for his use as Patriarch of Jerusalem. The central tabernacle shows the Crucifixion with St John and the Virgin Mary. The feet are crossed and fastened with one nail, as was usual at that date in the West. In the neatly designed panel below are the three women with the angel at the empty tomb; below is an arcade with the sleeping soldiers. The Bishop himself is figured in prayer in the bottom compartment between patriarchal crosses. The wings show the Virgin and Child on one side and St Cuthbert holding the head of St Oswald, King and Martyr on the other, a reference to Durham where St Cuthbert's body is enshrined. In this Gothic design the symbolic images of Crucifixion and Resurrection have been used to enhance and substantiate the authority of the holder, whose titles are lettered round the rim of the seal.
(*Photograph Society of Antiquaries*)

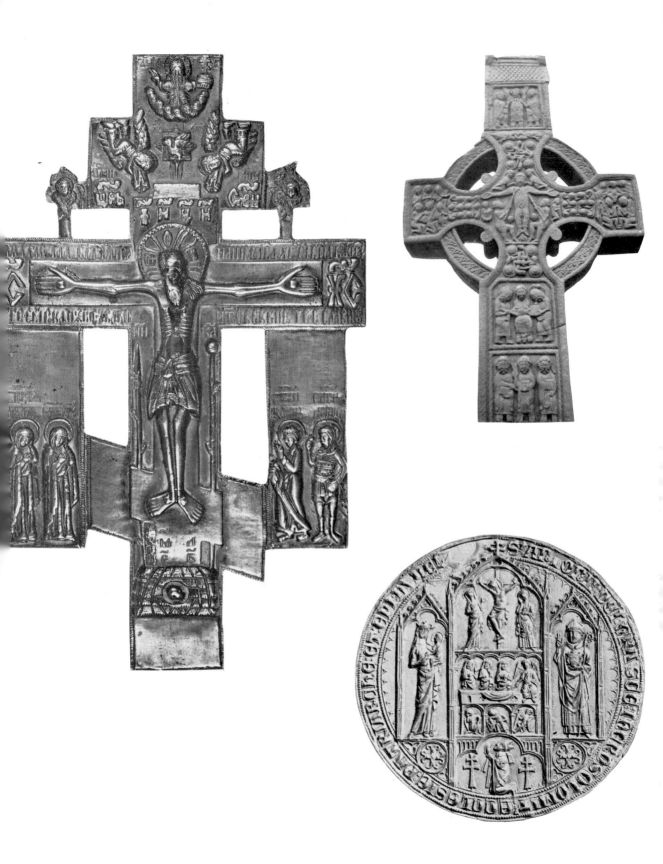

Plate 3: *The Crucifixion: Modern Examples*

Right: A modern gilded brass figure in the Chapel of the Goldsmiths in Notre Dame, Paris, by Philippe Kaeppelin. The fall of light on the sculptured forms emphasizes the pathos of the figure, already stressed by deliberate distortion and by the glimmering diagonals of shadow on the bare stones of the wall.

Left: A stained glass window designed by Marc Chagall for the church at Tudeley, Kent, in memory of the daughter of Sir Henry d'Avigdor-Goldsmid, MP, who died in a sailing accident in 1963. (*Photograph 'The Times'*)

Below: Christ falls beneath the Cross: one of a set of Stations of the Cross by Donald Potter in ceramic for St Matthew's Church, Bethnal Green.

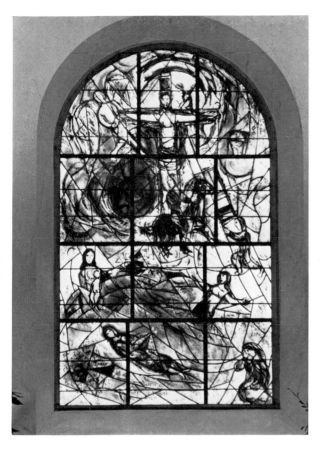

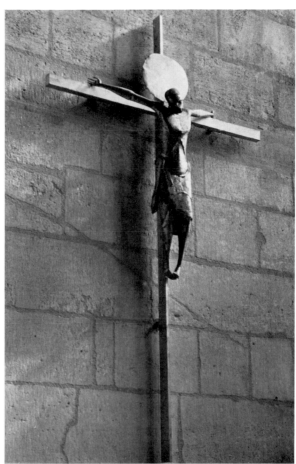

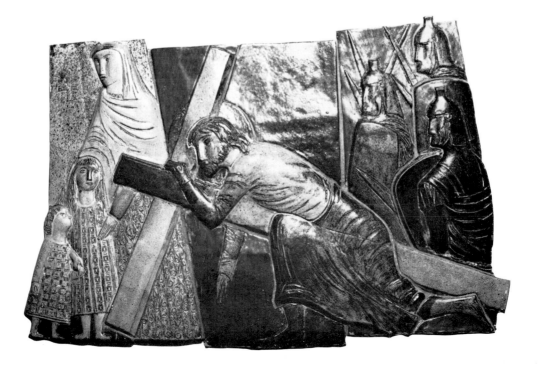

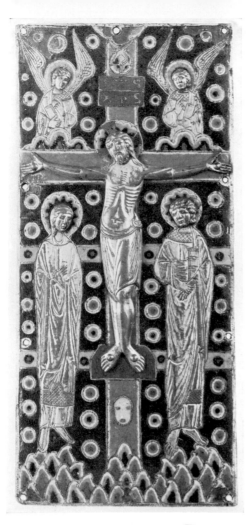

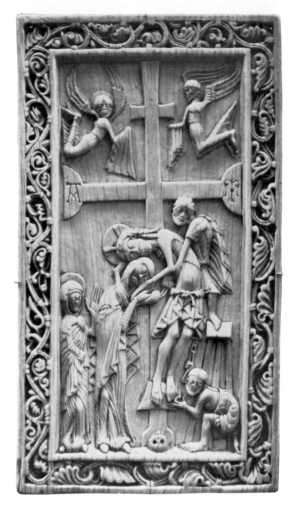

Plate 4: *Good Friday*, *Deposition*, *Resurrection*

Left: Crucifixion with the Virgin, St John and two Angels. A French Limoges enamel plaque of the thirteenth century in the Fitzwilliam Museum at Cambridge. Above the Cross the Hand of God is seen with a cruciform nimbus appearing from clouds; at the foot of the Cross is the stylized skull of Adam.
(*Photograph Fitzwilliam Museum, Cambridge*)

Top right: The Deposition: Anglo Saxon ivory relief of about 1150, in the Victoria and Albert Museum. This is one of the most moving expressions of this subject in English art.

Bottom right: Saints appearing from their graves. A French Limoges *champlevé* enamel on coppergilt in the Victoria and Albert Museum; illustrating 'The tombs also were opened, and many bodies of the saints who had fallen asleep were raised'.

materials were used for reliquaries of the True Cross and Gospel book covers in the Middle Ages. The setting of five jewels alone on a Cross stands for the five wounds of Christ.

> *A wondrous Tree towering in air,*
> *Most shining of crosses compassed with light.*
> *Brightly that beacon was gilded with gold;*
> *Jewels adorned it fair at the foot,*
> *Five on the shoulder-beam, blazing in splendour.*
>
> (from the Anglo-Saxon *Dream of the Rood*)

In the work of craftsmen today the cross may be made of new materials such as perspex and aluminium and in unconventional and adventurous forms. At Coventry the memorial cross of actual nails from the roof of the destroyed Cathedral preceded many variants of this symbolic form for processional and altar crosses.

The Sign of the Cross and the Circle

The circle without beginning or end is one of the simplest of all visual forms and yet it has been the symbol for complex and profound ideas. It may stand for the Cosmos, for Time, for Eternity or for the World. More obviously it may symbolize the sun's disc. When the circle encloses the cross it reinforces the symbolism of both images and becomes a potent sign, embodying the pre-Christian symbolism of the sun-wheel, an idea common to Northern and Eastern mythologies. Clement of Alexandria said that he saw the six days of creation as a three dimensional cross radiating out from a centre like a wheel, the spokes turning and extending up and down, right and left and backwards and forwards; while the hub, standing for the seventh day of rest remains fixed, as God remains fixed at the heart and centre of his Creation.

> *I saw Eternity the other night,*
> *Like a great ring of pure and endless light,*
> *All calm, as it was bright . . .*
>
> (from Henry Vaughan's *The World*)

The early form of the monogram of Christ made by superimposing the initials of the Greek name *ΙΗΣΟΥΣ ΧΡΙΣΤΟΣ* resembles a six-pointed star; the symbol of the sun's life-giving rays thus becomes the cruciform symbol of earth, where the tree of death paradoxically becomes the Tree of Life.

11. *Crosses in Stone*

Top left: Low relief carving from a slab in the fifth or sixth century basilica of St John at Ephesus showing elegant variation of form.

Right: Leaved cross with rosettes on the cross and background. The leaves take the form of ivy tendrils. From a panel in Santa Fosca, Torcello.

Below left: Carving from the back of the Bishop's Throne, Torcello. Cypress trees bow to the cross on which a scrolled design encloses the Hand in the gesture of blessing flanked by miniature emblems of the sun and moon.

Right: Carved stone with the ansated cross or *crux ansata*. Coptic, fifth century AD, now in the Louvre. The laurel crown round the cross signifies eternal life and the Alpha and Omega symbolize Christ as the beginning and end of all things. The form of this cross is closely related to the ankh or 'sign of life' of the ancient Egyptians.

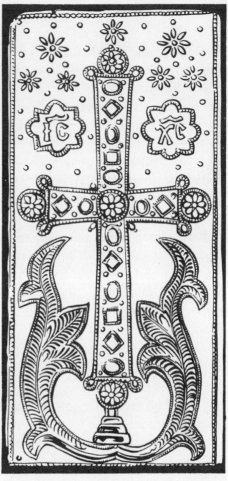

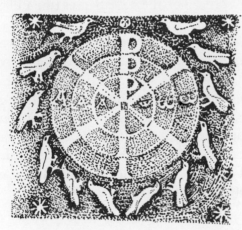

12. *Stone, Silver and Mosaic Crosses*

Top left: Carved Lombard font or well head, about eighth century AD, in the Victoria and Albert Museum.

Right: An embossed leaved-cross flanked by the Greek Monogram of Christ; from the reverse of a twelfth-century silver-gilt reliquary in the Louvre.

Below: Mosaic from the Baptistry of Albenga near Genoa, fifth or sixth century AD; twelve white doves, symbol of souls, encircle the threefold monogram of Christ against a blue background. The convert was baptized in the name of the Father, Son and Holy Spirit and the design stresses the triple nature of the Rite.

Christ said: 'I, when I am lifted up from earth will draw all men unto myself', and by its nature the cross draws men from the four corners of the earth to its own centre. In some early depictions Christ is shown carrying the orb of the world in his hand; in the medieval illumination illustrated on Plate 6, for example, the world in his fingers is diminished to the size of a nut. The orb of early representations was traditionally divided into three parts which represented in schematic form the then known geographical world, with Jerusalem actually and symbolically marked as the centre. When the orb became a symbol of both divine and earthly Kingship the cross was depicted surmounting and projecting above the sphere.

Men of the Middle Ages loved to illustrate abstract ideas with visual forms. The concept of the wheel was used to illustrate other aspects of experience beside the Creation of the World, for example the Wheel of Life on which a man rises to maturity and falls to old age and death, or the wheel of Fortune with its sudden changes of fate which can also demonstrate the moral teaching of the Wheel of Pride; or the Anglo Saxon wit in the elegant brooch of the Five Senses (the Fuller Brooch) in the British Museum.

The Celtic imagination evolved a form of cross and circle peculiarly its own; whether in elaborate manuscript illumination, incised slabs, or carved as massive free standing stone crosses with a surpassing richness of surface texture and figurative imagery, the Celtic cross is unmistakable and breathes a spirit of veneration. A literary parallel to the intensity of feeling can be found in the *Dream of the Rood* already mentioned, a poem quoted in a runic inscription along the edges of the Ruthwell Cross which was carved in the seventh century with figurative sculpture of high order. In the poem the Cross itself speaks to the reader with the vigour of an Anglo-Saxon riddle but with greater depth of imagination and insight.

The Leaved Cross

This attractive form abounds in Eastern Christian art. It is found in sculptured reliefs, in metalwork and painting and most of the minor arts. Springing from the base of an upright cross the leaved fronds divide and take a variety of forms, ranging from long thin stems ending in triple buds to short stylized palmettes; more often they resemble acanthus leaves, a graceful form which curves upwards on either side of the vertical shaft. The cross itself may have looped corners at the ends of the arms; the surface of it may be plain, decorated with patterns, or with plaited ornament from which the ribbons of the plait emerge to become the stems

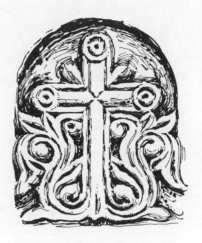
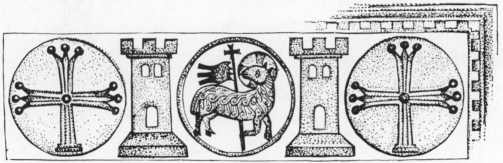

13. *Contrasts in the design of early low relief carvings*

Top left: A carving on the outer wall of St Catherine's monastery in Sinai built in the sixth century AD.

Centre: Coptic slab carved with ornate cross, from Oxyrhynkhus, fifth or sixth century AD.

Top right: Leaved cross set in a lintel. Byzantine Museum, Athens.

Below: The Agnus Dei between castles and crosses carved in very low relief on the massive rose marble tomb of Raimondo della Torre in Aquileia cathedral.

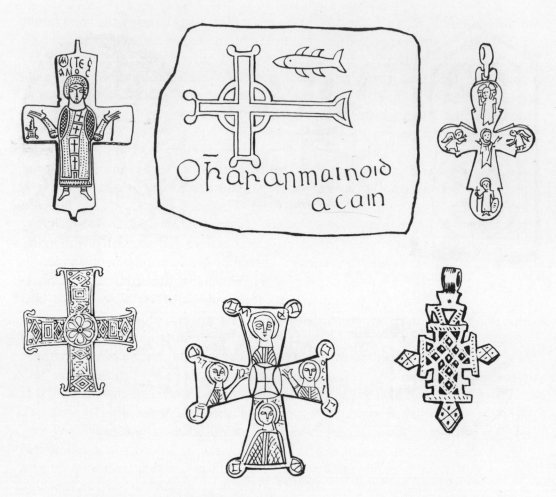

14. *Incised crosses in metal and stone*

Top left: Bronze reliquary cross with orante, twelfth century. British Museum.

Centre: Fish symbol with cross on a tombstone at Fuerty in Ireland.

Top right: Byzantine gold pectoral cross with incised figures and angels. British Museum.

Below left: A cross incised as if jewelled. Cividale del Friuli.

Centre: Bronze cross incised with figures of the Virgin and Saints, from an eleventh century tomb at Aphrodisias in Turkey.

Below right: Abyssinian pectoral cross in copper as sold in the bazaars of Addis Ababa today.

of the leaf forms. At times the decoration resembles wings flanking the cross rather than foliage; some forms resemble the flukes of an anchor and some the martyr's palms. The idea of this leaved cross may well have originated in the East, in Armenia and Georgia; it was certainly carried to Western countries by the wide ranging influence of the Byzantine style in art and decoration. It is said to be in use by Nestorians, a sect which survives in spite of being regarded as heretical by the Council of Ephesus in 433.

Armenia was evangelized as early as the fourth century AD and developed distinctive carved crosses on stone slabs, called *khatchk'ars* for commemorating the dead or for victories or other special occasions. These slabs may be as tall as ten feet, free standing or carved on walls or rock faces. The large-scale leaved and floriated crosses on them are in very low relief usually designed within a rectangle which may be surrounded with borders of intricate abstract pattern and associated with figure carvings. The later versions have been influenced by Moslem styles in ornament.

A variant of the leaved cross is the form in which it is flanked by trees or ornamental plants which bow inward towards the symbol of their Maker. This idea probably derives from the potent image of the Tree of Life, widespread throughout the East long before the time of Christ. The Harbaville ivory illustrated on Plate 29 is an exceptionally refined example of this concept with its delicate evocation of the garden of Paradise.

The meaning of the leaved cross might well be pursued by artists today. It stresses the life-enhancing vitality of the symbol and conveys visually the experience of those many believers who find that acceptance of Christ's command 'If any man would come after me, let him deny himself and take up his cross and follow me' flowers into joy and fulfilment. Life, however difficult, is then borne up by new growing points of experience and insight that are also wings of the spirit and anchors for hope. The harvest vine of Eucharist becomes also the wine of fellowship. The bare and rectilinear symbol of death, the winter of the spirit, is suddenly alive with bud and leaf and is transformed into a springtime image of Life with all its flux and urgent sense of purpose, confirming the faith held in the heart, against all logic of the brain, that life is Spirit and does not perish.

The Design of Crosses

It could be said that the Latin cross with parallel sides, plainly conceived as two planks of timber at right angles, lacks the vitality and humanity of the typical

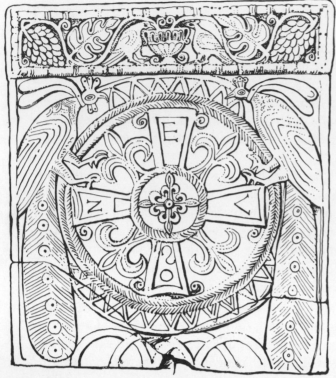

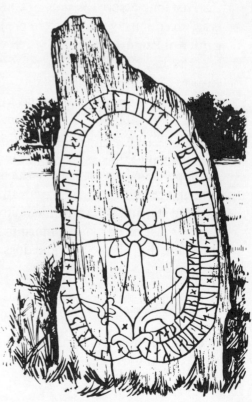

15. Top left: Low relief carving from a screen, probably Lombard, at Aquileia. The cross within the sunwheel is centred and angled with lily forms and flanked with peacocks of immortality. The doves drinking from the cantharus, from which spring vine scrolls, symbolize souls refreshed by the Eucharist.

Top right: Modern pectoral cross: incorporating the rose and heart emblems. Grace Lutheran Church, Cleveland, Ohio.

Below right: One of two eleventh century rune stones from Broby bridge near Stockholm which record the travels of Osten to Jerusalem and Greece, where he died.

16. (*facing*) *Lombard Designs*.
Top: Low relief carving on the frontal of the high altar in the Abbey Church of San Pietro in Valle, Ferentillo, built under Duke Hilderich in 739–40. This crude work gave its Lombard craftsman such pride that he carved his name URSUS MAG-ESTER. The disc-headed crosses recall Celtic designs.

Below: From a carving on a choir screen in the cathedral of Cividale del Friuli. The central cross is decorated with heavy lily forms at the angles and flanked by vines and sun and moon discs.

[34]

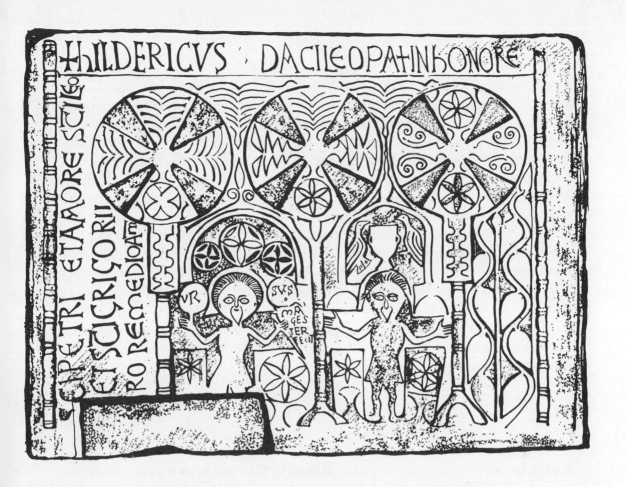

HILDERICVS · DACILEOPATINHONORE

SCIBPETRI ETAMORE SCIBO ETSCIRICORII RO REMEDIOAM

VR · SVS MA GES TER FECIT

Byzantine form with outward flaring arms or the joyous intricacies of Celtic crosses. Possibly the most harmonious of all designs are those in the early Byzantine tradition, and these develop sympathetically into the flowering cross, the symbol of Life. The proportions of the arms to the height and to each other are particularly satisfying, and this visual harmony radically affects the quality of the symbolism. A badly designed cross is painful to observe and no honour to the Redeemer. Some artists today have used elaborate distortion of the form to stress the Cross as a sign of physical suffering, and even of horror.

The old forms are also being employed in new ways with modern materials and the familiar symbol revitalized with a fresh vision, not always acceptable to the conservative mind. On the other hand it has also been said in criticism of modern work that designers do not show enough originality in their use of symbols, tending to 'fall back' on the sign of the cross as being the obvious choice of ornament in ecclesiastical crafts. The best path lies in the artist understanding its true significance and not appearing to reduce this central symbol of the Christian faith to a vehicle for decorative novelty.

Ecclesiastical Heraldry

The Influence of the Crusades

Paramount among the religious emblems used in the Holy Wars was the Cross: indeed the Crusades, those extraordinary predatory expeditions to recover the Holy Land from the power of Islam, which took place between the years 1096 and 1291, were named from the cross which the Crusaders bore on their clothing, banners,

17. Some Modern Designs

Top left: Altar piece with the anchor cross, Chi Rho, Fish and Alpha and Omega sand-blasted onto a glass panel set against a sheet of polished copper, by Donald Murray.

Top right: Wrought iron screen decorated with crosses and dolphins from the main entrance porch of Liverpool Anglican cathedral.

Below left: Young leaves symbolizing New Life springing from the wood of the Cross, the star in the centre signifies 'I am the root and offspring of David, the bright morning star'. Designed by Robert Sellars for use by Protestant churches in Northern Ireland.

Below right: Pulpit and lectern. Designed by Geoffrey Clarke and Robert Potter for Chichester Cathedral in 1966. The cast aluminium cross has been used as a decorative pattern of multiple uprights and horizontals; its curved forms contrast with the severe lines of the pulpit.

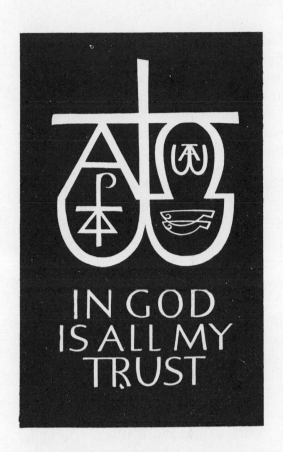

IN GOD
IS ALL MY
TRUST

pennants and horse-trappings. The Cross of Christ was depicted at first blood-red on white, but the advantage of distinguishing colours for the different armies soon led to variations in the colour and form of both cross and background.

Even in the advanced weaponry of our own century military units have found the value of easily recognizable badges or flashes on uniforms and vehicles, especially in the Middle Eastern desert war of the nineteen-forties. How much more necessary must recognition have been to the Crusaders with their motley armies of different tongues and races. The Orders of Chivalry which developed at this time naturally adopted differing individual signs. The Military Order of the Templars bore the cross of eight points red on white. The Knights Templar took their name from the Temple at Jerusalem; originally they were a body of laymen living the monastic life, whose duty it was to protect pilgrims on their journey to Jerusalem and the Holy Places from the coast. The white habit of the Order was distinguished by the red cross. The Knights Hospitaller, or Knights of St John, bore the cross of eight points white on black; this came to be known as the Maltese Cross and survives today as the badge of the well-known Venerable Order of the Hospital of St John of Jerusalem and the St John's Ambulance Brigade. The Knights of St John shared with the Knights Templar the military virtues of bravery and discipline. They adopted the Benedictine Rule and black habit with the familiar white eight-pointed cross. They founded hostels for pilgrims and hospitals for the sick. The Red Cross organization, with humanitarian aims, formed by a Swiss in the nineteenth century, is concerned today with the victims of wars and disasters.

The Crusades may be said to have engendered the science and art of heraldry and although this practice may have evolved as a means of recognition for men obscured by heavy armour, the actual signs, which were termed 'charges', were picked in many cases for their meaning. Symbol would perhaps be too strong a word to use, but the devices on shield and crest were often chosen to bless the wearer as well as label him publicly according to his origins and loyalties.

The paramountcy of the cross as a sign of Christian faith led to an astonishing proliferation of its plain and decorative forms for use on shields and surcoats, banners, seals and buildings.

After the capture by the invaders of the city in 1099 the arms adopted by the Crusader Kings of Jerusalem were five gold crosses on a silver shield. The crosses may signify Christ with the four Evangelists, or the Five Wounds of Christ, which would have sprung readily to the minds of the invaders after the hardships endured in winning back the Holy Places.

Palestine was the centre for the veneration of St George, the warrior saint; he is

reputed to have been martyred there at the end of the third century AD. As patron saint of England his red cross on a white ground is flown today from the towers of cathedrals and churches throughout the land at festivals and on ceremonial occasions.

Plain or ornamental forms of the cross are found on ecclesiastical seals from an early date and on medieval documents at the head of a deed and before a signature. Other Christian emblems and devices were aptly incorporated in the seals of bishops and religious houses even before heraldic arms were used; subsequently these devices were repeated in the armorial bearings of a bishop's see or diocese. The arms of sees in the Church of England today display among other devices the image of the Virgin and Child; the image of Christ; the Sacred Monogram; the Agnus Dei; the cross in a variety of forms, and such emblems as the keys of St Peter, the sword of St Paul, the archiepiscopal staff and pallium, the mitre, the crozier and the crown.

The Orb and the Sceptre and the Crown

These attributes of kingship are ancient symbols of power and authority. The rod and sceptre is probably the earliest of kingly insignia. The patriarch Moses – having suffered under the despotic crook and flail, traditional emblems of the power of the Pharaohs – was much concerned with rods of authenticity. In the Exodus story it was his brother Aaron's rod that blossomed by divine intervention, selecting him and his heirs for the priesthood.

Rods, batons, staves, sceptres and wands are still used as insignia of office. In Christian monarchies the sceptre is tipped with a cross and carried in the right hand; the orb, symbol of the round world and thus of dominion, is also surmounted with a cross and placed in the left hand of the monarch. In certain depictions of the Almighty the orb of dominion is shown in his left hand and with his right he gives the blessing.

The crown remains the most obvious and general sign of royalty (although no longer of power). Traditionally it is made of gold with jewelled enrichment to display royal wealth. The custom of putting votive crowns in cathedrals in early medieval times enabled some fascinating examples of goldsmith's work to survive the predatory centuries; for example, the seventh century crown of the Visigothic King Recceswinth, from Toledo, has the letters of his name hanging like little jewelled mobiles from the hoop of this golden votive offering.

18. Crosses used as Heraldic Devices

a. The Latin cross with limbs of unequal length is sometimes placed on steps or degrees; the three steps represent the Christian virtues: Faith, Hope and Charity. It is described heraldically as the Calvary Cross.

b. In heraldry the plain cross may be varied with ornamental border lines. The cross *raguly* simulates the wood of the Tree with the branches lopped, the projections must point along the limbs outwards from the centre.

c. The cross *pomy*, or *botonny*, may have been designed to represent the limbs budding; an expressive symbol.

d. Maltese Cross, shaped like four spear-heads with their points joined together. Several of the crusading Military Orders adopted an eight-pointed cross; each point was said to stand for one of the Beatitudes. It is a form of cross used in the insignia of Orders of Knighthood, such as the Order of the Bath. Other Orders use a group of crosses distinguished from each other by their tinctures and the number of their points, for example the badge of the Order of St Michael and St George consists of a cross with seven limbs and fourteen points.

e. The voided cross or *gammadia* is composed of four Greek gammas, emblematic of Christ as the Corner-stone of the Church; it is frequently seen on vestments in the Greek Orthodox Church.

f. Cross *potent*. A development of the Greek cross in which a transverse is added to the end of each limb making a T, or four crutch-shaped Tau crosses joined at the centre.

g. Cross *floretty*. There are many heraldic crosses with flowering ends to the limbs, in some the fleur-de-lis is joined to the cross, as it is here, and in others it is developed from the end of the limb.

h. Jerusalem Cross or Crusaders' Cross, worn by Godfrey de Bouillon, first ruler of Jerusalem after the liberation from the Moslems. A cross *potent* between four smaller Greek crosses.

i. Cross-Crosslet. Four Latin crosses set foot to foot and making a Greek cross. It represents the missionary spirit of Christianity spreading throughout the world.

j. Cross *botonny* with trefoil buds.

k. Arms of the See of Lichfield: *per pale gules and argent, a cross potent quadrate between four crosses paty all counterchanged*. The cross *paty* is a variant of the straight-armed cross; it is widely used for decorative purposes.

l. The cross of Lorraine, sometimes confused with the Patriarchal cross. The difference lies in the position of the transverse which is as near to the foot of the upright as the upper one is to the head.

m. Arms of the See of Coventry: *gules a cross potent-quadrate in the centre argent, within a bordure of the last charged with eight torteaux*.

n. St Julian's Cross. A cross-crosslet set with limbs aslant.

o. Arms of the Province of Canterbury: *Azure an archiepiscopal staff in pale argent ensigned with a cross paty or, surmounted of a pall argent fringed or, charged with four crosses formy-fitchy sable*. The pall, or pallium, is a circular band of white woollen material with two strips pendant from the back and front on which are marked six crosses. It is held to symbolize the pontifical office and participation in the authority of the Pope. It is worn on the shoulders of the Pope and granted by him to Archbishops. A province is a group of dioceses forming an ecclesiastical unit. A see is properly the official 'seat' *sedes*, or 'throne' *cathedra* of a bishop. The seat, which is the earliest of the bishop's insignia, usually stands in the cathedral of the diocese; hence the place where the cathedral is situated is itself known as the bishop's see.

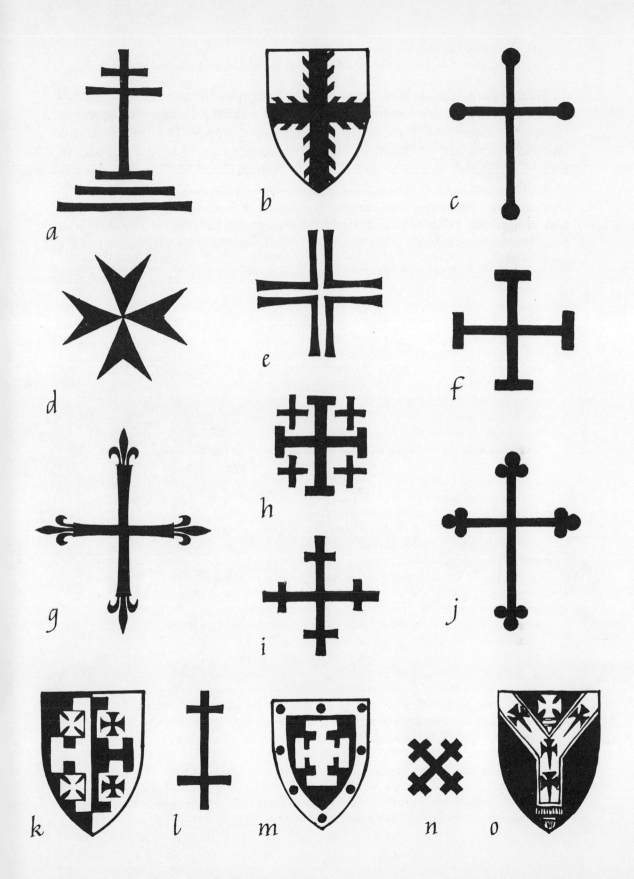

a

b

c

d

e

f

g

h

i

j

k

l

m

n

o

The figure of Christ the King crowned and reigning from the Cross expresses the unity of defeat and triumph. The figure of God the Father may be shown crowned, sometimes with the triple crown proper to Popes. The Virgin Mary is also shown crowned as Queen of Heaven in many medieval representations. In some Continental churches statues of the Virgin, often distinguished works of art, have been smothered by the later additions of tawdry crowns and jewels from donors of generous but misplaced piety. In mosaics the figurative crown of martyrdom may be shown carried in the hands of the martyrs, as at Ravenna in both the baptisteries and at S. Apollinare Nuovo in the long procession on the walls of the nave.

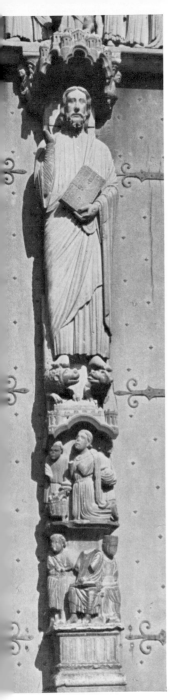

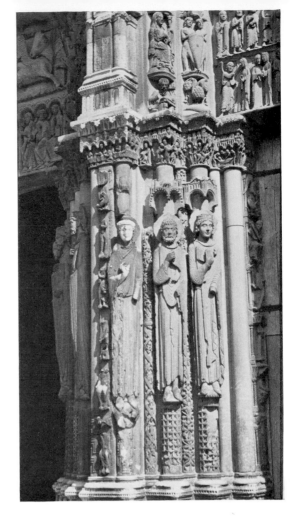

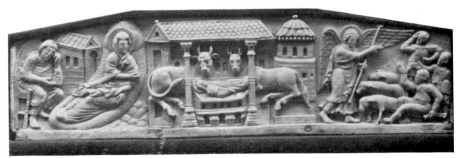

Plate 5: *The Coming of Christ*

Left: Christ on the trumeau of the south porch of Chartres Cathedral, thirteenth century, as described by Emile Mâle: 'Clothed in divine beauty, treading the lion and dragon underfoot, He raises the right hand in blessing and in the left holds the book of the Gospels . . . The whole New Testament is so forcibly summed up in the figure of the teaching Christ on the trumeaux of the French cathedrals that to the Middle Ages it did not seem necessary to depict the Gospel scenes at any length.'

Right: The Forerunners of Christ, detail from the Romanesque Portal Royal, Chartres Cathedral. These column figures represent the Kings and Queens of Judah in an elaborate symbolic context foreshadowing the coming of Christ.

Below: The Nativity and Adoration of the Shepherds. Part of the ivory cover of the Lorsch Gospels, ninth century; in the Victoria and Albert Museum.

Plate 6: *Contrasting Images of Christ*

Christ in Glory with Angels at the Second Coming: massive carving high on the south gable of the Georgian church of Nikordsminda near Kutaisi, dating from 1014. The splendid barbaric energy of these 'carved angels ever eager-eyed', is sustained by the balance between the horizontals of their bodies and the diagonals of their wings; making a great inverted triangle supporting the figure of Christ. The enormous hands stress the importance given to gesture in conveying intensity of feeling. The carved ornamental bands round the windows, gables and portals show in yet another form the geometry underlying the rich and intricate designs of Georgian craftsmen. (*Photograph Dr Ellen Macnamara*)

Below left: Christ in Glory from a tenth century manuscript Codex Vigilanus, at the Escorial, Spain. The figure of Christ is depicted between Alpha and Omega, holding the minuscule world in his right hand. Seraphs and Archangels fill the corners of the angular design.

Below right: Shimmering mosaic of Christ on the east wall of the new church of Skàlholt at Biskupstungur in Iceland by Nina Tryggvadóttir.

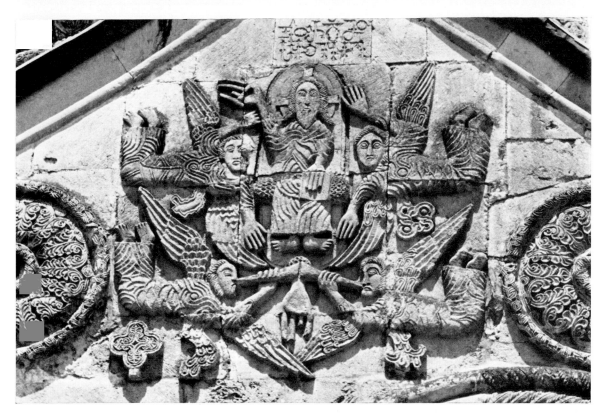

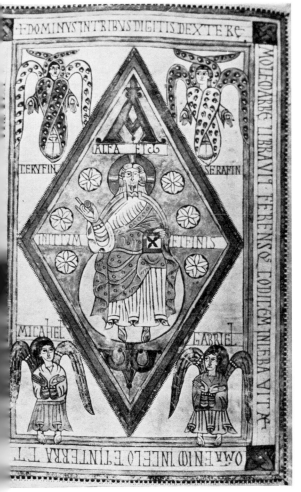

Plate 7: *Majestas*: designed by Francis Stammers for the chapel of St Michael's College at Llandaff. The figure of Christ in Majesty surrounded by the four Beasts of the Apocalypse is eleven feet high: 'It is made of small sheets of gilded metal and purple glass within a sweeping silvered vesica, the whole great composition held together by aluminium wires, and superimposed on a blue wooden cruciform background. The surface of the effigy is enlivened by thin metal strips set at right angles to the curved forms beneath, giving something of the sharp linear effect of the great throned figures in Romanesque manuscript illumination.' (*The Times*) (*Photograph Stanley Travers*)

Plate 8 (opposite): *Christ the Worker*: sculpture in Blackburn Cathedral by John Hayward. The work is fourteen feet high and carried out in aluminium and fibreglass with a forged and welded iron mandorla.

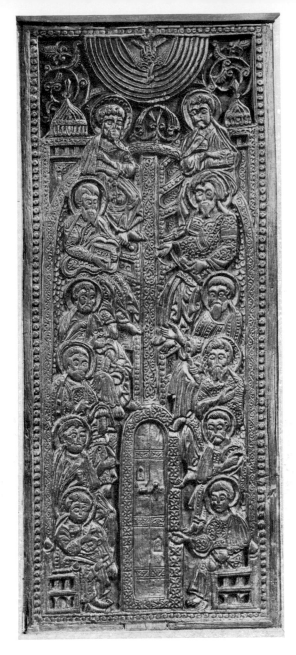

Plate 9: *The Inaugural Events*

Right: The Baptism of Christ: modern wall painting in the south aisle of Chichester Cathedral by Hans Feibusch. The setting within a niche enhances the dignity of this sensitive rendering of the event.

Below right: The Last Supper: carved wooden roof boss from Salle Church, Norfolk. This serene and moving work is beautifully composed within the circle of the boss. (*Photograph National Monuments Record*)

Left: Pentecost: early medieval Coptic carved wood panel from Cairo now in the British Museum. Although the dense surface ornament obscures the underlying composition it is worth disentangling the formal symmetry of the design. The stylized dove of the Holy Spirit dives through seven arcs upon the vertically arranged group of the Apostles. Peter at the top left is differentiated by his keys. The youngest figure at the bottom right is locking the carved door, complete with bolt and peepholes. Interesting variations of character have been expressed in the carved heads. (*Photograph British Museum*)

The Trinity

THE DOGMA of the Trinity is that One God exists in Three Persons and One Substance. This doctrine attempts to express a mystery that cannot be known by reason alone without revelation. Although the word 'Trinity' is not used in the New Testament the doctrine originally developed from passages in the Gospels, especially from accounts of the Baptism of Christ, the words of the Angel of the Annunciation, and the sayings of Jesus after the Last Supper as recounted by St John. Some of St Paul's writings encouraged this direction of thought, the early Fathers of the Church continued the development of the idea and certain incidents in the Old Testament were held by them, in their allegorical use of scripture, to prefigure the doctrine.

The idea of the Trinity was naturally difficult for simple people to understand; some early heresies were occasioned by the variety of interpretation of the nature and kind of the Unity of God. The philosophical Greek mind must have enjoyed the mental dexterity needed in solving the theological problems, but many of the faithful were confused so that painful controversy and deep divisions in the Early Church resulted. The domination of Constantinople in matters of belief caused smouldering resentments in some provincial communities of Christians and this has been said to be a factor in the swift Islamic conquests of the seventh century.

From the artists' point of view there is no doubt that this basic dogma of the Church is singularly difficult to render in visual terms and the exactitude of theological definitions has been inhibiting. For instance, during the later Middle Ages representations of the Annunciation showing God the Father sending the Dove in flight towards the Virgin sometimes included a tiny figure of the Christ Child, but this was held to be detrimental to the faith as it suggested Christ was not formed in the womb.

In the First Letter of St John he writes, 'No man hath seen God at any time'. The Godhead, the First Person of the Trinity is invisible and cannot be represented except by symbol. Light in its various manifestations is perhaps the noblest of symbols that can be used. Because of the Incarnation of Jesus as Man it is possible to represent God the Son in human form and he is so represented in all the

[43]

19. *Threefold Forms*

Top left: Norman tympanum from Peakirk church. Three fan-shaped forms, two of five folds and one of seven. It has been suggested that this pleasing abstract shape is intended to demonstrate the Trinity. Fan or shell-shaped forms were used in classical times in mosaics and niches, and variations were used in medieval mouldings.

Top right: Pentagram, pentalpha, pentacle or pentangle. This symbol is drawn from a carving on the side of the stone font in the Baptistery of St John at Split in Yugoslavia, which was formerly the Temple of Aesculapius. If the circumference of a circle is divided into equal parts and each point is joined to the next in succession a pentagon is formed, but if every other point is joined the result is a pentagram and the crossing of the lines suggests five A's or pentalpha. The five-pointed star can be drawn in one movement or carved as an endlessly interlacing form. The symbolic use of the pentagram has not been limited to the Christian faith alone. It was long regarded as a sign to ward off witchcraft and the Evil Eye; it has been termed 'The Endless Knot' and 'Solomon's Seal' and it is also the sign of the five senses; when the letters S A L V S are found in the five points it is a symbol of health. The pentagram can be read as three overlapping triangles signifying the Trinity, in whose name a child is baptized. There is an interesting appendix on the symbolism of this sign in Brian Stone's edition of the fourteenth century poem 'Sir Gawain and the Green Knight' (London 1969).

Centre: Threefold signs used to represent the Trinity. Top row, left to right: the *Trefoil* was used by St Patrick according to legend, to demonstrate the threefold form of the Trinity to his converts. The *Pentagram* is a five-pointed star which can be drawn with one unbroken line.

The *Triquetra* is an early symbol of the Trinity; the continuous interweaving of indivisible but equal arcs may be taken to express Eternity; in the centre is the triangle of the Trinity. The *Fork* is an ancient sign with several meanings; in medieval times it was an emblem of the Trinity, it is also the Greek Y used by Pythagoras as the two divergent paths of virtue and vice; in the early Church it became a cryptogram of the Cross of Christ.

Below, left to right: the *Triangle* has three equal but distinct angles which unite to make one complete figure.

Three Triangles joined to make one figure. The *Triquetra* combined with the circle of Eternity. *Three Circles* interlocked, sometimes inscribed TRINITAS UNITAS, represent the doctrine of the unity, equality and co-eternal nature of the Trinity.

Below left: Geometric floor mosaic from the fifth century church of Shavey Zion in Israel. The imperial decree of 427 forbade the use of crosses where they would be trodden underfoot on floors. However, abstract related forms of the cross have been found at many early sites.

Below centre: Bezel from an Anglo-Saxon gold and niello ring in the British Museum. This sophisticated design of tightly interlocking triangles appears also on Viking slabs.

Below right: Three hares with three ears between them forming a triangle; from a medieval roof boss at Stampford Courtnay. The hare is considered a figure of the soul. Three hares together may have been imagined as implying the Three Persons of the Trinity. This design is found elsewhere in Gothic art and is related to the fylfot.

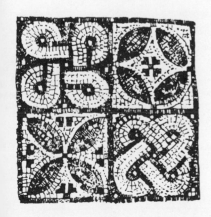

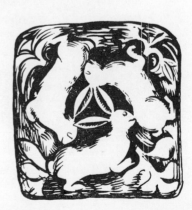

20. *Images of the Trinity*

Top: Drawing of part of a fourteenth century ikon in the Tretiakov Gallery in Moscow. This example of the Novgorod school gives a remarkable sense of the majesty of the subject. God, on a red throne with seraph and cherub behind him and his feet on a footstool supported by the winged wheels called Thrones, holds his Son on his knee, who in turn holds a circular mandorla of midnight blue on which a white dove of the Holy Spirit is displayed. The dignity of this ikon is enchanced by the severe geometry of the design.

Below left: A thirteenth century boss from the Lady Chapel at Chester cathedral. This is a graceful version of the accepted formula for the Trinity of the period. The movement of the censing angels rounds off the stately composition in which the figure of God, crowned, holds the Cross with the body of Christ; the dove of the Holy Spirit between them perches on the arm of the Cross. The dove is more usually depicted with outstretched wings.

Below right: Abraham entertaining the three Angels at Mamre; from a mosaic in St Mark's, Venice. In the Orthodox Church the angels of this story were held to represent the Trinity.

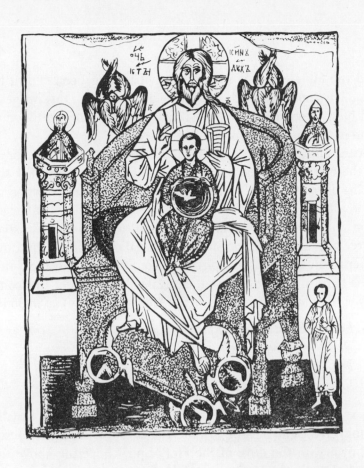

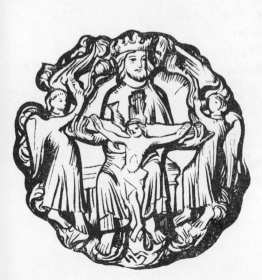

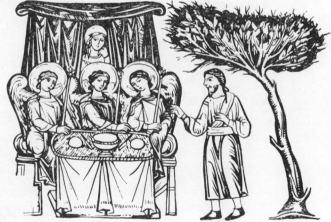

images of Christ. God the Holy Spirit is invisible, but has long been shown by artists in the form of a dove sometimes with an aureole or rays. With this image of the Spirit the Old and New Testaments are linked, from the dove of the Flood to the dove of the Baptism narrative in the Gospels.

Threefold geometrical and rhythmical signs have long been used to express the Trinity. Some of these are illustrated on page 45. They do however lack the majesty of the initiating idea. One feels that abstract artists of our own time might well be fitted to reactivate these formal symbols. Modern works of sufficient grandeur of conception and execution would help people to grasp the Christian mystery of One in Three and Three in One, and the eternal cycle of Divine Love pouring from the Father to the Son and the Spirit and from the Son and the Spirit back to the Father. It is hard to think of a visual equivalent as succinct and compelling as the brief prayer of Judith, translated from the Anglo-Saxon by Gavin Bone:

> *Lord of Creation, and Spirit of Comfort,*
> *And Son of the Almighty – will I pray*
> *For Thy mercy to me in danger,*
> *Strength from the Trinity put forth*

The Dextera Dei was used as a sign of God the Father from early times, usually in the gesture of directing, giving and blessing. In the scenes of the Baptism of Jesus the Hand of God is shown with the dove of the Holy Spirit hovering above the figure of Christ, thus including the Three Persons of the Trinity in one image.

The symbol of the Hand is brilliantly elaborated in the fourteenth century *Vision of Piers Plowman* by William Langland, rendered into modern English by Henry Wells:

> *For God is fashioned after your hand. Now hear and know it.*
> *The Father was first like a fist with fingers folded,*
> *Till at his love and liking he unloosed his fingers*
> *And proffered his palm to the place he favoured.*
> *That palm is plainly the hand which proffers the fingers*
> *To make and to minister what the might of the hand wishes.*
> *And truly it betokens, as you may tell at pleasure,*
> *The Holy Ghost of Heaven; he is the palm.*
> *The fingers that are free to fold and fashion*
> *Signify the Son, who was sent among us.*
> *The palm taught him to touch and try his mother,*
> *The maiden, Saint Mary, and snatch man's salvation.*

[48]

In 1373 the medieval mystic Julian of Norwich had a personal vision of great intensity in which she saw all creation as it were a hazel nut in the palm of her hand. Piers Plowman extends his own splendid metaphor with a related vision:

> *The hand holds hard all that is within it,*
> *Through four fingers and the thumb and the force*
> * of the palm.*
> *So the Sire and the Son and Spiritus Sanctus*
> *Hold the wide world within them,*
> *Air and wind and earth and water,*
> *Heaven and hell and all that is within them.*

And linking this understanding to the daily life of craftsmen he continues:

> *The full hand is formed with fingers; for painting*
> * and drawing*
> *Carving and cutting are all craft for the fingers.*
> *And so is the Son the science of the Father,*
> *A full Deity as the Father, neither feebler nor*
> * stronger.*

The same imagery is expressed visually in the Spanish illumination on plate 6.

21. *Emblem of the Trinity*: Sometimes called the Arms of the Trinity. A concise abstract device which expresses in graphic form the doctrine of the unity and individuality of the Holy Trinity. It reads: 'the Father is not the Son, the Son is not the Holy Spirit, the Holy Spirit is not the Father; the Father is God, the Son is God and the Holy Spirit is God.' This emblem was popular in the Middle Ages especially in stained glass and in wood carvings.

Centre: Symbol of the Hand with ornamental nimbus from the Irish high cross of Muiredach at Monasterboice.

Below: The Hand of God – *the Dextera Dei*, from a panel in the eleventh century bronze doors at Hildesheim cathedral.

Although we ourselves are the first generation to have looked back at our tiny world from the depths of interplanetary space, yet the medieval imagination had already leapt ahead of us in these visions.

In the Orthodox tradition the three angels who appeared to Abraham under the oak at Mamre in the guise of men are an image of the Trinity as prefigured in Old Testament story.

The Byzantine and Russian depictions of this attractive tale are outstanding, they are usually linked with the sacrifice of Isaac, often appearing together as in the sixth century mosaics on the lunette of the north wall in the apse at San Vitale: illustrated on page 53. The magnificent and renowned ikon of the three angels by Rublev in Moscow dates from the fourteenth century and looks back to earlier forms.

The image of the Throne symbolizes the Three Persons of the Trinity. The throne itself signifies God the Father, the book signifies the Logos, or God the Son, and the dove signifies the Holy Spirit. Various forms of this imagery can be seen in mosaics in Rome at Santa Maria Maggiore; in Ravenna in the Orthodox Baptistry; and in an evocative carved slab in Venice on the outer wall of San Marco on plate 30.

In western medieval art from the twelfth century onwards one of the most usual ways of representing the Trinity is to show God the Father in human form as a regal old man enthroned and usually crowned, holding Christ on the Cross on his knees, while the Holy Spirit as a dove hovers above. This symbolic rendering appears in most styles of western art; on carvings, brasses, painted glass, manuscripts and embroideries. Although an image of dignity and pathos it is too naturalistic to be satisfying. The Russian version of this idea in the ikon at Novgorod, drawn on page 47, is perhaps more convincing as a concept of majesty.

In the Middle Ages some strange representations appeared of the Three Persons in human form as three identical figures, sometimes holding individual emblems such as the orb, the cross and the book; or as a group of partly triune forms. These images were inappropriate and were not widely used.

One of the most explanatory diagrams current in the later Middle Ages was the so-called Arms of the Trinity, often being shown on a shield. It does not attempt to illustrate or describe the mystery of the doctrine but it does express in graphic form the triune unity and the dogmatic relationship of the Three Persons. It is drawn on page 49.

On the ceiling of at least one dark medieval church in Ethiopia the Trinity has been symbolized by three sundisc faces with enormous eyes. Beatrice Playne has described the compelling effect of these forms when seen from below by the glimmering light of tapers.

The most outstanding modern version of the Trinity is probably the tapestry in the Cathedral Church of the Holy Trinity at Chichester, given by the Friends of the Cathedral and dedicated in 1966. Designed by John Piper, it was woven by Pinton Frères at Aubusson. The separate panels hang closely together so as to form one design; it is illustrated on Plate 22. Interesting modern hornbooks are provided by the administration for visitors to the tapestry, from which this descriptive quotation is taken:

> The symbols of the Holy Trinity occupy the centre three panels immediately behind the altar. God the Father is represented by the circular source of light, God the Son by the Cross and God the Holy Spirit by the Flame of Fire; the Unity of the three Persons being emphasised by the Triangle. The outer panels on either side (in the upper half) are the Four Elements: on the left Earth and Air; on the right Fire and Water: in the lower half are the symbols of the four Evangelists, taken from the book of Revelation. On the left the beast with the face of a man representing St Matthew and the lion of St Mark; on the right the calf of St Luke and the eagle of St John.

Although at first the brilliant colours appear harsh, even crude, the tapestry makes an immediate impact on the viewer entering from the west end and looking up the full length of the nave. The unprejudiced observer may find that his understanding of the doctrine of the Trinity will be enriched by the mental effort of disentangling the strands of meaning woven into the design.

It may be worth comparing this imaginative conception with another from the prose version of *Piers the Ploughman* by J. F. Goodridge:

> 'The Trinity can also be compared to a torch or taper, which consists of wax and wick twined together, and a flame that flares from them both. And just as this wax, wick, and flame are used to light a fire, so the Father, the Son, and the Holy Ghost kindle among Christian people a fire of love and of faith which cleanses them from their sins.'

22. *Abraham and the Three Angels at Mamre*: from the sixth-century mosaic decoration in San Vitale at Ravenna. Abraham has always been considered a pattern for the faithful soul, obeying the divine command in leaving home for strange lands and trusting in God when bidden to sacrifice the son of his old age. Allegory and symbolism have been woven round almost every event in his life. The three angels of this mosaic, who appeared to him as three men, were considered a foreshadowing of the Three Persons of the Trinity. In the dramatic story of the sacrifice of Isaac the allegorical interpretation is carried further, Isaac is seen as a prefiguration of Jesus and represents his human life which was sacrificed. The whole demonstrates that God provides for those who trust in him and that salvation is certain to those who faithfully follow his commands.

The symbolism of San Vitale is worth considering in some detail as it epitomizes the quality of Christian thought and art of its time. Not only does the soaring geometry and luminosity of the building contribute to a lift of the heart but the harmony of the style and symbolism of the mosaics engenders a rare sense of liberation in the mind of the beholder.

Set in a verdancy of gold and green and white, shot through with brighter colours, the relationship between God and man unfolds through history as a perpetual and reciprocal act of Giving and being Given – the Hand of God is shown accepting the offerings of Abel, and Melchizedek the legendary priest king from the Old Testament. Moses is depicted receiving his commands from God and being given the Law of Sinai. The holy ground burns with the flames of Pentecost. In giving food to the angels Abraham receives the promise of his son; in offering his son to God he receives him back and is given the Ram itself to be offered and accepted by the Dextera Dei.

On the chancel wall Justinian the Emperor brings the golden bowl for bread to the altar in procession with his followers and thus partakes in image in all future offerings of the Eucharist within this building. Opposite him the Empress Theodora sumptuously arrayed brings wine to the altar, the springing fountain beside her symbolizing the gift of the living water of Eternal Life; the Magi embroidered on her dress stressing the concept of kingly gifts to a Divine King. In the dome of the apse above the altar the youthful figure of Christ as Lord is enthroned on the orb of the heavens with the seven-sealed scroll in his hand. He offers the crown of martyrdom to San Vitale and in turn is offered the church of San Vitale by the bishop Ecclesius. These majestic pictures are accompanied with a profusion of angels, prophets and evangelists, embowered in wreathing vines, plants, doves and peacocks, fruit and flowers so that the entire apse shimmers with a joyousness and delight in life, in God and in his Creation.

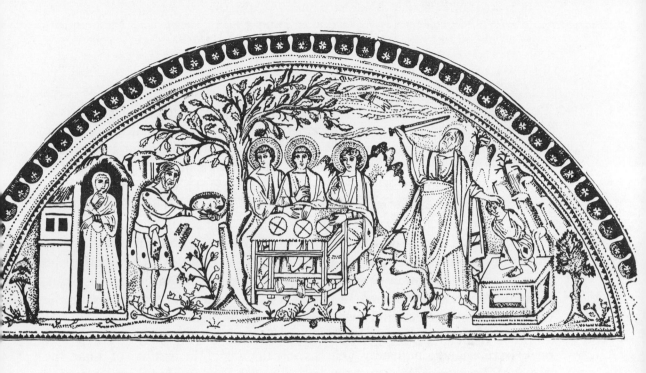

Images of Christ

Form and Scale

TO BE ASKED to represent the image of Jesus Christ is a great challenge to the imagination and skill of an artist. The variety of response to this challenge down the ages is of interest to makers and historians whether Christian or not but particularly so for those who work for the Church. The concepts of theologians as well as architects have shaped the buildings made by men for the worship of God. The forms of the liturgy call for particular arrangements of space and light embodied in a worthy setting for the sacramental acts of worship which are often accompanied by ritual and music. It may be said that the imaginative power and spiritual insight of any historical period is measured by its concept of Deity expressed within the essential architectural framework. Henri Focillon, the distinguished art historian, sums up: 'The world is in God, the world is an idea in the mind of God, art is the writing down of that idea, and the liturgy is perhaps its dramatization.'

The development of Christian architecture (which falls outside the scope of this book) has a magnificent history. One has only to think of the basilicas of Rome, the domes of Constantinople or the cathedrals of France – to name but three contrasting forms – to quicken the inward eye.

The walls of such great buildings enabled designers of mosaic and fresco to carry out large symbolic schemes of decoration including figures represented much larger than life. The carvings on façades, tympana and portals offered similar opportunities to sculptors. In their different kinds, however, the smaller arts, decorative, illustrative or precious also express the imaginative ideas of their makers although obviously not on so grand a scale as Christian architecture or music, but for that reason perhaps easier for the beholder to grasp.

It may well enlarge the understanding to compare the range of images of Christ made by craftsmen – sculptors, ivory carvers, metal-workers, embroiderers and illuminators from very different periods and places, and contrast their spirit and technique with the work of craftsmen of our own day. If this study leads to mere pastiche of the style and mannerisms of other cultures it is obviously sterile, but if it is

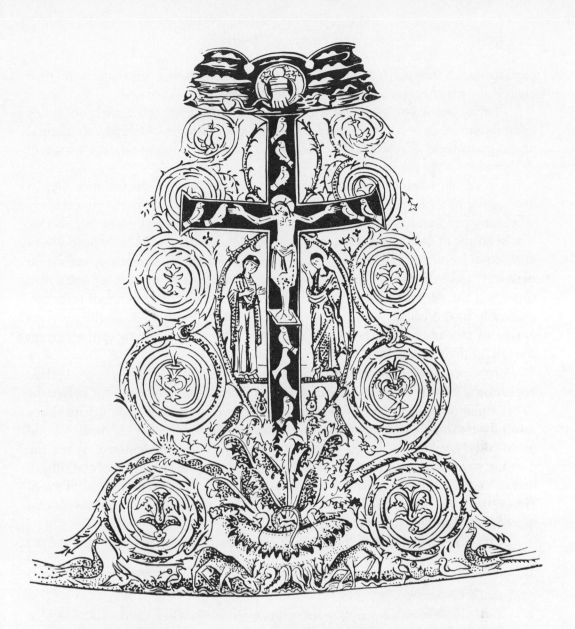

23. *The Triumph of the Cross:* From a tenth century mosaic in the church of San Clemente in Rome. This deservedly famous composition of Christ on the Cross in the midst of the Tree of Life, is based on a fifth-century model and breathes the early pastoral spirit. The harts lead the procession of birds to drink at the four streams of Living Water flowing from the hill of Paradise on which stands the Cross, wreathed in chalice-bearing vine-scrolls, symbolic of the Church as a vine the root of which is Christ. The figure of Christ, his Mother and St John are thirteenth century additions. The sense of Resurrection and renewal is conveyed with serene conviction.

[55]

used to absorb their spirit and quality and so to widen the horizons of the mind then such study may become a growing enrichment to living workers.

The subject is obviously too wide for any book to cover adequately so in this compilation we have selected from among the types of images of Christ – the natural and supernatural – hoping these examples may help to illuminate the minds of designers.

It is perhaps harder to make representations of Christian themes now than at any former time. Not only do we inherit through illustrated books the almost overwhelming panorama of the Christian art of nearly two thousand years, but also we live in an age of non-representation in the arts. Many serious makers believe a work should not be related, either as an image or a symbol to any idea or being, but should exist only as itself. It is difficult to swim against the tide of opinion of one's own times, yet the very magnitude of a challenge may increase the energy of response, especially in the young, who tend to reject the mental limitations of the previous period in favour of ideas, not necessarily new in history, but new to the current thought of their generation.

A representational image of a living person can be made merely by copying their appearance. Now that we have the camera this skill is little esteemed. But before the days of photography the better portrait painters did more than copy nature. They carefully considered the manner in which to show the subject, as his character and personality would be reflected by the style in which he was depicted. When the portrait was made posthumously of an historical figure the rendering of the subject had to embody the current mystique about him in the guise of a physical likeness. Hence the images of great leaders, Alexander or Augustus for example were cast in a conventional heroic form.

In representing the person of Jesus Christ this profound consideration of the

24. *The Crucifixion*

Top left: Nineteenth-century Russian peasant brass crucifix. Great numbers of these devotional metal ikons were made in Russia before the Revolution, continuing the long tradition of Byzantine iconography.

Right: The Lamb as the Symbol for Christ; a detail from one of the elaborately carved columns of the high altar at St Mark's, Venice; Sol and Luna are seen above the arms of the cross and the soldiers dicing for Christ's garment below. This use of the Lamb to represent Christ on the cross was forbidden in the seventh century.

Below: Medieval carved wooden roof boss from Salle, Norfolk, one of a series of masterly circular compositions.

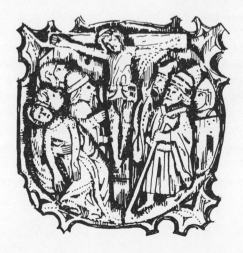

interaction of manner and meaning is the more essential in that he is the Great Paradox. In this one being the apparent oppositions of Human and Divine nature meet and are reconciled. Christ Crucified is the symbol of self sacrifice, humiliation and physical suffering and also of the triumph of Resurrection and Majesty. Compassion and humility contrast with Power and Glory. The carpenter, the teacher and the shepherd of men is also the King, the Creator, the Lord Almighty; God is contained in the form of Man. No single representation or image can possibly convey all the aspects; putting a cruciform halo round the head of an idealized human figure is not an adequate response. Obviously it is not possible to create a compelling image without inner depths of thinking and feeling. These need not be expressed in orthodox phrases, or even in words at all. For most artists the meaning will emerge in the image he makes and not in comments about it.

While mannerism for its own sake is obviously fatal to sincerity, distortion of form may be absolutely necessary to communicate that quality the artist desires to express. The urgent images of some Romanesque works serve as an example of exaggerated rhythm carrying a charge of meaning. On the other hand the emphasis on length of form and stillness of the late Byzantine style conveys the sense of spiritual tranquillity and grace especially valued by the Orthodox Church of those turbulent times, and visible in the noble frescoes in Serbia and Macedonia.

In the work of certain modern artists it is the physical suffering of the Crucifixion that seems to have become an obsessive preoccupation. Apparently inspired by the sixteenth-century Isenheim Altarpiece by Grünewald, the crucifixion paintings of Graham Sutherland and Francis Bacon show no sign of the absolute redeeming power of this self-sacrifice – it is Good Friday without the gleam of Easter.

25. *Christ in Glory*

The Transfiguration: From the mosaic in the apse of the church at St Catharine's monastery on Mount Sinai. This superb sixth-century composition, of which only the central part is drawn here, depicts the figure of Christ in dazzling white and gold against a mandorla of concentric tones of dark blue with silver rays. The dark oval contrasts with the plain gold background and the white robes. The majesty of Christ between the grave vertical figures of Moses and Elias emphasizes the awestruck agitation of Peter, James and John. The remote location in the wilderness of Sinai, an apt setting for Moses, saved this masterpiece from the Iconoclasts.

Below: Christ and the twelve Apostles: from a twelfth-century panel painting for an altar frontal by the Master of Urgel, now in the Museum of Catalan Art in Barcelona. Only St Peter with the keys is differentiated from the other Apostles who all hold books or scrolls.

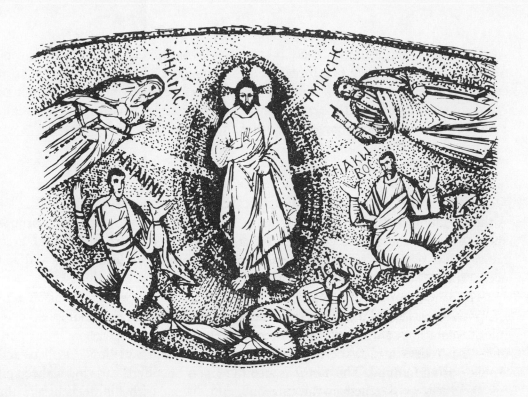

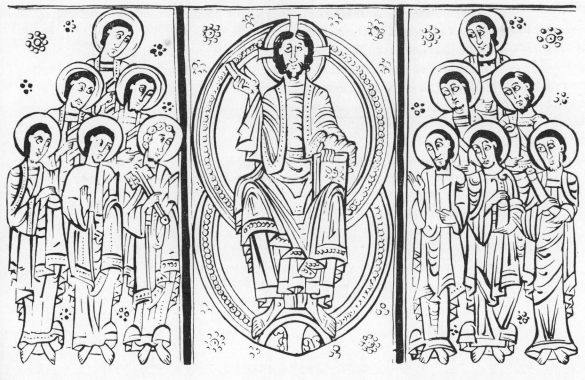

Although ours is an age of violence and cruelties it has also become a time of exceptional capacity for human betterment and this emphasis on the physical aspects of crucifixion seems a concept of despair. It expresses a narrowly material attitude to death, in total contrast to the serene courage of the martyrs whose spiritual insight made early Christianity so brave and comforting a faith.

Style and Idea

Although the vigorous paintings in the third-century synagogue at Dura Europos show that Jews did not reject illustrative art altogether, the earliest Jewish Christians would not have expected to make representations of Jesus. Jews did not accept the idea of any graven images of God.

The Christians of Rome on the other hand naturally expressed themselves in the prevailing classical tradition; their paintings in the catacombs are simple economical decorations, aids to prayer and particularly to faith and salvation. The figure of Jesus is represented as the Golden Youth, beautiful and beardless; Orpheus and Apollo spring to mind. This figure is also the Good Shepherd carrying a sheep on his shoulders as sketched in the catacombs, or sitting with his flock beside the waters in a green meadow, as in Galla Placidia's fifth-century building in Ravenna. In Rome in S. Constanza of the fourth century he gives the law to St Peter; in Ravenna of the sixth century, he sits on the heavenly globe holding in one hand the apocalyptic scroll with seven seals and handing with the other a martyr's crown to San Vitale. In the Passion scenes at Sant' Apollinare Nuovo of the fifth to sixth

26. *Frontal Images*

Left: Christ in Benediction: from the stone relief, late twelfth century, above the portal in the Cathedral of Ciudad Rodrigo, Spain. This is one of the most serene and majestic sculptures of Christ in Spain, a country rich in Christian carvings.

Right: Christ in Majesty: from the Limoges Sacramentary of about 1100, in the Bibliothèque Nationale, Paris. The symbols of the Evangelists are depicted as animal-headed human figures.

Below: Traditio Legis: early eleventh-century carving on the ciborium at S. Ambrogio in Milan. In this well-balanced design Christ is rendered in the guise of an authoritarian Byzantine Emperor, even his halo is carved with jewels; he hands the Keys to St Peter and the Book to St Paul who wait obsequiously with veiled hands as though they too were officials of the Court.

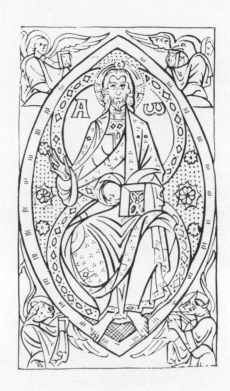

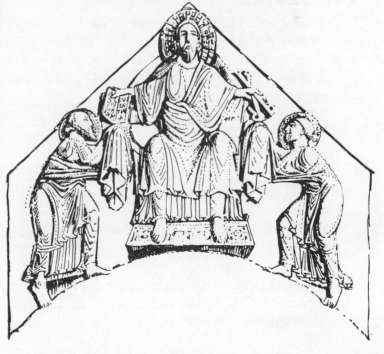

centuries he is first shown wearing a beard. The crucifixion itself, as is customary at that date, is not shown.

When Christianity became the state religion the Emperor in Constantinople claimed to be Christ's representative on earth and the images of Christ took on the Byzantine panoply of Imperial Majesty. The unencumbered Saviour of the classical imagination became the stern Pantocrator, most memorably represented in later art in such dome mosaics as those of Daphni and Cefalù; here is the Eastern concept of omnipotent authority with the judgement of the world on his shoulders. Even on the smallest scale the image retains its grandeur, as is shown in the enamel plaque from the Pala d'Oro on Plate 26. The formal proportions of face and figure and the prescribed gestures were established in Byzantine iconography and faithfully followed by generations of artists: this led to the superficial judgement that the Byzantine style is monotonous and the individuality of the artists submerged by regulations. A study of the actual works shows the range of feeling and quality possible within prescribed forms, the style developed historical and geographical variations within the overall Byzantine manner. The figures of Christ in the mosaic of the Deisis at Hagia Sophia and at Kariye Cami, for instance, blend the traditional imperial dignity with a sense of his Divine humanity.

In the far West there are fewer early images of Christ that have survived. The Celtic peoples had no native figure art and relied on foreign inspiration to set them to such a task. The Christ figures on the Irish crosses are cyphers in the imagery; they have meaning but no personality. By Anglo-Saxon times however the fertile native talent flowered into memorable drawings in manuscripts, both gay and dignified, that represented the human qualities of the Saviour in their own idiosyncratic style.

The Romanesque imagination by contrast was fired by the supernatural and transcendental aspects of the Incarnation and their most powerful images of Deity are perhaps those of Christ in Glory or in Judgement, on the façades of European cathedrals. Their work in enamels and manuscripts shows the consistent dignity of concept – the subject is never trivialized. Some of the most moving of all depictions are those Romanesque sculptures of Christ on the Cross in Spain and Germany. As Western artists researched more deeply into the physical manifestations of suffering they moved away from the remote and kingly concepts of Christ that came from the East.

With the rise of the Gothic spirit the images of Christ grew more serene and compassionate in gesture and expression. The tenderness and suffering of his Passion can be seen working on the imaginations of the artists, especially in the

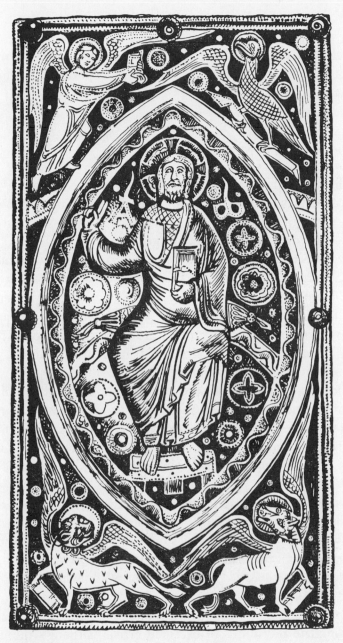

27. Christ in Majesty

From the Limoges enamel plaque for a thirteenth-century book cover in Lyons cathedral treasury. Although Gothic in date this dignified panel looks back to the majestic Christ of many Romanesque tympana and Carolingian manuscripts. The mandorla is outlined by formal clouds and displays Christ throned upon a rainbow between Alpha and Omega, all against a dark blue ground powdered with flowery stars. The Gospel creatures fill the corners. The form of Christ and the heads of the creatures are cast and the rest of the design is engraved and enamelled – a combination not always as harmonious as in this fine plaque.

rendering of the Crucifixion. Christ the Logos, as shown on the trumeau of the south portal of Chartres is a summing up of the concept of the Gothic outlook and Christ as the teacher of mankind.

Illustration and Image in the Gospels

The images of Christ fall into two principal categories, those of the events in his life as recorded by the Gospels and which are primarily illustrations to narrative, and those which are images of Celestial Power or Divine Compassion but not of events, in other words natural and supernatural images.

These categories include specific figures of differing aspects of Christ such as the Teacher, the Servant, the Worker; the Good Shepherd, the Golden Youth, Christ Suffering; the Logos, the King in Majesty, the Pantocrator, Lawgiver and Judge of Mankind.

The illustrations to Gospel narrative were of greater importance in the days when few could read; the actual stories told in pictures, painted carvings, and stained-glass windows were remembered by the illiterate faithful from their coloured depictions. The drama of events in the Gospels is rich material for craftsmen and designers, offering scope for the composition of single figures or crowded scenes of action; scope too for expressing a wide range of emotions – contrition for instance, when Mary Magdalene brought a jar of precious ointment to anoint the feet of Christ; or conflict – as in the uproar with the money changers in the Temple.

From the squalor of the Prodigal Son among the swine, to the Glory of Christ at the Transfiguration – the sweep of action and emotion offer exhilarating opportunities to the artist. These Gospel stories have been for centuries the inspiration for fine works in all the visual arts, from the smallest scale of illuminated initials in manuscripts, to the great cycles of paintings on the walls of monumental buildings.

In the graphic arts, especially in the field of book illustration for children, these dramas still stimulate the minds of excellent artists, although there is perhaps a current tendency for a too deliberate archaism of manner. Bible illustration, however, is outside the scope of this book, as it would fill a shelf on its own.

In the decoration of new churches much present day thinking in art and architecture has been unsympathetic to modern interpretations of Gospel narratives on walls or windows. One view is that a church interior with many pictorial images is

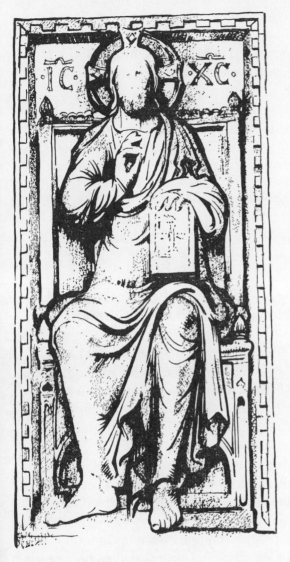

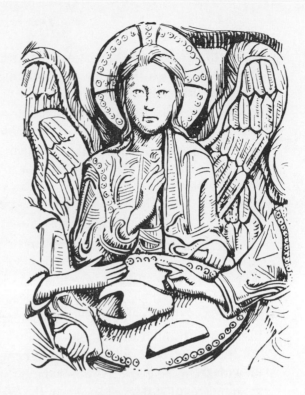

28. Images of Christ

Left: Carved marble slab on the exterior of St Mark's in Venice. This worn carving of Christ the Teacher combines Byzantine and Italian qualities of design in its dignified simplicity.

Right: Christ as one of the three angels at Mamre eating the meal provided by Abraham. This event was held to prefigure the Trinity. From the early medieval carving at the church of Schio-Mgwime in Georgia.

Below: Head of Christ: from a ceiling painting in the thirteenth-century church at Hallingdal in Norway. The bold black outline of the original is contrasted with red decoration on the halo and the red cloak.

distracting to the worshipper and diminishes the full impact of the liturgical rites; another, to which the authors subscribe, is that some modern churches offer too little nourishment to the mind's eye which in its turn should feed those deeper levels of the personality beyond our conscious reach. The new cathedral at Heraklion in Crete for instance, is decorated inside with fine modern frescoes in the Byzantine manner carried out in the rich and sombre colours of the Cretan school. To stand there and 'read' these familiar stories is a stimulating experience, not least an aesthetic one.

The Ministry of Jesus

The synoptic Gospels of Matthew, Mark and Luke describe the life of Jesus in narrative form. It comes to us as a chronological series of events, with accounts of his teaching, his healing and his incomparable stories worked into the narrative of his life, death and Resurrection.

In a book about symbols it might be wondered what if anything, symbol has to do with recorded event. However the early Christian writers sought for an allegorical interpretation of every event in the life of Jesus. They wove so elaborate a web of allegory and inner meaning into each single phrase and action that St Augustine of Hippo was stirred to say they were in danger of losing sight of the true event altogether.

Today there are certain writers who are anxious to 'demythologize' the Gospels and to question the narrative accuracy of some of the events recorded there, because among other objections their obvious relevance makes it seem that they were later inventions to support a symbolic viewpoint.

The current scientific outlook of our own day conditions many assumptions. We are for example, so convinced of the randomness of chance that the opposite view is all but unimaginable and for many intelligent thinkers, although not by any means all, the randomness of natural selection as an instrument of Evolution of mankind is still unquestioned.

Types and Antitypes

Other cultures in other times were more willing to accept the idea of a pattern in events. According to the Evangelist, Jesus himself saw certain aspects of the story of

Jonah as symbols of his Passion and Resurrection. The enormous Christian claim that God intervened in history in the Incarnation leads on to the assumption that all history is designed by God, that his 'will may be done on earth as it is in Heaven'. Naturally then early Christian writers explored the foreshadowing in the Old Testament of events in the Life of Christ. Characters from the Old Testament were seen as 'types' of the New. Readers of Emile Mâle's book *Religious Art in France of the XIII Century* will find the fascinating details of these parallels as worked out by medieval theologian and artist, especially in the figured portals and windows of Chartres Cathedral:

> 'God who sees all things under the aspect of eternity willed that the Old and New Testaments should form a complete and harmonious whole; the Old is but an adumbration of the New. To use medieval language, that which the Gospel shows men in the light of the sun, the Old Testament showed them in the uncertain light of the moon and stars. In the Old Testament truth is veiled, but the death of Christ rent that mystic veil and that is why we are told in the Gospel that the veil of the Temple was rent in twain at the time of the Crucifixion.'

It might well be asked what is the relevance today of all the allegory making. For those whose view of history is restricted to the belief that events happen by chance it is hard to see any value. But for others, particularly those perhaps who find the archetypes of Carl Jung ring true to their imaginations, it is possible to see cyclical patterns in recorded history. It has been suggested that if the racial unconscious throws up the same archetypes in each generation then the foreshadowings and forerunners, the types and antitypes of early medieval theology are not mere fantasies but intuitions of the structure of history and of the enduring relations between man and his experience of reality.

Parables

There is no doubt that Jesus himself greatly valued the double strength of the parable form, with its inner message held suspended within a dramatic story, as fish in water, to be caught by those with sharpened perception. Even today an oriental storyteller with his vitality, vocal range and expressive gesture can grip a village crowd so that they participate more deeply in the tale than we, the passive watchers of the television screen, can easily imagine.

29. *Simplicity*

Top left: From an Ethiopian miniature in a fourteenth-century Gospel manuscript in Addis Ababa. Christ as a half-figure, almost obscured by a crimson cross, is supported in a hexagonal mandorla by angels and the symbols of the four Evangelists.

Top right: Saxon cross at Sandbach, Cheshire: the Crucifixion with the symbols of the four Evangelists. Two discs representing the Sun and Moon are placed side by side above the arm of the cross and the Nativity is shown below.

Below left: The Risen Lord: from a stone roof boss in the north transept at Exeter Cathedral, fourteenth century. Christ has his hands raised, one in blessing and one to show the mark of the nail. The gentle stillness of the figure contrasts markedly with the swirl of lines in the stylized foliage flanking the throne.

Below right: Carved medieval wooden bench-end from Launcells in Cornwall. This version of the Ascension compresses the majestic composition of early iconography into visual shorthand: the feet of Christ are seen vanishing into formal clouds leaving his footprints on the rock. Pilgrims to Palestine were shown such footprints in the Church of the Ascension on the Mount of Olives.

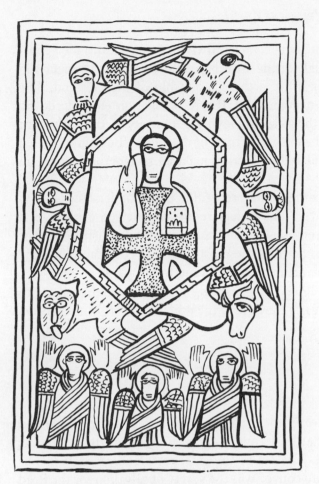

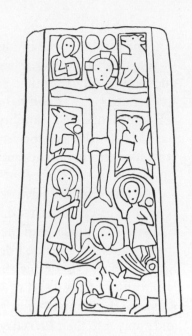

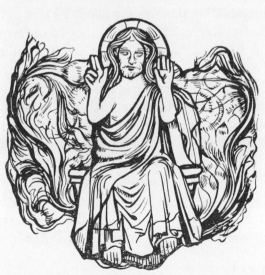

The parable of the Prodigal Son, so succinct and vivid, demonstrates the genius of Jesus the storyteller. Here the tale of the wise father, adventurous younger son and piqued elder brother pictures in little the relationship of men to God. The freedom to go away and to be able to come back, the reconciliation engendered by self-knowledge and humility and the steadfast loving generosity of the Father are parallels of ordinary experience. The musical setting of this tale by Benjamin Britten with its glittering orchestration and stylized acting makes a memorable impact on the viewer.

All the parables have secret cores, some more difficult to understand and to represent in visual terms than others. The transparently clear lesson of the Good Samaritan contrasts with the apparent uncharity of the Wise and Foolish Virgins or the story of the Talents. For artists perhaps the most relevant is the Parable of the Sower, which is a parable about the nature of perception, but so too in another way is the story of the Pearl of Great Price. The paintings of young children done to illustrate the parables show how clearly they grasp the point of a story with a kernel and apply it to their everyday world.

The Miracles of Jesus

The Raising of Lazarus was so clearly the archetypal miracle of the promise and power of Christ's Resurrection that its frequent representation in the art of the early Church is easily understood. The art of the catacombs and sarcophagi was funerary and the message it aimed to convey was the surety of salvation for the dead and consolation for the bereaved in contemplating this shining hope. To this purpose of strengthening fortitude and faith the pictures and carvings showed the most dramatic salvation stories from both the Old and New Testaments. The healing miracles of Jesus were illustrated with examples of the paralytic carrying his bed; the woman with the issue of blood; the leper, and the healing of the blind man.

The miracle at Cana of the Water into Wine prefigured the Eucharist, as did the feeding of the Five Thousand, sometimes summarized by the drawing of loaves and fishes. From the Old Testament Noah, Jonah, Daniel and Susanna were popular exemplars of deliverance from disaster. The subject of Moses striking the rock from which sprang the stream of life-saving water was first favourite, witnessing not only to the deliverance of his people but the prefiguring of Christ as the Rock. In medieval commentaries this analogy was taken further into every detail of the scene: the spring from the Rock representing both water and blood from the pierced side of

the Saviour on the Cross and the parched crowd before Moses standing for those crowds thirsty for the 'living water' of Christ's teaching.

Miracles were natural subjects for stained-glass and frescoes during the ages of faith and the miracles of Saints were particular favourites. The appetite for marvels and for friendly human links with the supernatural world went hand in hand. The power to work miracles that emanated from the relics of men and women of exceptional spiritual quality was required evidence for their later canonization.

The New Testament miracles are unlikely material for modern artists. Our pervasive materialism has eroded faith in their likelihood. In this century however, to take but two examples, Jacob Epstein has carved a haunting image of Lazarus rising from the tomb, and in Benno Elkan's great bronze candelabra at Westminster Abbey certain of the New Testament miracles are depicted with economy and power.

The Passion Sequence

The Passion is the name given to the redemptive suffering of Christ during the last few days of his earthly life and especially to the Crucifixion. These crowded hours of dramatic action and spiritual conflict came to be depicted in a series of scenes drawn from the accounts in all four Gospels. The traditional iconography which was early established epitomized the events and stressed their symbolic value.

By medieval times the pictorial representations of the life of Christ were usually restricted to the two main cycles of the Nativity and the Passion and were closely linked to their liturgical celebrations. It is obvious that some of the events of Easter week are more charged with inner meaning than others. In the art of the Middle Ages the prevailing vision of history and nature as vast symbols enabled the artists to render the Passion scenes with the double perception of earthly event and cosmic drama.

The Entry into Jerusalem opens the Easter cycle and this tumultuous and joyful scene adds to the poignancy of lonely suffering and grief in the days that follow, while it parallels and illuminates the triumph of the Resurrection. In traditional versions Christ is shown riding on the ass toward the right of the scene, the multitudes are summed up in a few figures waving palm branches while some strew their clothes in the way and there is usually a boy climbing up a tree.

The Last Supper is the next subject in the sequence. As the initiating event of the central sacramental act of Christian worship the portrayals of this scene naturally

signify far more than mere narrative. The feast Jesus was celebrating with the disciples was of course the Passover, ritually commemorating the exodus of the Jewish people from bondage in Egypt and demonstrating their faith in the divine guidance of their destiny.

To the disciples the salvation imagery of the dramatic first Passover story in Exodus would have augmented the new salvation teaching of Jesus at the Last Supper; and the parallels of persecution, blood sacrifice and deliverance increased the resonance of the symbolism.

It is as if every word and action of this gathering had layer upon layer of meaning; and as if Jesus willed that the understanding of the disciples should come to discern his metaphors as their insight slowly deepened.

The scene of Christ washing the disciples' feet is described only in St John's Gospel and is less usually included in the cycle. Traditionally St Peter is shown on the right, with perhaps one other figure and Christ kneeling before him on the left, as in the carving at Modena cathedral on the *pontile*. The symbolism of this act which Christ himself made explicit is particularly relevant to the current emphasis on Christ the servant; and the Church as a service to that social welfare which some Christians feel should be one of its chief concerns today.

All the events between the Last Supper and the Crucifixion lend themselves to portrayal in visual terms and the works of many great artists come to mind. The Agony in the Garden, perhaps the most difficult to render, contrasts the sleeping forms of the three disciples with the solitary figure of Jesus farther off; standing as in the earliest of all depictions at Ravenna, or more usually kneeling, suppliant to

30. *Crucifixion, Deposition, Resurrection*

Right: From an ivory carving of the Crucifixion on a French pastoral staff of the early fourteenth century now in the Victoria and Albert Museum.

Left: Deposition: from a twelfth-century stone capital formerly in the cloisters of Pamplona cathedral. These expressive carvings are outstanding in Spanish art of the period. The other three faces of the capital show the Burial; the three Maries at the Tomb with the Angel and soldiers; and Mary Magdalene announcing the Resurrection to Peter.

Below: The Resurrection: English alabaster carving of the early fourteenth century in the Victoria and Albert Museum. This vigorous angular composition illustrates the moment of Christ's rising from the tomb carrying the *vexillum*, or cross with pennant which signifies his Resurrection. The action of Christ stepping on to the sleeping soldier is used by M. D. Anderson as an example of the influence of the mystery plays and shows 'the practical advantage of giving an actor a human stepping-stone to enable him to rise from a deep tomb-chest with apparently effortless dignity'.

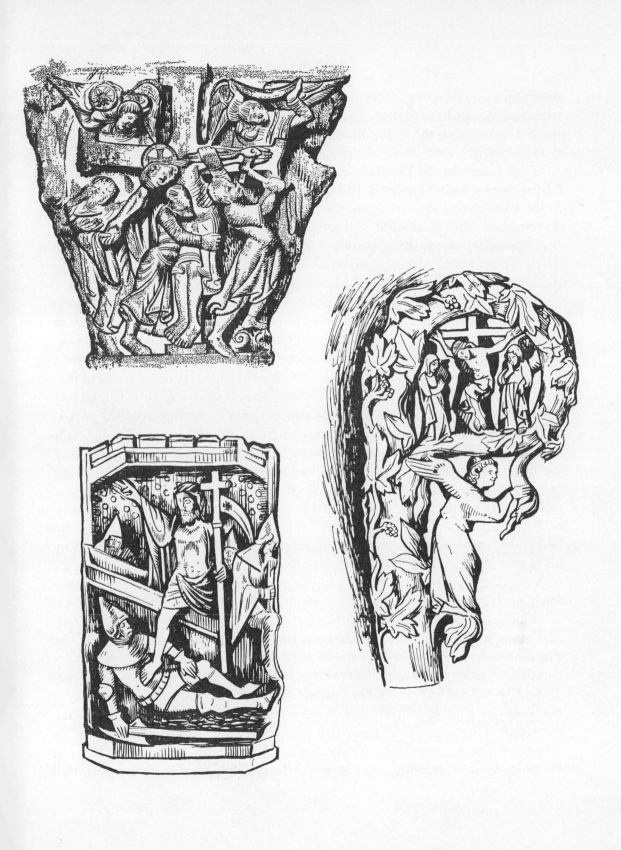

the Father for strength to accept his Will. The angel with the cup, implicit in the narrative, is sometimes shown. In the modern cathedral at Coventry this angel is figured in mosaic on the wall of the chapel of Christ in Gethsemane visible at a distance through the iron-work grille depicting the Crown of Thorns.

In the scene of the Betrayal the Kiss of Judas signifies the actual betrayal of Christ to the soldiers. The act of Peter striking off the ear of Malchus is often shown in the same scene, thus contrasting the treachery of Judas with the physical energy of Peter in defence of his Lord, and comparing this courage with his triple denial in the same night. In the later Middle Ages the soldiers and servants of the High Priest are delineated with exaggerated depravity as though the pious artists wished to imply that no ordinary men could have been capable of such sacrilegious action.

In the drama of the Denial of Peter where each scene subtends meanings beyond mere action; the pattern is shown of vaunted courage failing at the test, of remorse and forgiveness, and subsequent strength enhanced by this very humiliation. The popularity in early art of this subject can easily be imagined. It must have been particularly heartening to those souls who had quailed before the tests of persecution to know that Peter, Apostle, Saint and Founder of the Church had himself been forgiven a panic loss of faith. On a fourth-century sarcophagus the cock is carved standing by Peter's feet, almost as if it were an identifying sign. Traditionally its place is on top of a column as in the mosaic sequence in Sant' Apollinare Nuovo and the actual column was thought to be the one preserved in Lateran. In later medieval art the Cock and the Column were included in the so-called Emblems of the Passion. The scenes of Christ's trial before Caiaphas and Pilate are shown in early carvings in the simplest form with few figures. The careful details of ewer and basin however, bring home the material reality of the ritual act of Pilate in washing his hands. Water, the perfect symbol of purification, here reflects the contrast in spirit between Christ washing the disciples feet as a pattern of willing service and Pilate a few hours later washing his hands of responsibility, thus coining a phrase for all time.

The scenes of the Trial, the Mocking of Christ, the Scourging, and the Crown of Thorns were not depicted in the early centuries. Although the subject of the Flagellation is shown on the twelfth-century bronze doors at Santa Sophia at Novgorod, such representations did not develop fully until the later medieval renderings of the more violent scenes from the Passion series had been influenced by the ardent piety of fourteenth- and fifteenth-century mystics. Emotional emphasis on suffering accompanied greater skill in the artists' rendering of it. The significance of the Crown of Thorns is undoubtedly reinforced by the combination of the ideas of kingship and suffering within one form, and the symbolic value has been recognized

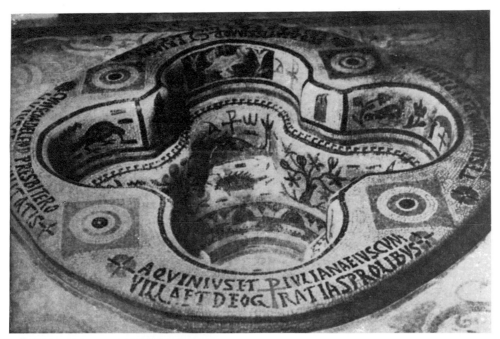

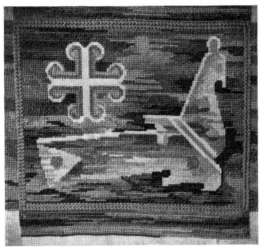

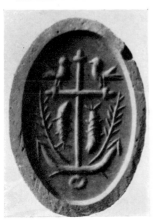

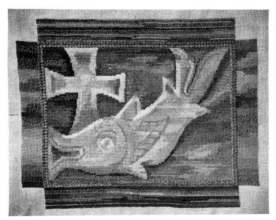

Plate 10 : caption overleaf

Plate 10: *Early Christian Emblems*

Top: Mosaic font of the fifth or sixth century from Kelibia now in the Bardo Museum, Tunisia. This quatrefoil font is richly decorated with the Christian symbols of Baptism: water, fish, the ark, dove with olive twig, candles, Chi-Rho, Alpha and Omega; it is ringed with inscriptions in bold mosaic letters between sun symbols and the Cross. (*Photograph Tunisian Embassy*)

Centre: Three contemporary kneelers based on early imagery and designed by the authors. Left: Peacock representing the Air from a set of the Four Elements; based on a Roman brooch in the museum at Aquileia. Right: PX monogram kneeler in coral and sea-greens based on a Tunisian floor mosaic; embroidered by G. Boekholt. Centre below: Fish representing Water from the Four Elements based on a Coptic carving in the Louvre.

Below left and right: Two engraved gems with: anchor, doves, palm branches and fish; dove with olive branch, fish and sacred monogram. Clement of Alexandria encouraged the use of these allegorical seals among early Christians. (*Photographs of the two seals, British Museum*)

Plate 11: *Vine and Wheat in Wood and Stone*

Top: The Vintage: lively carving on the exterior of the tenth century church at Achtamar on Lake Van famed for the richness of its external sculpture. (*Photograph Dr Ellen Macnamara*)

Left: Carving of the Chalice of the Eucharist on one of two similar pillars in the Piazetta at Venice which were brought from Acre in Palestine during the Crusades.

Right: Contemporary relief carvings on the altar panels for the church of Le Chamblac near Rouen by John Skelton.

Below right: Fifteenth century carved wood rood screen in the church of Llanegryn in Merioneth. The angular geometry of the vine patterns contrasts with the rounded forms from Pella.

Bottom: Elegantly geometrical vine pattern carved on a limestone sarcophagus found beneath the floor of a destroyed sixth century Byzantine church in Pella on the eastern slopes of Jordan. The early Christians fled to Pella during the attack on Jerusalem by the Romans in AD 69–70.

Plate 12: *Stars, Clouds and Water Patterns*

Top: Anglo Saxon sculpted pelta pattern slab from Breedon-on-the-Hill.

Left: Ravenna, fifth or sixth century double cloud pattern mosaic in the arch of a window in Sant' Apollinare in Classe.

Right: Star and Sea patterns in blue, white and gold from the roof of the mausoleum of Galla Placidia.

Centre right: Single cloud patterns from a window in the Archbishop's chapel in Ravenna.

Below: Grado: water patterns from the notable floor mosaics in the early baptistry and cathedral of Grado near Venice. Carried out in black, russet, yellow, grey and white stones these floors suggest the shimmering ripples of shallow water.

Plate 13: *Symbols of the Gospel Makers : Twentieth century examples*
Top left: Lion of St Mark: stained glass window in the chapel of HMS *Lion* by L. C.
Evetts. (*Photograph King's College, Newcastle*)
Right: Banner by Pat Russell for the church of St Luke, Barrow-in-Furness, 1964. The
symbol of St Luke is carried out in orange, gold, red and purple materials applied with
both machine and hand stitchery using some gold kid and metallic fabric.
Below: Lion of St Mark: detail from the marble floor mosaic in the form of a ten-
point Star of Bethlehem containing numerous emblems, designed by Einar Forseth for
Coventry Cathedral and given by the people of Sweden.
(*Photograph by permission of the Provost and Chapter*)

by silversmiths, ironworkers and embroiderers. The reputed relic of the True Crown in Constantinople was of rushes bound with ties; the twined filet used in thirteenth- and fourteenth-century representations was influenced by the arrival in Paris of this very relic. The barbaric thorns of later images were among the agonizing details described in the visions of devotional writers.

The influence of the medieval Passion plays in the depiction of scenes on the Via Dolorosa has long been acknowledged. Simon of Cyrene was pressed by soldiers into carrying the Cross when Christ fell beneath its weight; the irony and pathos of this very incident in Peter Brueghel's great panel in Vienna may well have been inspired by drama. A witness to the Oberammergau Passion Play of 1970 has described the unforgettable impression made by the actors in this scene.

The last journey of Christ has given rise to the devotional images known as the Stations of the Cross, listed in detail on a later page.

The Crucifixion

This momentous subject was the central theme in medieval cycles of the Passion and represented the greatest challenge to artists, who were of course expressing the ideas of theologians in the Church and not their personal reactions to the solemnity and grandeur of the event. The early Church, as is well known, did not represent the Crucifixion itself or related scenes of suffering. Even in the sixth century portrayals were extremely rare and the use of symbols such as the Lamb were preferred. On page 57 is a drawing showing this form carved on the column by the high altar at St Mark's in Venice. The date of these late antique carvings is disputed but is probably before the use of the figure of Christ on the Cross, instead of the Lamb, was prescribed in 692 at the Council of Constantinople. The eighth-century depiction of the crucifixion in the fresco at Sta Maria Antiqua in Rome shows Christ fully robed on the Cross, as a living symbol of Resurrection, not as a dying man. The image makers had the difficult task to distinguish between the figure of Jesus enduring pain and death (thus moving the beholder to enter into the suffering of the Son of Man) and the reciprocal concept of the radiant Resurrection of the Son of God. Later images such as Christ the King, crowned and reigning from the Cross, arose from the attempt to reconcile these opposites. The changing swings of emphasis have produced notable works of very different types at varying times of religious feeling. Although there are Byzantine mosaics and frescoes of the crucifixion that express

[75]

the profound sorrow of the participants of the scene, these emotions seem to be filtered through the knowledge that this was a Divine Event, fulfilling the Will of God. These stately compositions emphasize the Divine Obedience of Jesus within the ritual framework of the liturgy.

The figures of the Virgin Mary standing on the right hand and St John on the left hand of the crucified Christ are shown as witnesses to the actual historical crucifixion, and also perpetual intercessors for the faithful. In the fully depicted scene tradition gives a place on the right hand to Longinus, the soldier with the lance, who pierced the side of Christ from which came water and blood, symbols of the sacraments. The corresponding figure on the left is Stephaton who holds the reed with the sponge offered to Christ when he said 'I thirst'. Of the two crosses one on each side of Christ, that of the Good Thief is on the right, that is to say on the dexter side. By medieval times the symbolism of the scene had been further elaborated; Mary was held to represent the Church and Longinus had become confused with the centurion and stood for those gentiles who recognized Christ. Legend had it that he was cured of blindness when the blood from the pierced side fell into his eye; that the actual cup of the Last Supper was held to catch the blood from the wound and this chalice was the Holy Grail, of yet further legend and poetry.

Carved Rood screens with the figures of the Virgin Mary and St John stood between the nave and the chancel in parish churches all over the country and some still survive intact in Europe to show what was lost at the time of the Reformation when vengeful iconoclasm destroyed the images in churches especially in England.

The scenes depicted after the Crucifixion include the Deposition or taking down of the body of Christ from the Cross. The gospel of Nicodemus provided details used in the iconography of this moving scene, showing Joseph of Arimathea pulling out the nails with pliers and Mary kissing the hand of her Son.

On Plate 4 is an Anglo-Saxon ivory of this subject that marvellously expresses anguish with formal economy, and on page 73 a drawing of the same subject from the capitals in the cloisters at Pamplona cathedral in Spain, famed for their compact and intense representations of the Passion scenes.

The poignant fourteenth-century image of Mary supporting her Son across her knees was often carved in the round, and is usually known as the Pietà from Italian examples. The Passion plays may well have inspired the makers of this image of grief. Many people will recall the youthful Michelangelo's marble statue of the theme in St Peter's in Rome, the figures are insulated from harrowing earlier conceptions by their perfect physical beauty. The Entombment of Christ is also a favourite subject of the Renaissance.

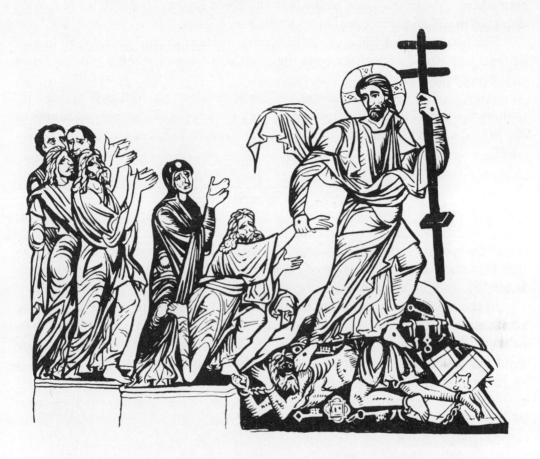

31. *The Anastasis* or the Harrowing of Hell, from the thirteenth century mosaic in St Mark's, Venice. Christ is seen hauling Adam out of hell with Eve behind him. Satan in manacles and chains is trodden under his feet and the sundered doors, scattered nails, bolts, locks and keys of hell are vividly depicted against the darkness of damnation. This splendid subject recurs many times in Byzantine frescoes and mosaics; the inspiring combination of triumph and action, of Resurrection and rescue, has produced outstanding works of art.

The scene of the Maries at the Tomb with the angel was early established in the Byzantine iconography as the symbolic event witnessing the Resurrection; sometimes Mary Magdalene's encounter with the Risen Christ – the *Noli me tangere*, is depicted in the same scene, as in the drawing on page 79.

The Anastasis, also called Christ in Limbo, or Harrowing of Hell, are all images of the Victory over death and depict the descent of Christ into Hell and the defeat of the powers of evil.

Other Resurrection appearances of Christ besides that to Mary Magdalene, include the appearance to the Apostles in the closed room, the journey to Emmaus, the incredulity of St Thomas, the miraculous draught of fishes and the Ascension itself.

Images of Celestial Power

Christ in Glory

The occasions for representing Christ in Glory were taken from the description of events in the New Testament or else were symbolic images of supernatural events in eternity and therefore outside time.

In the first category there are the Transfiguration, that mysterious prefiguring of Christ Risen; the Resurrection itself; and the Ascension; an equally mysterious occasion but one which nevertheless sent the Apostles homeward not perplexed but rejoicing. In the second category are the Second Coming and the Apocalyptic Day of Judgement from the book of Revelation.

The Transfiguration

This subject has had its most splendid illustrators in the Eastern churches whose formal style is peculiarly fitted to communicate the strangeness and awe of this meeting between Christ, Moses and Elijah. It is the one appearance of Christ in a mandorla of celestial light in his earthly life and symbolically prefigures the Resurrection. The magnificent and remote mosaic in St Catharine's monastery in Sinai dates from the time of Justinian. It is sketched on page 59.

The three central figures are balanced by the prostrated forms of Peter, James and John; the unearthly glory is conveyed by a dark blue mandorla outlining the dazzlingly white form of Christ vividly described in the Gospel narratives. Another later example is the mosaic in the squinch of the dome of the church at Daphni which

32. *Resurrection*

The Three Maries at the Tomb: from a miniature in the Sacramentary of the Cathedral of St Etienne at Limoges, about 1100, now in the Bibliothèque Nationale in Paris. This finely illuminated manuscript shows the influence of Byzantine iconography on medieval scribes.

Below: Two Resurrection appearances: from an eleventh century Spanish ivory panel now in the Metropolitan Museum, New York. In these dramatic scenes the main emphasis lies in the gestures of the enormous hands.

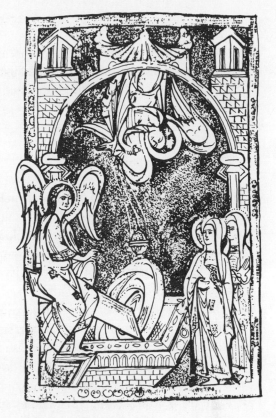

DHS LOQ.V.IT.VR.MARIE

The upper panel shows the road to Emmaus; Christ unrecognized by his two disciples is explaining 'in all the scriptures the things concerning himself'. The sense of absorbed and serious discussion during a long walk is aptly conveyed. The figure on the left, thought to be St James the Greater, brother of St John, carries a neat pilgrim satchel embroidered with a cross ending in a fleur-de-lys; a familiar sight to a medieval carver. His pilgrim flask is hung on a stick, shadowed by a cloak to keep the water cool. The stately figure of Cleopas on the right walks with a tau-headed stick. Christ himself holds a copy of the scriptures he is expounding. The onward going movement of the composition balanced by the strong diagonals of pilgrim staves is set off against the eloquent horizontal of hands and arms in the illustration to the scene of *Noli me Tangere* below, and the reciprocal gestures are dramatically exaggerated to express attraction and recoil. It is worth noting how the broad simplicity of the figures is enhanced by ornamental borders to their robes and to the ivory itself.

makes imaginative use of curved space. In the medieval liturgy of the West the Transfiguration was linked with the abstinence of Lent. Both mosaics and stained-glass windows proved admirable visual means for expressing the radiance of the event.

The Resurrection

The events as described in the Gospels do not give an outstanding triumphant moment to the Resurrection. There is no single visual climax; the story flows on so swiftly that Mary Magdalene, having looked into the empty tomb is addressing the supposed gardener and the Resurrection has already happened. But narrative artists need a significant pictorial incident. Even Piero della Francesca, the most monumental of painters, imagined the Risen Christ standing in the tomb: so did the humbler alabaster carvers of Nottingham.

The Byzantines chose the Anastasis as their symbolic pictorial climax. This word means Resurrection, but the usage now includes the scene also called the Harrowing of Hell, when Christ went down into Limbo and rescued Adam and Eve from the realm of Satan. Satan is shown bound under his feet and the bolts and bars of Hell are scattered, the story comes from the apocryphal Gospel of Nicodemus and we illustrate the version in St Mark's, Venice, of this splendid composition. In the fourteenth-century Vision of Piers Plowman, in J. F. Goodridge's graphic prose translation of this episode, the Devil in hell says:

'And now I can see a soul sailing towards us, blazing with light and glory – I am certain it is God. Quickly, we must escape while we can; it would be more than our lives are worth to let Him find us here. . . .' Then again the Light bade him unlock the gates, and Lucifer answered saying, 'What Lord art thou? – Who is this King?' 'The King of Glory' answered the Light at once; 'The Lord of power and might, the king of every virtue . . .' With that word, Hell itself and all the bars of Belial, burst asunder, and the gates flew open in the face of the guards. . . . And then our Lord caught up into His Light all those that loved Him . . .

Christ Triumphant with the Vexillum represents Christ after the Resurrection. He may be pictured holding on high the cross with a banner and treading on the asp and the mythical basilisk to fulfill the prophecy in Psalms: 'Thou shalt tread upon the lion and adder; the young lion and the dragon shalt thou trample under feet.'

The Ascension

The early Eastern imagery of the Ascension has been lost, nothing remains for instance of the mosaics and paintings that decorated Constantine's buildings in Jerusalem; but it is thought that some of their iconography survives on the pilgrim flasks preserved at Monza dating from about the sixth century, which were souvenirs with holy oil brought home by pilgrims to the Holy Land. On these little vessels the image of Christ at the Ascension is shown in a mandorla supported by angels, centrally below him his Mother, personifying the Church, stands serenely in the orante position flanked by the Apostles, a composition that is also seen in greater detail in the Rabbula Gospels, an eastern manuscript of the sixth century. Some of the Western medieval illustrations of this event, especially on roof-bosses or bench-ends have an irresistibly comic piety. Their economy of design may render the pendant feet of Christ in a frilly skirt of clouds; or sometimes, as on page 69 not even the feet but merely the footprints. M. D. Anderson has a lucid explanation for this version – just such footprints were shown to pilgrims in Jerusalem on the Mount itself.

The Second Coming and the Last Judgement

There were two sources for the representation of the Day of Judgement, the first from Matthew: 'They will see the Son of man coming on the clouds of heaven with power and great glory; and he will send out his angels with a loud trumpet call, and they will gather his elect from the four winds, from one end of heaven to the other.'

The second source is from St John's Book of Revelation with the vision of God as Judge and King surrounded by the four-and-twenty elders and the Living Creatures, presiding over the end of time. The vision from Revelation has a burning intensity of colour and metaphor and the oriental imagery has had an enduring effect on the rendering of the scene in Western art. The exact interpretation in pictorial terms of much symbolic literary imagery produced some peculiar illustrations in medieval painting in which the monstrous forms of the visions have been diminished to 'here be dragons' from fairy tale.

The Day of Judgement was magnificently depicted in tympana of French cathedrals and churches until about 1200 when the less awe-inspiring description of the Judgement from St Matthew came to be preferred. The magnificent carving on the gable of Nikordsminda on Plate 6 is specifically identified by the inscription

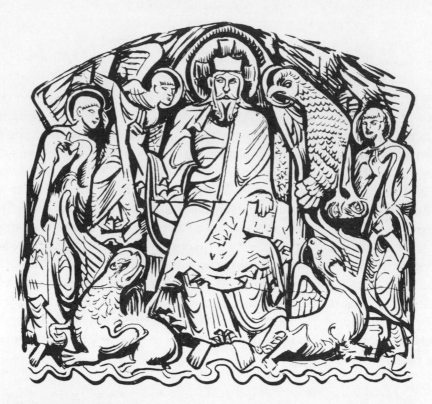

33. *The Day of Judgement*
Christ enthroned with angels and the four Living Creatures: part of the epic tympanum
carved in the early twelfth century over the South Portal at Moissac, representing the
Day of Judgement as described in the Revelation of St John. Emile Mâle says: 'examples
are numerous but none surpass in beauty the tympanum at Moissac, which is comparable
even to the text'.

above as the Second Coming of Christ. Doom paintings on the west walls of parish
churches sprang from both Biblical sources and the representations of the horrors of
hell were used by the Church to cajole and persuade sinful man to mend his ways
while he yet has Time.

The Eastern church preferred the Ascension as the occasion for representing
Christ in Majesty, as in a grand eleventh-century fresco in S. Sophia at Ochrid.

The Abbot Beatus of Liebana wrote an influential commentary on the Apoca-
lypse in the eighth century which was widely propagated in manuscripts from the
ninth to the twelfth centuries, with remarkable illustrations by illuminators who
combined Spanish and Moorish style and imagination. In the British Museum there
is a twelfth-century example of fine quality, which was executed at the monastery of

Santo Domingo del Silos in Spain, and gives an idea of these powerful renderings of the apocalyptic imagery. The less transcendental Anglo-Saxon manuscript cycles of the Apocalypse are full of skilful drawing and intelligent composition. The thirteenth century in England saw the production of a number of illuminated versions revealing new understanding of the Revelation of St John. Among the most celebrated manuscripts on this theme are the Douce Apocalypse at the Bodleian, the Lambeth Palace Apocalypse and the Trinity Apocalypse.

Our ideas today about Hell and damnation make it difficult for a modern maker to attempt the theme in the old spirit. But the cataclysmic twentieth century – glimpsing as never before, the possibilities of the end of the world – should be capable of producing awe-inspiring modern work on the theme of just retribution. Individual images from Revelation, such as the Woman clothed with the Sun as imagined in a tapestry by Jean Lurçat in the church at Assy, or the carving of the Apocalyptic Lamb by Albert Schilling at Mohlin, have been given memorable form. Details from an interesting African interpretation are shown on Plate 17.

34. *The Annunciation*

Carved twin-capital from the elaborate cathedral cloisters at Monreale in Sicily built at the end of the twelfth century. The composition of this elegant diptych is well worth careful attention. The stately figures in their domed pavilions are counter-balanced by the related swirl of the looped curtains and the corner volutes. The Virgin is shown with a distaff, illustrating the Eastern legend that she was spinning thread for the very veil of the Temple in Jerusalem that was 'rent in twain' at the Crucifixion.

Left: *The Visitation*; detail from an eighth century carved ivory book cover from Genoels Elderen, now in Brussels Royal Museum. The iconography of this scene probably derived from models in the Holy Land and was widely disseminated by pilgrims carrying souvenirs such as the flasks now in Monza. Closely similar versions can be found in Coptic textiles, Ethiopian wall paintings, Lombard carvings and Ottonian ivory book covers. This particular example has a choreographic quality; actors in mystery plays may well have mimed these gestures of greeting.

Right: The Annunciation: from the bronze doors of the Baptistry in Florence made by Lorenzo Ghiberti between 1403 and 1424. This deceptively simple composition is formed of a subtle counterpoint of angles and curves. The austere geometry of frame and pavilion is sweetened by the swinging lines of the figures. All Ghiberti's work seems to have this musical quality of line.

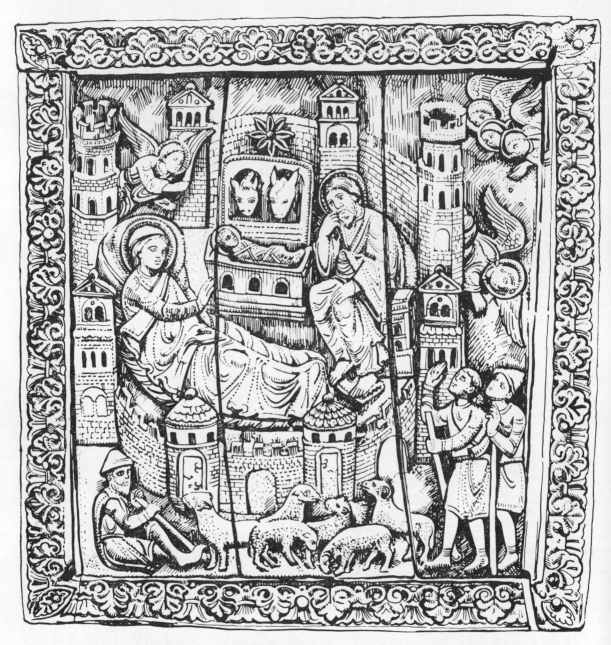

35. *The Nativity :* From a twelfth-century Rhenish relief in walrus ivory now in the Victoria and Albert Museum. This monumental composition shows the concept of the Nativity as a ritual with the Christ Child raised as if on an altar and Mary and Joseph meditating on the supernatural event. The walls of Bethlehem replace the lowly stable and allude to the Church as well as the New Jerusalem. The narrative interest of the artist has been transferred outside to the lively shepherds listening to the angels. The ox and the ass are not mentioned in the Gospels, but early became essential elements in the Nativity scene as they were held to fulfil the saying of Isaiah 'The ox knows its owner, and the ass its master's crib'. In the medieval mystery plays the beasts were probably represented by heads modelled in wood and leather, in the manner of heraldic crests.

The Virgin Mary: Her Place in Art

AN APPRECIATION of the role of the Virgin Mary in the Gospel story, in subsequent legends and as a symbol in herself, is essential to an understanding of Christian art. The events in her life described in the Gospels have been the source of inspiration for artists and craftsmen for generations and the origin of works of outstanding power and beauty.

Considering the intrinsic importance of her role the Virgin Mary is represented in the catacomb paintings comparatively seldom. However the Council of Ephesus in 431 refuted the Nestorians (who held that there were two persons in the Incarnate Christ, one Human and one Divine) and declared the Virgin Mary to be Theotokos – the Mother of God. This formal definition of her status as not merely the mother of Jesus as man but of Jesus as God, greatly enhanced her importance in the eyes of the theologians and therefore her place in the elaborate schemes of decoration in church interiors. The decision at Ephesus also released a widespread popular desire to do her honour both for herself and for the symbol she had become of the place of woman in the Incarnation. Eve the woman had been tempted and yielded, and so was held responsible for the Fall; but Mary the maiden was the means of bringing the Saviour into the world to redeem mankind. She was felt to be a symbol of purity and obedience to God; of motherhood, of grace, of suffering and of the Church itself personified as a Mother.

After the Council of Ephesus many new churches were dedicated to her, the first and foremost being the great basilica of Sta Maria Maggiore in Rome, begun in 432 by Pope Sixtus III. In the mosaics on the 'Triumphal archway' in the church she is depicted in the dress of an Empress with purple robe, jewels and veil. In the sixth century catacomb of Commodilla in Rome she appears between martyrs, sitting on a throne wrapped in a dark robe, she holds the Child frontally on her knees. A rare early ikon at St Catherine's monastery in Sinai, from the fifth to sixth century shows a similar composition. Although not crowned she is a truly regal presence, at once the mother and the throne for her Son; whose bright, pale shape is enclosed and defined by contrast with her dark enveloping robe. This basic

composition became ever more formalized and was to be maintained as a living symbol, with stylistic variations, by artists in mosaics and paintings, metalwork, ivories, manuscripts and carvings for more than a thousand years. The Virgin is transformed from the serene robed figure of Eastern origin into the enthroned and crowned Queen of Heaven, who reigned so high in the West in popular esteem during the Middle Ages that it has been said she almost superseded the worship of her Son.

On pages 90 and 91 are drawings of the Virgin; from the tenth-century Rambona ivory and the twelfth-century Portal of St Anne at Notre Dame in Paris, showing variations on this same hieratic theme. This image is also one of the three classical Byzantine types of the Madonna, developed in her own city of Constantinople, called Nikopoia or Bringer of Victory. When shown standing with her Son in her arms she is Hodigitria. One of the most memorable versions of this same image is the well known mosaic in the golden apse at Torcello; the tall blue-robed figure is an unforgettable combination of the holy and the human, dignity and loneliness. The third Byzantine type shows the Virgin frontally, standing with her arms in the orans position, or gesture of prayer. The earliest versions of the

36. *Events in the Life of the Virgin*

Left: Adoration of the Magi: from a carving on the Norman font at Cowlam in Yorkshire. The Virgin and Child wear lofty crowns and the head-dresses of the Magi are as varied as the wrappings on the gifts they bring. The Virgin's rod is triple-budded. (After Romilly Allen.)

Below left: The Flight into Egypt: from the St Albans Psalter of the thirteenth century now at Hildesheim. The design is full of human detail such as the water-bouget carried on his pilgrim staff by St Joseph and the expression on the face of the guide leading the Holy Family to safety in the town of Sotinen. The original illumination is in tones of green, blue and deep rose with the Tree of Life picked out in white.

Right: Annunciation and Nativity. Carolingian ivory bookcover, twelfth century. Victoria and Albert Museum. Seated on a cushioned stool within her curtained room Mary stiffly acknowledges the salutation of Gabriel who appears on her left; in Western iconography he usually approaches from her right. The lower scene assembles the symbols of the Nativity with tidy charm. Mary lies in contemplation on a pleated mattress. Joseph sits pensively on the other side of the tree of Jesse whose topmost leaves support a little lunette, within its arch the faces of the ox and the ass look down on the swaddled infant in an altar-manger. On either side the symbols of the Star and the walled city of New Jerusalem stress the inner significance of the scene. The Virgin's slippers placed neatly on a stool beside her testify to the carver's sense, both of humanity and of space-filling.

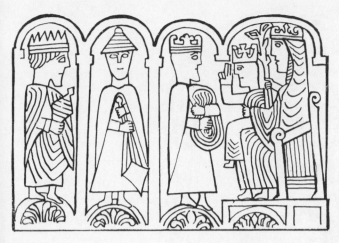

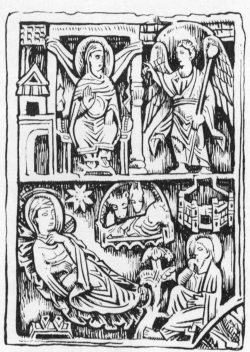

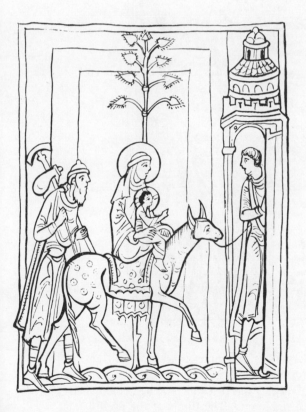

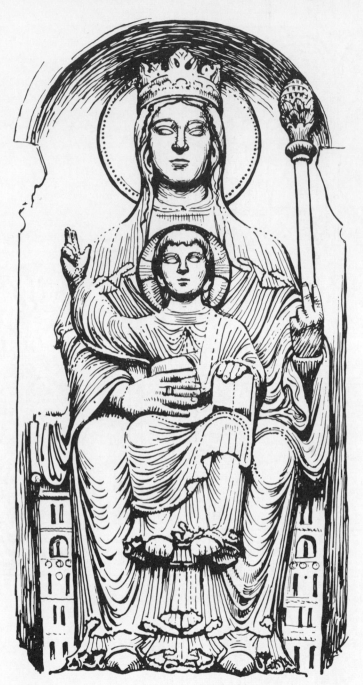

37. *The Hieratic Image*

Virgin and Child from the twelfth-century Portal of Sainte Anne at Notre Dame in
Paris. Émile Mâle says: 'Amid the host of ideas and sentiments which then gathered
round the figure of the Virgin, the idea of majesty was that which art best comprehen-
ded and expressed with the greatest force and beauty. The Virgin of the twelfth and
early thirteenth centuries is a queen.'

Plate 14: caption overleaf

Plate 14 (overleaf): *Genesis*

Mosaic of the Creation in St Mark's, Venice, in the dome of the narthex. Although this is a twelfth century work it is thought to be based on a manuscript original perhaps of the sixth century. The figure of God creating the world is expressed in the form of the late-antique version of Jesus Christ, with a cruciform nimbus and wearing a toga. The image of the haloed Dove set against the disc of the earth is an evocative rendering of 'The Spirit of God was moving over the face of the waters'. The Sons of the Morning with veiled hands, standing on the winged wheels of Ezekiel's vision can be seen on the right of the creation of the birds and fishes. The bold lettering is used to tell the story and to bind the concentric design together. The strong colours of the scenes are enhanced by the gold background of the mosaic and the gleaming light reflected up from the sunlit marble pavement below. (*Photograph O. Bohm*)

Plate 15: *The Image of the Tree*

The Great Candelabrum of the New Testament in Westminster Abbey created by Benno Elkan. This noble bronze candlestick, six feet high, is designed to flank the High Altar at festivals together with its companion work of the Old Testament. There are twenty-four groups of figures set in the scrolls of the candle-tree, chosen to epitomise the life and teaching of Christ, with emphasis on his healing mission and victory over death. The Resurrection is symbolized at the apex of the composition by a group at the Tomb with the Angel. All the figures express human emotion, especially compassion, with an intensity and range rare in contemporary work. (*Photograph Gordon McLeish by courtesy of the Dean and Chapter of Westminster*)

Adam and Eve: a modern wall tapestry in coloured wools by Karima Aly from Professor Wissa Wassef's studios at Harrania in Egypt. The theme of the Paradise garden before the fall is interpreted in witty flat pattern by the young peasant weaver.

Plate 16: *Tree : Symbol and Story*

The Finding of the True Cross: the right wing of the Stavelot triptych; twelfth century copper and enamels now in New York in the Pierpont Morgan Library. The vigorous narrative roundels read from below upwards. On this wing St Helena in Jerusalem is seen threatening Judas with fire unless he reveals the hiding place known only to the Jews. Next above, he is seen digging for the crosses and at the top the testing by miracle of the three crosses to distinguish the True one. The Hand of God in the top two roundels shows Divine Intervention.
(*Photograph Trustees of the Pierpont Morgan Library*)

Tree of Jesse: this battered English alabaster from the early fifteenth century retains the haunting and poetic elegance of Gothic symbolism. Victoria and Albert Museum.

The Trinity on the Tree of Life: gilt bronze pectoral cross from Mosan, early eleventh century. This unusual image shows Christ on the Cross as a symbol of life with the lopped branches already budding. The eyes are open and the hands and feet are not nailed. The Hand of God holds the Dove of the Holy Spirit as it were a bird in flight. The raised hand at the top is a ring for suspension. Victoria and Albert Museum.

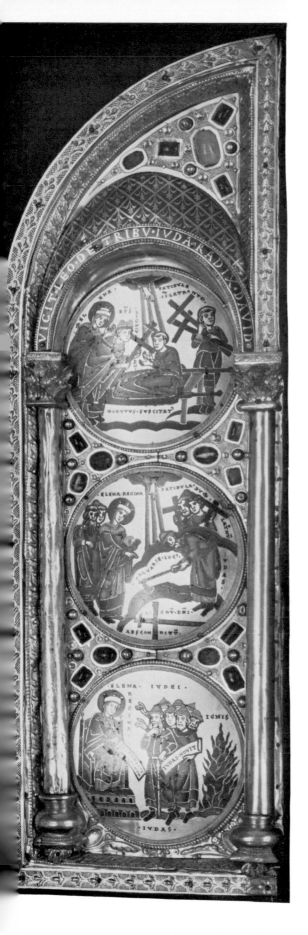

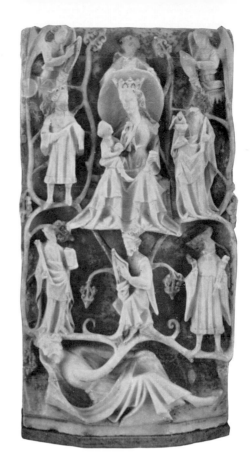

Plate 17: *Apocalypse from Africa*

Panels from the modern roof decoration in the Chapel of St Francis at Makerere University, Uganda. This striking scheme was carried out in the 1960s, instigated by the Chaplain, the Reverend Denis Payne; there are over seventy panels forming the roof. The visual themes are taken from the book of Revelation and stress the difference between the artist's imagination, the supernatural world of St John and our narrowly rational western culture today. The artists who worked on the project are Jonathan Kingdon, Ignatius Sserulyo and Peter Binaka. The strong drawing and primary colours of the individual panels stand out against the calm grey background. The apocalyptic visions contrast with the rich plant forms and the gentle humour in the drawing of the elders and their various African musical instruments.

38. The Rambona Ivory

The Virgin and Child enthroned between Seraphs: from the richly decorative ivory diptych of Rambona, now in the Vatican; about AD 900. The saints Gregory, Silvester and Flavian are shown above a flying figure with palm in one hand and torch in the other.

39. Left: Coronation of the Virgin: from a thirteenth-century stone roof boss in the Angel Quire at Lincoln Cathedral. This series of figure bosses are exceptionally fine, the carving sensitive, the masterly draperies full of fluid movement and the character in the heads is outstanding.

Right: Virgin and Child. The formal framework of this medieval silver book cover from the treasury at Cividale del Friuli enhances the delicacy of the enthroned Virgin and Child. It might well give ideas to designers of banners.

Ascension show her in this attitude in the midst of the Apostles. Professor F. van der Meer has pointed out how vividly in this particular composition she conveys and combines the symbolic idea of Mother Church and Mother of Christ.

In the workshops of Western artists this formal Byzantine imagery developed in the direction of greater human sympathy. The twelfth-century English ivory drawn on page 95 well combines the formality and tenderness of her roles as Queen and Mother. During the widespread veneration of the Virgin in the Middle Ages almost every event in her life became the subject for the visual arts and where the Gospel narrative is silent the intensity of human interest led to the use of the apocryphal Gospel of Pseudo-Matthew, as material for narrative works. This apocryphal Gospel, compiled from sources going back to the second century, contains the

40. Left: Virgin and Child: from the chapel of San Zeno in St Mark's, Venice. Dignity and tenderness are blended in this thirteenth-century relief sculpture, known as the Virgin Aniketos, the Invincible, of Byzantine origin.

Right: Madonna and Child with Angels by Agostino di Duccio, from the stucco version in the Museo Nazionale in Florence. The sculptor is noted for his delicate swirling line. The poise and remoteness of Byzantine images of the Virgin were abandoned as artists became involved in rendering the human aspects of the Madonna and Child. It seemed that the qualities of natural and supernatural could not exist in the same image.

richly pictorial stories of Joachim and Anna; the birth of the Virgin, her dedication and life in the Temple where 'she danced with her feet and all the house of Israel loved her'; the testing of suitors and the choice of Joseph; with further legends of the Birth and Infancy of Jesus and the Flight of the Holy Family into Egypt. This compilation was the origin of the iconography of many narrative pictures especially

in the Eastern Church. Students wishing to unravel the imagery will find that reading *The Apocryphal New Testament* in M. R. James's version adds much to their understanding of the sources of Christian iconography. The narrative mosaics at Daphni, for example, include a lunette illustrating Joachim talking to the angel, and Anna, childless and disconsolate before the nesting birds in the tree, while between them is a well with a splendid fountain playing. The artist must indeed have been thinking of the 'living water' and all the symbolism that has flowed from that metaphor. By the thirteenth century artists in the West no longer illustrated many of the legendary events in the Virgin's life, legendary material was inadmissible to her liturgy; although representations of her death, Assumption and Coronation retained their place and great popularity.

While the eleventh-century Greek mosaicists expressed the Incarnation with the symbol of a fountain, in northern Europe contemporary artists of the Romanesque with their strong sense of the supernatural portrayed the Virgin and Child as a statuesque and sanctified image. The crowned Queen seated with her divine child on her knees is not only carved on the tympana of cathedrals such as Chartres, Notre Dame in Paris, and Parma, but as memorable separate statues, often in polychromed wood, set inside the churches for devotional purposes; the aesthetic distinction of these dignified statues was generally overlaid with votive offerings of all kinds. The well-loved twelfth-century window in Chartres called the '*Belle Verrière*' displays the Queenly figure with the Child in stained glass of a sumptuous richness of glowing reds and blues. The sense of Majesty is sustained by this frontal aspect even in the small scale of manuscript illumination. On Plate 19 an example from a twelfth-century MS. at the Bodleian Library displays a remote hieratic dignity, enhanced by the formal geometry of design.

41. *Madonna and Child*

Three versions of this subject spanning eight hundred years. The medieval seal of the convent at Konigsdorf conveys a regal dignity within its three inch span.

Below: The monumental statue in St Matthew's Church at Northampton was carved in Hornton stone by Henry Moore in 1943–44 and is larger than life. The sculptor said he aimed at 'Austerity, grandeur, quiet dignity and gentleness, complete easiness and repose, hieratic aloofness'.

Right: This English group of the Virgin and Child, now in the Victoria and Albert Museum, was carved from walrus ivory about 1150 and is not quite six inches high. The work is outstanding for its rhythm and tenderness; quality as art and quality of feeling.

The Gothic development of the image of the Virgin and Child is less to the taste of artists today, perhaps, but produced images of incomparable grace and sweetness. The Queen of Heaven has become a beautiful woman, as merry with her son as any young mother. The Romanesque sense of stability, with the emphasis on vertical lines of construction, gives place to the swinging asymmetrical attitudes of the thirteenth- and fourteenth-century Madonnas, executed with a complete technical mastery of the material and the sense of lightness and grace that irradiates Gothic architecture with its upward flight of lines.

Just as Romanesque gave place to Gothic ideals so Gothic in its turn gave place to the uprush of ideas of the Renaissance, and its prodigal flowering of talent in Italian art and architecture. The Madonnas of Italy are so numerous and so richly varied that no brief survey can begin to convey their range or quality. The great men of the times, from Cimabue and Giotto through all the Florentines and Sienese, Umbrian and Venetian artists, delighted to represent Our Lady in fresco, painting, statues and reliefs. The importance of the subject and a natural sense of rivalry with their peers challenged them to produce their finest works on this theme. This era, however, is outside the scope of this book, for the days of thinking in symbols had ended. The inner meaning of representation had become of less importance to artist and patron than the work itself as Art. Mastery of form and colour, of perspective and of rendering light, space and the control of delineating figures in action, all these skills combined to make this a marvellous period in the history of art. But it was an art rooted in the material world of physical being and delight in life and in man's own capacities.

Beneath the burgeoning of talent and all the wealth of painting, carving and precious arts that decorated the cathedrals, churches and monasteries, the seeds of dissent were sprouting. Mariolatry was merely one factor in the unease of Christendom. There were of course many other causes for the painful divisions leading to the Reformation and the breaking up of the unity of the Church.

The reformers swept away much of beauty in their sincere desire for simplicity of worship and purity of life and the pendulum of reaction swung too far in the direction of the puritanical. Modern Anglicans vary widely in their views on the place of the Virgin Mary in the faith and in the Church. The subject has been carefully and thoroughly discussed by Dr Gilbert Cope in his rewarding book on *Symbolism in the Bible and the Church*. In his sensitive summing up of the difficult symbolism of the virginity of Our Lady he says that it is:

. . . recognition of the creative activity of God manifest in human procreativity

and a symbolic adjunct to the mystery of the Incarnation. Her 'motherhood', though historical, is also ultra-historical, and the ubiquity of the mother-and-child figure witnesses to its eternal significance as a symbol of the mystery of human generation. Her 'queenship' is a profound religious myth which seeks to express humanity's need for a feminine intercessor at the Judgement and a recognition that a womanly element is necessary to human appreciation of the mystery of the relationships of love which prevail within the divine rule.

The designers of memorable modern Madonnas have reacted in their turn against the sentimental imagery of the nineteenth-century Gothic Revival, which still survives in the mass-produced plaster images sold by church furnishers, too often poor in design and feeble in conception. The work of genuine artists on the other hand has moved toward a monumental simplicity of statement.

Many parish churches are dedicated to the Virgin Mary, and the right use of her image enhances their quality. Banners offer occasion for dignified modern design but excellent craftsmanship may be marred by a sentimentality that is almost Victorian!

Literary metaphors and parallels of the Virgin have proliferated in devotional writings. She has been likened to flowers, stars, seas, to a closed Door or a walled Garden, and obviously to a Queen. Drawings of the emblem of a crowned M are shown on page 244. Much of this imagery appears in the carvings and windows of medieval churches. In Norwich cathedral carved roof bosses which survived the iconoclasts illustrate some of the legends about her. In the monastery of Studenica in Serbia a series of vivid thirteenth century frescoes give visual form to both legends and metaphors.

The Nativity of Jesus Christ

THE STORY of the Nativity of Jesus is told in terms of dramatic encounters between the Divine and human personalities which can clearly be imagined and presented in visual terms. It is not surprising that the first two chapters of the Gospels of St Luke and St Matthew have inspired so many notable works of art.

The sequence of divine intervention began with the appearance of the angel Gabriel to Zacharius in the Temple to announce the coming birth to his wife Elizabeth of their long-desired son. His disbelief led to his being struck dumb until the child was born and named John. Six months after the visitation to Zacharius Gabriel appeared again, this time to Elizabeth's kinswoman Mary to foretell the birth of another child: 'He will be great, and will be called the Son of the Most

42. *The Nativity*

Top left: Carved wooden roof boss from Salle in Norfolk. The late medieval bosses in this church are notable for skilful composition and narrative detail. The faithful beasts and piping shepherds peer at the Holy Family over a wattle screen, alongside the figure of Joseph sitting comfortably in a carved chair.

Top right: One of a series of early medieval carved wood panels now in the Coptic Museum in Cairo, formerly in the church of St Mary. The design has much in common with the walrus ivory on page 86 from the other side of Christendom, including a pensive Joseph and the animated shepherds whose figures here merge with three homely Magi bearing gifts. The star has become a disc, holding sun and moon faces and pouring rays of light upon the Child whose altar-manger is decorated with little crosses.

Below left: Detail from the thirteenth-century casket of St Ebbo in the church of Sarrancolin. The copper-gilt casket is decorated with roundels showing figures and scenes from the Infancy of Christ. The workmanship has all the elegance and charm of early Gothic, though the image of the Nativity is far removed from the stable at Bethlehem.

Right: The Annunciation. Fourteenth-century roof boss from Lichfield Cathedral in the south quire aisle. This charmingly gay concept of the scene shows Gabriel with a scroll addressing Mary; between them stands a large pot of stylized lilies and overhead hovers a great dove symbolizing the Holy Spirit.

[98]

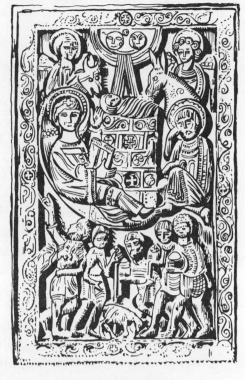

High.' As if in token of this truth he tells her of Elizabeth's conception. This celebrated encounter between the celestial messenger and the human girl has given rise down long centuries to innumerable carvings, paintings, ikons and images many of singular imaginative strength. On page 85 is a drawing of a capital at Monreale of this scene. The medieval theologians held that the Annunciation took place in the springtime so that St Bernard wrote of Christ: 'The flower willed to be born of a flower, in a flower, at the time of flowers.' This idea led to the inclusion in the scene of a flowering plant in a pot placed between the Angel and the Virgin, later depicted as a lily with its concept of purity. Unlike the sceptical Zacharius before Gabriel, Mary's husband Joseph was willing to believe his dream that this child was created by divine intervention. Matthew tells us of no less than four of Joseph's angel-inspired dreams. Drawings of two versions are illustrated on page 125.

The Visitation of Mary and Elizabeth when both were with child has been another theme widely used by artists in the early Church. Dramatically apt, it set a necessary scene between the Annunciation and the Nativity. The journey of Mary and Joseph to Bethlehem for the taxation census, ordered by the Roman occupation forces, is less usually shown although a carved ivory panel can be seen on the throne of Maximian in Ravenna, with an angel leading the donkey.

The Birth of Jesus in the stable and his cradling in a manger is of all scenes perhaps the most familiar in Christian art. Although later periods were to handle the subject with paintings and carvings of narrative richness the early representations were simple and economical in effect.

In the Orthodox Church this stable is shown as a cave and Mary is lying on a mattress which frames her figure as though it were a premonitory mandorla. The manger is often designed as a little altar. The ox and the ass although not mentioned in the Gospels early became essential characters in the imagery – they are there as fulfilling the prophecy of Isaiah. In the apocryphal Gospels which exerted a widespread influence on artists, Joseph is described encountering the two midwives and the scepticism, punishment and subsequent healing of one of them. It was not only apocryphal writings that influenced artists, M. D. Anderson has described how the visions of the mystic St Bridget of Sweden in the fourteenth century affected the position of the Virgin who was usually shown as kneeling and adoring her shining Son in Nativity scenes depicted thereafter.

Meanwhile the chain of divine and human encounters continued with the angels appearing to the Shepherds in the fields and bidding them seek the Child, a drawing of this scene from an English window is shown on page 128. In European art the homage and gifts of the Magi to the Child and his Mother was the favourite

image from the scenes of the Nativity and appears in the art of the catacombs as an early example. It was taken as a significant parallel for the subsequent recognition of Jesus by later Gentile converts to the Christian faith. Tradition has given names and conventional appearances to the Magi – the Three Wise Men – Caspar is aged and has a long beard, Melchior has a short beard and is in the prime of life, Balthazar is young and beardless; sometimes represented as a negro. The strange gifts they offered to the Infant Jesus have inner meanings: gold for his Kingship, incense for his Priesthood, myrrh for his Burial.

The Circumcision, the Presentation in the Temple, the Flight into Egypt, and the Massacre of the Innocents are among the familiar subjects from the Nativity sequence in art. Examples of picturesque legends of events on the road to Egypt during the Flight were also used, such as the fall of idols in the Egyptian town of Sotinen. Not all incidents were illustrated with the same frequency because the Church did not develop complete cycles of illustration of Gospel narratives; depictions tended to be those that celebrated the Festivals of the Church.

The Nativity scene recurs every Christmas in a flood of greetings cards; in miniature Cribs for children and grander Cribs for churches; in reproductions of Old Master paintings; every novel variation of design is used to bring the subject to the front of the festival, till the mere banality threatens to dull all response in the heart.

To the eyes of faith the wonder, the marvel of this new born Babe is that through his birth God has entered the material world of time and death in which we all live, and because he – the Son of God – has become one of us, Christians believe we too may become Sons of God – this is the meaning of the Incarnation.

Living Water

Water in the Desert

FOR NORTHERN peoples living in a rainy land it is the sun which is longed for and welcomed back after winter, bringing with its growing warmth the life and green renewal of spring. But in desert countries of the Middle East the sun shines relentlessly and summer heat can drain the life of plants, cattle and men. Even today death from thirst can strike the traveller lost in the desert and the white bones of victims lie on the ochre sand as a witness to old disasters. All life is visibly sustained by water and until modern technology can change his lot the peasant irrigator spends tedious days bringing water to his plants. When rain is so rare it seems a special gift of Providence; the sudden storm will flood the dry watercourses in the arid wastes, within two days the desert will be green with grazing for the nomad flocks, and wherever the water flows life is renewed.

For town dwellers to whom light and water come obediently by switch and tap it is hard to visualize how precious they seem to simpler communities, and we need to picture the value of water to desert peoples, settlers and nomads alike if we are to grasp the rich significance of water symbolism in the Jewish faith and history, flowing thence to its meaning for Jesus himself and so to Christian Baptism.

In Palestine the sweet waters of Jordan flow mysteriously into the salt Dead Sea which has no outlet. The contrast between the full tree lined river and the desolate moonscape round the Dead Sea shores underlines the metaphor of 'living water'. In his long conversation with the woman of Samaria recorded in St John's Gospel, Jesus was using this image to equate his message of the Kingdom of God with life itself. Scientists believe that life had its simple beginnings in water and the poetry of Genesis also sees Ocean as the cradle of Creation: 'Darkness was upon the face of the deep; and the Spirit of God was moving over the face of the waters.' The Old Testament includes several dramatic water-stories, beginning with Noah and the Flood. Archaeologists place this legend in a real location where the uncontrolled floods of Tigris and Euphrates might well have decimated populations and left legends behind

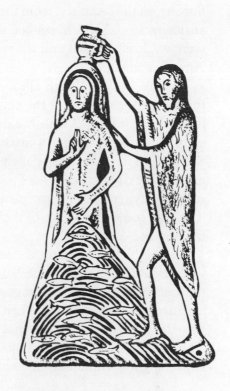

43. *Baptism of Christ*

Left: From a seventeenth century Ukrainian painted ikon now in Kiev. The design shows the continuity of the Byzantine traditional form of this scene.

Right: From a thirteenth century copper-gilt relief, cast and chased, with enamelled eyes, now in Boston. The pictorial effect of this calm baptism is of a ritual rather than a narrative.

them as racial memory of catastrophic loss. The story, so graphically told in Genesis is the first of the salvation epics of the Old Testament, and so came to figure in Christian iconography as an example of the saving of the just. The escape of Moses and the Israelites fleeing from bondage in Egypt across the dry bed of the Red Sea and the drowning of the pursuing army was used as another such example. Later Christian thinkers saw this episode as a prefiguring of Baptism which also leads through water to Salvation. The wanderings of the Israelites in the wilderness and the miraculous provision of food and water were taken as another exemplar of saving grace. The modern traveller to Petra will be shown the clear and rushing water still flowing, so the locals say, from the rock that Moses struck. This event was one of the analogies so elaborately worked out in medieval Christian thought. The Rock was seen as Christ himself and the water as the sacraments and as the teaching of the New Testament.

In the story of Jonah allegorical parallels were likewise clearly drawn and the three days Jonah spent in the belly of the whale were equated in the words of Jesus in the Fourth Gospel with the days before the Resurrection. This was a favourite subject for early Christian artists in Roman catacomb paintings and sarcophagi carvings. The waters of Babylon, the Rivers of Paradise, are among the many memorable riverscapes in the Old Testament. The twenty-third psalm is one of the most satisfying; it evokes the paradisal green landscape beloved by desert wanderers. The hart was an apt image of the soul's thirst and appears widely in early Christian mosaics and carvings.

In the New Testament the first of the recorded miracles of Jesus is that of the wedding at Cana in which the Water became Wine. Linked as it is with baptism and the Eucharist the symbolism of this event made it a favourite subject with theologians and so for artists. When John came preaching repentance to the Jews it was the baptism in Jordan that signified their change of heart to his converts. The Fish is still carved on fonts as a symbol for Christ and for the faithful soul swimming to salvation through the waters.

Symbolism of Early Baptisteries

The rite of baptism – being itself a symbol in material form for a spiritual change in the whole life of the convert – led on appropriately to symbolic decoration in the structure and on the floors and walls of early baptisteries.

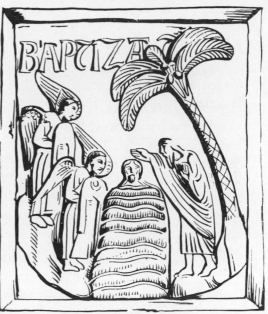

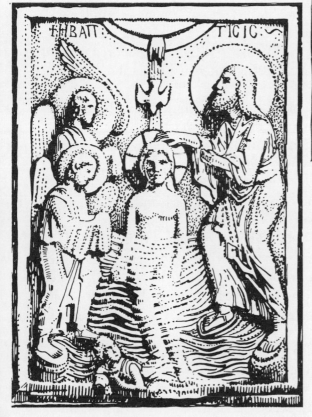

44. *Baptism of Christ : variations*

Left: From an eleventh century Italian carved marble slab now at Rouen. This harmonious composition is the result of a blend of revived classical and Byzantine styles. The vestigial river god of Jordan with his waterpot can be seen at the bottom.

Top right: From the twelfth century bronze doors at Pisa by Bonanus of Pisa : the same iconography but a different spirit.

Below: Stylized rendering of Jacob's Well where Christ spoke of the Living Water to the Woman of Samaria ; from the mosaic of this scene in St Mark's, Venice.

The change in the neophyte was seen in terms of rebirth and regeneration so symbols of these came naturally into the work of decorators. The saving grace of Christ was believed to rescue the sinner from his ignorance and darkness and so depictions of salvation such as Christ rescuing Peter from drowning were promises wholly appropriate; as shown in the earliest church yet found, that at Dura Europos dating from AD 230. This simple house church has scenes (now in America) whose iconographical value outweighs their limited quality as art. Among others the wall paintings show Christ walking on the water, the Samaritan woman at the well, the Good Shepherd and the three Maries at the Tomb. So within two hundred years of Christ's Resurrection it can be seen that the pattern of visual ideas about baptism were already formulated.

In North Africa for example remains of early baptisteries have been found burgeoning with the symbolic animal and plant decoration of Christian culture. The beautiful sunken quatrefoil font from Kelibia in Tunis, illustrated on Plate 10, is surfaced with mosaics whose meaning was readily understood by the believers of the time. Amongst the trees represented are fig, olive, date palm and apple, the bee is shown and the candle from her wax, the fish, the ark and the ubiquitous peacocks add to the allegorical decoration.

The early baptisteries in Italy were usually domed octagonal buildings and the choice of the octagon as the most frequent shape is another intentional symbol. This number represents the eighth day. The world was believed to have been created in the six days of Genesis, God rested on the seventh and on the eighth, sometimes called the Ogdoad, a new dispensation began with the Resurrection of Christ.

An atmosphere of gaiety and rejoicing was evidently inseparable from the concept of baptism and these early structures at Rome, Ravenna and Grado for instance, witness this sense of praise and renewal. This stems perhaps as much from the intimate scale of the octagonal buildings and the relatively large windows filling the dome with light, as it does from the noble wall mosaics with their colour contrasts of white, gold and blue. The finely preserved decoration in the fifth-century Orthodox Baptistery in Ravenna is worth the most detailed study. The decoration in the dome signifying the heavenly world shows the apostles in gold and white robes with crowns of victory in their veiled hands, wheeling in a celestial circle against a peacock ground of green and blue around the central medallion of the Baptism of Christ. The circle of the Apostles contrasts with the mosaic decoration below the dome showing four gorgeously arrayed thrones set in pavilions with flowering trees and shrubs alternating with four golden altars in niches supporting open gospel

books. Above the lunettes stucco designs of wreathing vines and peacocks contrast their creamy pattern against the glowing background colours of crimson and blue. The splendour of effect emphasizes the richness of the symbolism and the spiritual splendour of Christian fellowship.

A homelier water symbolism can be found in the mosaic floors of the sixth-century baptistery at Grado, an island in the marshes a few miles from Venice where the Christians of Aquileia fled from invasion in the fourth century. These designs are based on classical geometric patterns. Smelling of the salt water just below the surface they give the shimmer of shallow wavelets on rippled sand. Modern patterns such as these may be used to decorate the floor area round the font and strengthen the symbol of water as a sign for new life; the cleansing of sins and guilt; and its other analogy that just as water supports the fishes so Christianity supports the souls of the faithful.

Fonts

When the Christian faith was adopted as the official religion of the Empire whole populations were converted, the drastic purifying of pagan adult converts ceased and in time the rite of infant baptism took its place. This led to changes in the shape and arrangement of baptisteries and the sunken fonts of early times gave place to basin or tub structures, and some modern fonts are movable structures.

The function of the font is to contain water which has been blessed. The infant is held over the vessel that the water may be poured over his head to symbolize his entry into the fellowship of the Church. In some Orthodox Rites the child is dipped bodily three times and the Roman Rite is now restoring this as an alternative form of administration. Although fonts have been made of wood, bronze and lead the traditional material is stone, underlining the idea of Christ as the Rock of Ages; the source of Living Water. It is fitting that they should have nobility of form and presence. The early sunken fonts were designed for the elaborate ritual of adult baptism; with the modest service of infant baptism the need for a building – separate from the church itself – diminished, although in Italy such buildings are still in use. In the Middle Ages it became the custom for fonts to be placed near the door at the west end of the church and this siting shows that baptism is the entry into the fellowship of the Church and it is only after Baptism and Confirmation that men come to the Eucharist at the altar.

The size and importance of the font made it an admirable structure for decoration. The carving and ornament on the hundreds of medieval examples that survive in England and Europe are one of the richest sources of iconography. Although some designs are merely decorative many others illustrate the ideas about baptism current at the time. In the Romanesque period for instance, the spiritual life of the Christian was seen as a struggle with the monstrous powers of evil. It was necessary for the soul to be armed by baptism; to enlist the power of Christ and his warrior Saint Michael in the unending struggle with the Devil. Subjects from the life of Christ include his Baptism as the obvious choice; the Norman example illustrated opposite is outstanding in its vitality. On the other side there are formidable representations of the Gospel Creatures; these four symbols of the Evangelists were obviously apt decorations for fonts.

During the thirteenth century in England an architectural style of decoration became customary; during the next two centuries figurative sculpture increased in popularity, much sensitive workmanship can be found in font decoration, perhaps less to modern taste than the Norman energy and roughness and often sadly battered by iconoclasts. Figures representing the Virtues and Vices appear as personifications of the battle of the forces of Good and Evil. Adam and Eve appear as the occasion of the Fall and subsequent need for baptism. Jonah occurs as a type of

45. *Fonts*

Top: Castle Frome: massive Norman carving showing St John as a priest with a maniple over his arm and Christ as a neophyte in a round font. The Dextera Dei and the Dove of the Spirit are included in the carving which thus represents all Three Persons of the Trinity. It is unusual in that the figures have moustaches.

Below left: From the eleventh century stone font at St Germigny des Prés, near Paris. The naïve carving shows St John baptizing by affusion, the Hand of God is issuing from the clouds and pointing to the figure of Christ.

Right: Font in the church of the Epiphany at Corby, designed by Alan Boyson in 1962. 'As a departure from tradition the font is placed in a prominent position near the central altar: visibly emphasising the importance of both the sacraments – Baptism and Holy Communion – to the Christian Church. The design consists of a tracery into which are woven representations of the three gifts surmounted by crowns – symbols of the journey of the Wise Men. Between these are a seedling, a flower and a fruit which suggest man's birth and development. They are menaced by a series of arrows – symbols of evil. Above the seedling is a fish – the ancient sign of Baptism. A dove, above the bowl of the font, signifies the presence of the Holy Spirit.' (Quoted from the guide to the church.)

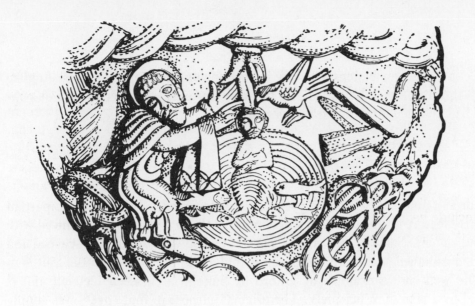

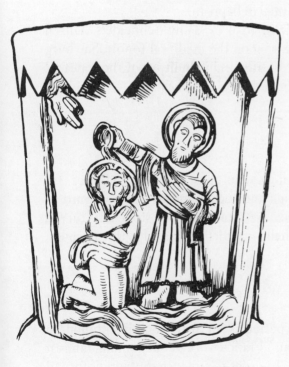

resurrection after immersion. The Seven Sacraments are popular on East Anglian fonts in the later fifteenth century. By this date however the inner vitality of symbolism had declined from the earlier version.

Font Covers

In medieval times the elaborately carved wooden covers became an important decorative feature of church fonts, when new these would have been enhanced with gold and colours. Some of these masterpieces of woodwork tower up in cusped and pinnacled canopied spires and are raised by pulleys in the roof when the font is in use. The well-known example at Ufford in Suffolk is eighteen feet tall and is crowned by a pelican in her piety. The original purpose of font covers was simply to protect the Holy water from profanation but these splendid examples also rendered honour to the font and dignity to the ritual of baptism.

A distinguished bronze font cover made in 1959 by Tony Schneider-Manzell and decorated with engraved designs can be seen on the medieval font in Salzburg Cathedral. A tall modern cover in Guildford Cathedral is built up of the repeated forms of doves of the Holy Spirit to whom the cathedral is dedicated.

Stoups

Holy water stoups placed in Roman Catholic churches near the entrance are derived from the fountain for washing hands and feet found in the courtyard of every early Christian place of worship. They are often made of stone and carved with symbolic decoration. The shape of a shell is particularly apt for this purpose.

Modern Fonts

As one would expect from so experimental a period as our own the design of modern fonts exhibits great variations. In Germany and France work of outstanding interest has been done since the end of the 1939 war. In order to enhance the significance of the ritual the idea of a specific area for baptism has returned to favour. This has been obtained by the use of railings or steps, floor mosaic or wall decoration. The font may be cited nearer the altar to emphasize the link between the Sacraments. In

other places, such as in the circular baptistery in the new Roman Catholic cathedral of Christ the King at Liverpool, there is at present no vestige of the pictorial symbolism and even the dome of the roof has been turned the other way up. This white baptistery with its white font is beautifully designed for visibility and participation but it lacks the warmth and fellowship of the idea of baptism and seems impersonal without any visual symbols of the sacrament. The font in the Anglican cathedral at Coventry is equally austere, being hollowed out of a great Bethlehem boulder. This would be less awkward if it were not balanced on a metal rod which is neither support nor root. On page 109 is a drawing of the striking modern font in the new church at Corby in which formal symbols have been effectively deployed.

The Holy Spirit

THE HOLY SPIRIT, the Third Person of the Trinity, is defined in *The Oxford Dictionary of the Christian Church* as: 'distinct from, but consubstantial, co-equal and co-eternal with, the Father and the Son, and in the fullest sense God.' The language of the theologians has grown from old Christian controversies about the doctrine of the Spirit. In the Old Testament the Spirit of God is active at the Creation and as the source of inspiration of men of action, skill and prophetic wisdom. In the New Testament the Spirit is present at the Annunciation and at the Baptism of Christ; the Spirit supports Jesus in the wilderness and in his Ministry and comes to comfort the Apostles after the Ascension. Other names used are Spiritus Sanctus, Holy Ghost, Paraclete and Comforter. The Latin word Spiritus means breath or air, the same thought as in the Hebrew word *Ruach*; this spirit is air in motion, in nature it is the wind, in man the soul, in both it signifies the power and movement of animate nature. A bird, with its soaring flight, is a fine choice to symbolize the Divine Spirit. All the Gospels describe the Holy Spirit at the Baptism of Jesus in the likeness of a dove descending. In later art the dove is haloed, and the halo marked with the cross stresses the doctrine of the Trinity. In Coptic art the

46. Top left: Pentecost: a fourteenth century roof boss in the nave of Tewkesbury Abbey, one of the fine series in this noble church. A large Dove of the Holy Spirit descends upon the group of the twelve Apostles with the Virgin Mary in their midst.

Top right: Pentecost: from a medieval enamel plaque now in America. The coming of the Holy Spirit is represented by rays from a disc bearing the haloed Hand of God touching each head with a tongue of fire.

Below left: Doves of the Spirit. From the richly carved fifth-century sarcophagus of Bishop Theodorus in S. Apollinare in Classe at Ravenna. The Dove of the Spirit descends on the cross rising from the Eucharistic vessel, the doves symbolizing souls perch on the scrolls flanking the cross.

Below right: The Dove of the Spirit descending. High relief carving in Clipsham stone by Alan Collins over a porch in the modern cathedral of the Holy Spirit at Guildford.

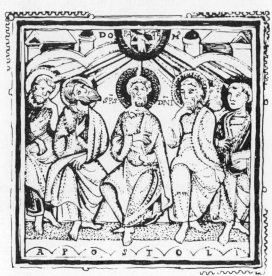

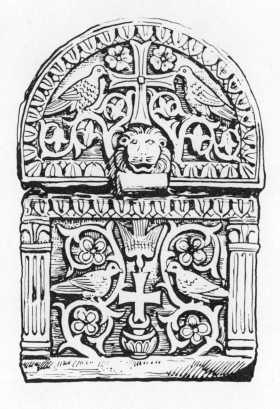

bird as an emblem of the soul is used in funerary monuments. The archetypal appearance of the Holy Spirit in the New Testament is the account in Acts of Pentecost, the fiftieth day after the Resurrection when the Holy Spirit came to the apostles:

> And suddenly a sound came from heaven like the rush of a mighty wind, and it filled all the house where they were sitting. And there appeared to them tongues as of fire, distributed and resting on each of them. And they were all filled with the Holy Spirit and began to speak other tongues, as the Spirit gave them utterance.

The great window designed by John Piper and made by Patrick Reyntiens, in the Baptistery at Coventry Cathedral symbolizes the Holy Spirit with a blaze of gold and white light, shot through with spectrum colours and irradiating the nave. Light is here most nobly used as the symbol of the illumination of the Holy Spirit in the lives of men.

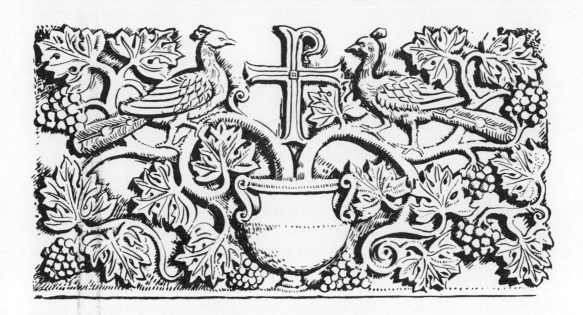

The Eucharist

THE CENTRAL act of Christian worship is called by the Greek word for thanksgiving. At the Last Supper Christ himself gave thanks, and the service is itself an act of thanksgiving. It bears other names: the Lord's Supper, Holy Communion, the Mass, the Divine Liturgy; of its nature it is a mystery. This service is held to have been instituted by Christ; to have been prefigured in the Old Testament by Melchizedek who for that reason appears on the portal of many medieval cathedrals. The inner nature of the ritual has been variously interpreted by differing theologians.

The faithful partake of bread and wine, the elements which are ritually consecrated at the service, and believe that they have received the Body and Blood of Christ, either actually by Transubstantiation, or as a symbol, or a memorial. On this difficult subject the dissensions within Christendom have been wide and tragic in historical effect. *The Oxford Dictionary of the Christian Church* defines Transubstantiation as the 'conversion of the whole substance of the bread and wine into

47. *The Eucharist*: from the sixth-century low-relief carving on a chancel slab in Sant' Apollinare Nuovo in Ravenna. Vine branches springing from the cantharus, support the monogram of Christ and peacocks of immortality; together these symbolize the Source of Life and the words of Christ: 'I am the bread of life, he who comes to me shall not hunger, and he who believes in me shall never thirst'.

the whole substance of the Body and Blood of Christ, only the accidents (i.e. the appearances of the bread and wine) remaining'.

The Eucharist is a thanksgiving, a sacrifice and a sacrament; these aspects have been variously stressed by Christian thinkers, and in art these ideas have been expressed symbolically. In the catacombs early wall paintings of celestial feasts combine the ideas of pagan ritual with the Christian celebration of Eucharist and the related ideas of 'agape', the early Christian communal meal. The feeding of the Five Thousand was a closely associated miracle; and the Fish and the Bread were also symbols of the Eucharist, the Fish standing for Christ. The Wedding Feast at Cana was another miracle closely connected with the sacrament. The drawing opposite from the sixth-century mosaic in Ravenna of the Last Supper shows Christ and his disciples at a sigma-shaped table and the meal is the symbolic Fish and Bread, whereas in the Rossano codex of the same century (not illustrated) Christ is shown as a priest giving the Apostles Holy Communion in both kinds. In a lozenge on the Campanile in Florence is a lyrical fourteenth century carving of the Eucharist with the priest elevating the Host, one of a series of the seven sacraments by Alberto Arnoldi.

In symbolic decoration the Vine, standing for Christ, is often shown in mosaics and carvings growing from the chalice of the Eucharist. Peacocks of Immortality may be included in the design or the harts of the soul or the doves of the Spirit. The Vine is a universal motif in early Christian decoration; it is found in Coptic

48. *The Last Supper*

Top left: Medieval wood carving from a church in Cairo, now in the Coptic museum there. The Coptic sense of decoration shows clearly in this version of the Last Supper. The classical sigma-shaped table seen in the mosaic below is here elongated to fit the vertical panel, the fish representing Christ almost fills the table, and is surrounded by thirteen loaves, one for each Apostle and one for Christ himself. The curtains, columns and crosses form a symmetrical frame.

Right: The Eucharist. Carved marble relief from a series of the Seven Sacraments on the outside of the Campanile in Florence; the building was begun by Giotto in 1334. This carving is attributed to the mid-fourteenth-century sculptor Alberto Arnoldi.

Bottom left: Vine scroll surmounted by a cross springing from a cantharus. Byzantine low-relief carving from a panel in the church of S. Donato at Murano.

Bottom right: In this sixth-century mosaic in Sant' Apollinare Nuovo in Ravenna, Christ and the Apostles are reclining round a table covered with a decorated cloth. On the table are seven loaves and two fishes, recalling the Feeding of the Four Thousand.

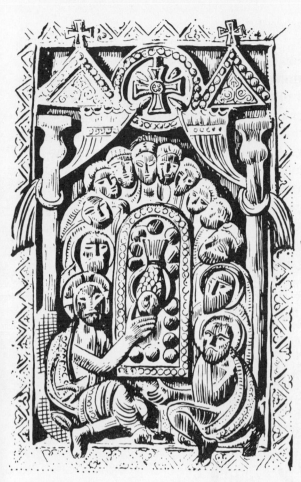

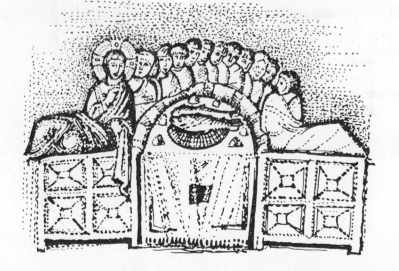

carvings and stuccowork, on Lombard slabs, Celtic crosses and in Byzantine mosaics and ivories. The significant spiritual symbolism associated the vine with heavenly and earthly gladness, and allied to the natural beauty of the plant-form this led to its dominant position in the decorative crafts of the early Middle Ages.

The combination of the wheat and vine together to signify the Eucharist has been a later development in art. On Plate 11, for example, is a modern carving showing the use of these motifs which are popular in the decorative arts today and lend themselves to stylized and non-realistic forms.

48a. Twelfth-century tomb slab, Bakewell, Derbyshire. This symbol was used in exorcism, and more widely as a decorative cross.

Angels

Winged Beings: Early forms in Art

THE IDEA of celestial power has been expressed by artists of many cultures in the form of winged beings of both animal and human shape. The history of such forms goes back millenia before the time of Christ. Composite winged creatures have been invented to represent the supernatural qualities of multiple powers within one being and to distinguish their possessors from earthly creatures.

Among the most impressive of the surviving ancient representations are the mighty winged bulls and genii of Assyria and these may well have influenced the exiled prophet Ezekiel in his description of the four Living Creatures that subsequently became the basis for the symbols of the four Evangelists in Christian art. The ferocious griffins of Minoan Crete, for example, express a very different form of supernatural power from the delicate wide-winged goddesses that hold the corners of the gold shrines of the Pharaoh Tutankhamen. The winged victories of

49. Angel of the Expulsion from Eden: from the thirteenth century carving in the choir of Lincoln Cathedral. The giant figure of the angel with the sword uses a singularly effective and mannered gesture to expel the little naked forms of Adam and Eve from the Garden. The Angel Choir at Lincoln is justly famed for the quality of its sculpture.

50. Left: *Byzantine Angels*. Angel of the Apse: from a twelfth-century Byzantine fresco in the church of St George near Kurbinovo, Yugo-slavia.

Right: Gabriel: from a battered marble slab of the sixth-century now in Antalya Museum in Turkey.

51. Right: Angel with a trumpet: from the carving on the angle of the crossing in St Mark's, Venice. This Romanesque figure shows his classical ancestry in dress; there is a sense of form and volume beneath the drapery and in the realism of the wings, which contrasts with the flatter forms of Byzantine figures.

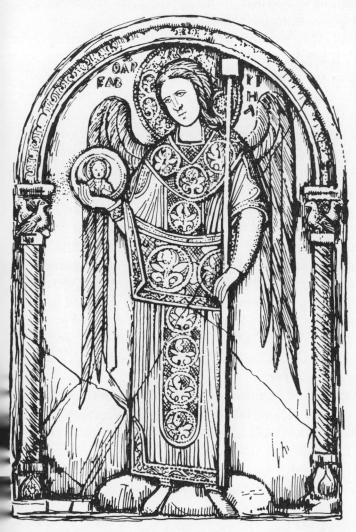

Left: The Archangel Gabriel: from a twelfth-century Byzantine carving in low-relief on steatite, now in Fiesole. The areas of plain and decorated surfaces balance the design; the archangel is given a presence both dignified and gentle; he holds in his right hand a disc with the head of the Christ Child, reminding the beholder of his role at the Annunciation. A designer of banners might well derive inspiration from this modest carving.

Greece are perhaps the most graceful of the beings represented in pagan religions of the Mediterranean and are forerunners in imagery to the familiar Christian angels of medieval art.

Both Eastern and classical Western ideas were absorbed and renewed in the forging of early Christian art. The craftsman in Italy who worked within the classical tradition naturally modelled their angelic beings on the current forms of Roman winged victories who bore round shields with memorial portraits, and who were themselves derived from the earlier Greek victory figures. Their classical ancestry shows clearly in the elegance of the carving of angels with the Chi-Rho from a sarcophagus at Istanbul, drawn on page 138.

The Jewish concept of angels can be followed in the many references in the Old Testament. The story of the Expulsion from the Garden of Eden ends with the appearance of the cherubim with the flaming sword: 'He drove out the man; and at the east of the Garden of Eden he placed the cherubim, and a flaming sword which turned every way, to guard the way to the tree of life.' This is one of the most dreadful appearances of angelic power; the flaming sword in its motion recalls the ancient image of the sun wheel. The drawings on pages 119 and 123 show two medieval versions of this dramatic story. In both the figure is drawn as an angel and not with the six wings proper to cherubim. The angels in the Old Testament were known to be messengers of God, sent to do his will, usually invisible and mysterious but sometimes coming without wings in the guise of men. Such are the three angels who appeared to Abraham under the oak at Mamre and who subsequently appear in Eastern Christian art as a form of the Trinity. In the detail from the Georgian relief from Shio-Mgwime drawn on page 65 the central angel is depicted as a figure of Christ. On page 53 is a drawing of the great mosaic at Ravenna illustrating the same event and expressing the symbolism with imaginative power. The archangel Raphael in the story of Tobias from the Apocrypha, is depicted in the early art of the catacombs as a selfless and noble being, who can declare 'I am Raphael, one of the seven holy angels who present the prayers of the saints and enter into the presence of the glory of the Holy One.' Yet in the narrative he appears as a mere man, an archangel incognito as it were.

In the story from the Book of Numbers an angel barred the way to Balaam on his journey and was perceived by the humble ass and not by the soothsayer himself. This tale was popular with medieval artists as it was understood to illustrate the pattern of Christ's reception by the Jews and was depicted in parallel with the homage of the Magi, typifying the Gentiles who accepted Christ. The drawing on page 123 shows a compact Romanesque carving at Siponto of this subject. The

Plate 18: caption overleaf

Plate 18: (overleaf) *Monumental Brasses*

The brass of Abbot Thomas de la Mare in St Alban's Abbey, 9 feet 3 inches by 4 feet 4 inches. This is considered one of the finest ecclesiastical brasses in England and was engraved about 1360 during the lifetime of the Abbot. The richly textured design shows the Abbot in full pontificals enclosed in an architectural canopy. The details of the vestments: amice, alb, stole, maniple, tunicle, dalmatic and chasuble are worth careful study. The fine decoration of mitre, crozier, gloves and dragon-supported slippers adds to the splendour of the central figure. Within the elaborate framework are many small figures of apostles and saints, the former with haloes and bare feet, the latter with caps and shoes and scrolls. The larger figures on either side of the Abbot's head are the English saints Alban and Oswyn and at the top of the design Christ is enthroned between angels. The border still contains part of the original inscription and three of the original four quatrefoils survive with the symbols of the Evangelists. The contrast between intricate detail and plain surface shows to advantage in the black and white of a rubbing; the one from which this photograph was taken is in the notable collection owned by the Society of Antiquaries.

Memorial brass of Bishop Trollope in the Cathedral of St Mary and St Nicholas at Seoul, Korea. This twentieth century brass, set in black Derbyshire marble, was designed and made by Francis J. C. Cooper. It is of latten, a brass alloy with a good surface for engraving. The Bishop is represented holding his crozier in one gloved hand and a model of Seoul Cathedral in the other. He is robed in a conical chasuble with Y-shaped orphreys, ornamented with vine scrolls inhabited by doves and an owl. Below the chasuble the fringed dalmatic and the tunicle can be seen. The apparelled amice, alb, stole and maniple are patterned with a geometrical design, crosses and the IHS monogram. The mitre ceremonially worn by a bishop or abbot is decorated with vine scrolls. At the corners of the brass are the symbols of the four Evangelists; on either side are the arms of the See of Seoul charged with the cross moline; below left, the lily emblem of the Virgin Mary; below right, the golden balls on a book, the emblems of St Nicholas. The contrast between dark marble and bright metal and between plain and patterned surfaces together enhance the dignity of the design. It is not permitted for bodies to be interred in cathedrals today, so the use of fine floor brasses has ceased. Wall brasses are not encouraged as memorials by the Church authorities.

Plate 19: *Contrast in Image and Material: the Virgin and Child*

Right: Majestic Romanesque illumination from St Augustine's Commentary on the Psalms, in the Bodleian Library. The circles of the mandorla are coloured red, purple and green; the hieratic figure of the crowned Virgin is drawn in red outline, the Christ Child robed in green is holding a green book. The tall sceptre delicately held by the Virgin is topped with a lily flower and a dove, perhaps in reference to the legend of Joseph's rod. (*Photograph Bodleian Library, Oxford*)

Left: Engraved glass panel from the great west window at Coventry Cathedral by John Hutton.

Below: Ceramic panel in the chapel of Corpus Christi College, London by Count Janusz Lewald-Jezierski. The colours are tones of deep peacock blue; the lettering is used as a strong border.

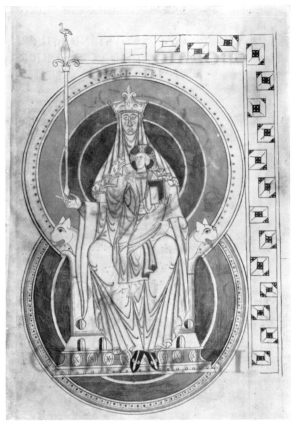

Plate 20: *Images of Compassion : Twentieth Century*

Left: The Virgin and Child: heroic group in lead by Sir Jacob Epstein on the wall of the Convent of the Holy Child Jesus overlooking Cavendish Square in London.

Right: The Crucifixion with the Virgin and St John: the original shale pebble carved by Arthur Pollen is only two inches high; within this miniature scale the sculptor achieves exceptional intensity of feeling.

Below: Pieta: from a set of Stations of the Cross in ceramic by Donald Potter, in St Matthew's Church, Bethnal Green.

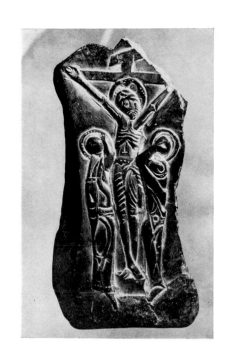

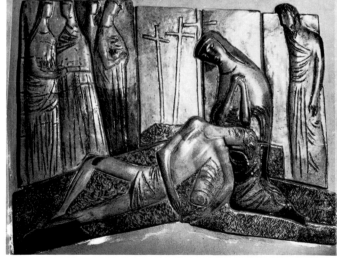

Plate 21: *Angelic Forms*

Left: Angels carry crowns: detail from a thirteenth
century stained-glass window in Amiens Cathedral.

Right: Winged Figure: Barbara Hepworth, 1963.

Below: Angel with trumpet: engraved by John Hutton
on the glass tympanum inside the south door of Guild-
ford Cathedral.

52. *Angels from the Old Testament*

Top: Balaam and the Angel. Carving on the capital of a doorway in the fine Romanesque church at San Leonardo di Siponto in Apulia, Italy. In the Middle Ages this subject was held to prefigure the coming of Christ and his acceptance by the Gentiles.

Left: Adam and Eve and the Angel of the Expulsion. One of the many bronze plates of different dates on the great doors of San Zeno in Verona made in the eleventh century. The simplicity of the narrative scene is in contrast to the mastery of the bronze founder.

Magi are carved on a similar capital on the opposite side of the door. It was Balaam who said: 'A star shall come forth out of Jacob and a sceptre shall rise out of Israel', which was of course taken to foretell Christ as the Star of Bethlehem.

Jacob's ladder with angels ascending and descending has been depicted in many forms. One of the most memorable is in the Church of the Chora in Istanbul. His struggle with the invisible angel, with whom he wrestled all night, was given memorable but barbaric form in this century by Jacob Epstein – carved from a huge block of alabaster. As an image of the mysterious dark powers we have to overcome in ourselves the idea might well inspire other modern artists. In this calamitous century mankind needs, more than ever, a spiritual symbol of the struggle to overcome his innate aggressive instincts before they in turn override his intelligence and, almost inadvertently, destroy civilisation as we know it.

Angels in the New Testament

The early chapters of the New Testament are radiant with the presence of angels; the teaching of Jesus, in line with Jewish thought, expresses their divine activity in the world of men. The evangelists quote actual sayings of Jesus about angels and

53. *Dreams and Blessings*

Top left: Anglo-Saxon carving from Breedon-on-the-Hill. This somewhat clumsy rendering of the angel with rod and lilies probably represents Gabriel at the Annunciation. The large expressive hands, the robes and the Eastern gesture of benediction show the inspiration to have come from the Mediterranean.

Top right: St Joseph's Dream: from a thirteenth-century mosaic in St Mark's, Venice. Angels were considered the agents of inspired dreams and by contrasting the figures of angel and dreamer the artist could render the inspiration in visual form. The agitated drawing of the lively angel in the mosaic compares with the serenity of the ivory below, with its austere linear arrangement.

Below left: St Joseph's dream: from an eleventh-century Italian ivory panel in the Victoria and Albert Museum.

Below right: Angel: coppergilt and enamel figure holding a twelfth-century rock crystal reliquary, from the church of St Sulpice-les-Feuilles. This poised and dignified angel may have been one of four corner figures from a tabernacle and then re-used for the reliquary. The severe lines enhance that intensity of expression characteristic of the Romanesque.

Satan on a variety of occasions and the later idea of the guardian angel derives from his words about the angels of children in St Matthew's Gospel. In the gospel narrative of St Luke the presence of angels surround the Nativity story with a luminous intensity. An angel foretells the coming of his son John – the forerunner – to the priest Zachariah in the temple sanctuary. Gabriel the archangel of the Annunciation, brings Mary the great tidings that she would bear 'the Son of the Most High'. Angels announce the news of the birth of Jesus to the shepherds in the fields. They are messengers in dreams of warning, both to the Magi and to Joseph. After his temptation in the wilderness they minister to Jesus; they comfort him in his agony in the garden and witness his Resurrection to the women at the Tomb; they are present at the Ascension and foretell the Second Coming.

The illustration of these Gospel scenes throughout the churches of Christendom were for many centuries among the chief subjects of art, at a time when art itself was largely the prerogative of the Church. Angels express Divine intention in visual terms and their presence in scenes such as the Nativity demonstrates the supernatural significance of the event, however modest the scale of the work or homely the talent of the artist.

When one considers the problem of symbolic visual representation of Divine action it is not surprising that angels – messengers and agents of God's purpose – have been so consistently attractive to artists and craftsmen in their work for the Church.

Form and Idea

In the past angel figures have been used to express a variety of ideas. Many opportunities have existed for the appropriate use of angelic forms in the enrichment of churches and their visual presence bestows a benison on the buildings and its works of craftsmanship.

It is obvious that the imaginative conception of angels has varied widely at different times: wings, flight, urgency; speed, energy, communication; dignity, poise, power; ministration, worship, praise; beauty, stillness and peace; all these attributes and others have been expressed in the forms of angels by artists in the Christian tradition. Angel figures have also been used for lesser purposes; as mere adjuncts to design, for decorating empty spaces or as servitors holding objects or inscriptions, musical instruments, coats-of-arms, reliquaries and the like.

In almost every part of Church enrichment and in almost every material angels are found as decoration or as structural ornament. In architecture they are carved on façades and portals, tympana and lintels. They are found on doors, roof bosses, corbels, spandrels, in niches and on tombs. They are richly embroidered on vestments, illuminated in manuscripts; painted in stained glass windows, wrought in precious metals and depicted on walls.

In the illustrations we have aimed to suggest the historical variety of forms and have selected figures from Classical, Coptic, Ethiopian, Byzantine, Georgian, Celtic, Anglo Saxon, Catalan, Romanesque and Gothic sources, each with their characteristic individual qualities. Then, as already explained in the Introduction, we have leaped in time to our own century with examples of modern work.

The angels derived from the late classical style are usually represented flying horizontally and holding a Chi Rho or other symbol within a wreath. Their purpose is decorative and although often of striking physical beauty, clothed with masterly rendering of flying drapery they are rarely charged with religious feeling. The angels in the early mosaics at Rome and Ravenna on the other hand seem to be beings of majestic serenity and imperial richness of guise. Wherever the widespread Byzantine tradition influenced Christian art the dignity and otherworldliness of their angel figures are outstanding. A linear sixth-century carving of Gabriel from Antalya on the Turkish coast is drawn on page 120; on the same pair of pages are drawings of a twelfth-century angel from the fresco at Kurbinovo in Yugoslavia contrasted with a little carved panel from Fiesole of similar date. Although the styles are varied the Byzantine sense of reverence can be felt in each work. The gift of the Greeks to Christian art has been recognized in this century with increasing enthusiasm and interest. The works of many art historians have brought the subject before a wide public.

While sculptural forms can reasonably be rendered in photographs, frescoes and mosaics in particular need to be seen in their settings for their impact to be appreciated. Facilities for travel have made it possible for more people than ever before to see for themselves the art of Christendom, and a delight in seeking out the treasures of the past can add much to the enjoyment of holidays.

Among less well-known examples from the Middle Ages are drawings of angel carvings from Armenia and Georgia which have an expressionist vigour and energy that appeals to our current taste. These relief carvings foreshadow the renowned achievements of Western Romanesque in France and Spain.

If the Georgian church of Nikordsminda was more accessible to tourists, for instance, it could attract the throngs that flood through Chartres and Moissac. The

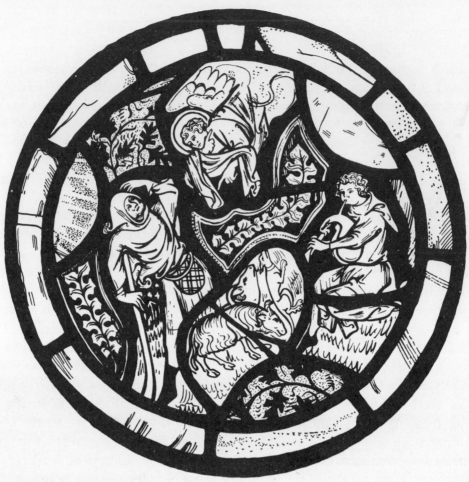

54. *'Good Tidings of Great Joy'*
Angel appearing to the shepherds at the Nativity: from the English fourteenth-century stained glass roundel, in vivid tones of red, blue and gold, now in the Victoria and Albert Museum.

55. *'Seraphs on Shining Wing'* (opposite)
Top left: Feathered angel playing a rebeck: from a stained glass window of the Norwich School, fifteenth century, now in the Victoria and Albert Museum.

Top right: Angel issuing from stylized clouds: from the corner of a fourteenth-century brass in Elsing Church, Norfolk.

Below left: Angel with six wings studded with eyes and standing upon a wheel: a detail from the Syon Cope, English fourteenth-century *Opus Anglicanum* embroidery, Victoria and Albert Museum.

Below right: A six-winged seraph embroidered with gilt threads and coloured silks from an English chasuble of deep blue velvet. The radiating lines and dotted spangles soften the contrast between the embroidery and the dark background; early sixteenth-century work.

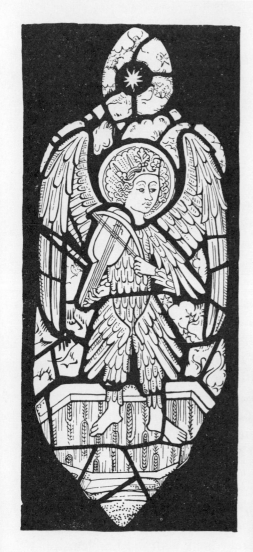

carved angels from this church have a singular intensity, a combination of the qualities of design and of feeling as can be seen in the drawing on the title page showing the Exaltation of the Cross. The seraph from the exterior of the church of the Holy Cross at Achtamar on page 137 is notable for the satisfying arrangement of his six wings.

A sympathy for naïve art is characteristic of the taste of our time. The rendering of form by early provincial craftsmen which was considered touchingly incompetent or even comic by earlier art-historians is appreciated by contemporary craftsmen, especially perhaps embroiderers and glass engravers to whom the strong sense of pattern native to peasant art makes an instant appeal. The drawing on page 132 of the Lombard carvings at Cividale is a case in point and some Coptic work also comes into this category. It is obvious that Christendom embraced artists of simplicity as well as those of mastery and even genius.

Romanesque art with its emphasis on the supernatural world has created angel figures of great power and urgency. The carved façades, tympana and lintels of this period, especially in France, are an endless delight to study.

The active angels of Anglo-Saxon manuscript and Romanesque carved decoration develop in their turn into Gothic angels with the superlative sweetness and grace of this flowering time. Carvings of angels from the cathedrals of Reims, Amiens and Rouen are well-known to sightseers; perhaps less well-known although on home ground are the angels from the south transept of Westminster Abbey, the choir of Lincoln Cathedral and the angel-roofs of East Anglia.

In her valuable book *The Imagery of British Churches* M. D. Anderson says:—

In no other country have the plastic possibilities of angels' wings been so richly exploited as in England. Their long pinions sweep forward to fill the spandrels of arcades, or are squared above the shields they hold, with the Emblems of the Passion, or the heraldry of benefactors, blazoned upon them. Heaven's eternal song of praise is represented by angels with musical instruments; the bosses above the High Altar of Gloucester Cathedral show an orchestra of angel musicians, holding examples of most of the instruments known to the Middle Ages. In the tracery of many windows the angelic musicians are interspersed with others holding scrolls, on which are inscribed the opening words of canticles, or phrases from the liturgy, to emphasize the connection between the Church festivals and those events in the life of Christ, or of the saints, which were once illustrated in the lower lights. Lastly, but most impressive of all, perhaps, we have the great angel roofs of East Anglian churches where winged

figures are carved upon every projection of the hammer-beam roofs; tier above tier of wings soaring up into the darkness of the rafters.

Now that art history books are so richly illustrated a student can summon to the mind's eye a host of angel-beings from all styles, while anyone designing for the Church is likely to compile their own anthology of forms, wings and compositions.

The Contemporary Artist and the Winged Forms

In the scope that they offer designers today angelic forms are one of the most flexible subjects which can be brought appropriately into the enrichment of churches, whether in embroidery or on metalwork, walls or windows. The formulation of these beings sets the designer fascinating problems in movement and rhythm; angles and thrusts. They can convey moods and meanings ranging from the most serene tranquillity to the most ecstatic energy; from the spirit of service to that of praise. It is true that the sentimentality and langour of the commonplace nineteenth-century concepts of angelic figures caused a revulsion of feeling against their use. In fact many architects and theologians today would prefer to dispense with the imagery of angels in churches altogether. It is sincerely felt that they are too anthropomorphic an idea, that as such beings are not visible among us as winged men the illustration of them in this form becomes at best a hindrance to modern faith and at worst a joke. This narrowly material point of view appears to limit the imagination by denying the validity of symbol. Divine powers and energies can be expressed in visual terms only by symbol and angelic figures can stand for spiritual forces beyond our apprehension:

> *The angels keep their ancient places :–*
> *Turn but a stone, and start a wing!*
> *'Tis ye, 'tis your estranged faces,*
> *That miss the many-splendoured thing.*
>
> (Francis Thompson)

However, one must admit that the use of these imaginative concepts requires moderation. The figures of angels in church embroidery sometimes appear to be vehicles for technique rather than messengers of God.

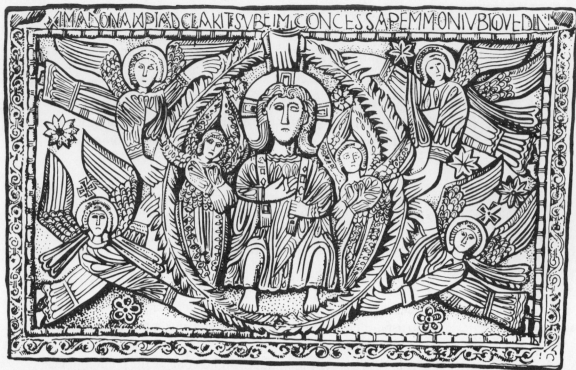

56. *Christ in Glory*: the Pemmo Altar in the cathedral at Cividale del Friuli. This Lombard work in creamy marble was carved in low-relief about AD 745: all four sides are decorated. The Lombard artist, following classical forms not fully understood, has created a work of extraordinary intensity neither photograph nor drawing can convey. The mandorla of light has become a laurel wreath and the stars have become daisies. Christ is wearing the stole of priestly authority and carrying the scroll of the classical teacher, with his other hand he is making the Eastern gesture of blessing.

57. *Contrasting Forms* (opposite)

Top left: Angels holding the Gospel of St Luke: from a tenth-century ms. in Gerona Cathedral. The form of the lifted wings is as effective in design as it is original in structure. Wings on stalks may also be found in Ethiopian manuscripts of later date.

Top right: Anglo-Saxon angel in a hurry: after the eleventh-century missal of Robert of Jumièges now at Rouen; Anglo-Saxon draughtsmen excelled in rending movement and vitality, and their flickering penmanship is characteristic.

Below left: Seraph with angelic Thrones, who are members of two of the three choirs in the first hierachy of angelic beings, according to Dionysius. This six-winged angel is a seraph and the flaming wheels, sometimes depicted with wings and eyes, called Thrones, revolve ceaselessly round the Being of God. This example comes from a sixth-century silver liturgical fan now in Ankara.

Below centre: The angel at the gates of Paradise: from the twelfth-century Albani Psalter in the Library of St Godehard, Hildesheim.

Below right: Angel holding the symbol of St John the Evangelist: from the twelfth-century fresco of Christ in Majesty in San Clemente de Tahull, Spain. This angel fits into the triangular shape between the mandorla of Christ and the arch of the apse.

There is a current vogue for unattached wings which needs to be handled with discretion if it is to be effective. Expressed with the controlled strength of the sculptor Barbara Hepworth as in Winged Form illustrated on Plate 21, it has a majesty and poise all the more startling to find in the crowded shopping centre of London's Oxford Street.

Commercial interests are more often the culprits in the widespread use of what can only be called 'twee' angel-figures on Christmas cards and decorations which cannot fail to diminish our imaginative conception of these spiritual powers. These dressed up winged dolls are ultimately derived through the putti of rococo art back to the amorini of the Classical repertoire; in this sense they are little loves, it is true, but sadly debased in stature and meaning.

On Plate 21 we include an example of John Hutton's angels engraved on glass from Guildford Cathedral. This craft has become one of the distinctive art forms of our times. The varied range of saints and angels he engraved for the great glass wall at Coventry shimmer in the changing play of light. This huge work has been

58. *Service and Praise*

Top left: Angel with bells: from a medieval wooden carving on the roof of St John's Church, Stamford, Lincolnshire. Angels with musical instruments are a feature of medieval art and from the artist's point of view this gave them a pleasing variety of shape, some action to perform and some object to hold. Images of music-making also express the belief that angels existed in a perpetual state of joy and praise to the Almighty.

Top right: Angel with a trumpet: this clumsy and ecstatic figure comes from the Last Judgement scene in the archivolt of the twelfth-century porch of St Trophime at Arles.

Below left: Angels with the instruments of the Passion: two of a series of outstanding roof bosses of the fourteenth century in the nave of Tewkesbury Abbey. The upper angel holds the cross and pillar, the lower holds the knotted scourge and the spear. Owing to their great height above the ground roof bosses have often escaped the iconoclasts. The blending of dignity with a certain chunky grace is characteristic of the period.

Below right: The angel at the Pool of Bethesda: from a panel of the painted wooden ceiling in St Martin in Zillis, Switzerland. One of the only two surviving Romanesque painted ceilings, this is dated mid-twelfth century. The next panel shows the sufferer, healed after thirty-eight years of his illness, carrying his pallet at the bidding of Christ. The bold naïve drawing is a feature of this remarkable ceiling which is made up of one hundred and fifty-three separate square panels; the number is itself symbolic and typical of the thought of the times. The pool is treated in a conventional manner similar to an heraldic fountain.

59. *Angel Supporters*

Christ in a mandorla supported by angels: from the counter Seal of Dunfermline Abbey, Fife. Religious houses used seals from an early date and under Edward I it became obligatory for such houses to possess one, to be held in common by the abbot and four of the monks. Although a late medieval choice for such seals, the design of Christ in Majesty was not considered an incongruous subject. Even on so small a scale the figure is shown sitting on a bow between emblems of the sun and moon in the starry heavens, holding in his left hand the book and blessing, in the Western form, with his right.

60. *Carvings in Stone* (opposite)

Top: The Exaltation of the Cross: tympanum of the south door of the seventh-century church of Jvari, or the Holy Cross, on the hill overlooking Mtskheta, Georgia.

Below left: A seraph with six wings filled with eyes: a relief from the tenth-century church of Achtamar in former Armenia.

Right: Angel from a sculptured capital in the tenth-century church at Oshki, formerly in Georgia and now in Turkey. It has been pointed out in David Lang's book on the Georgians that these carvings are early forerunners of those in European churches of the Romanesque period.

Below right: Christ holding the cross of the Resurrection between angels, from the low-relief carving in stone, possibly seventh-century in the church of S. Maria, Burgos.

[136]

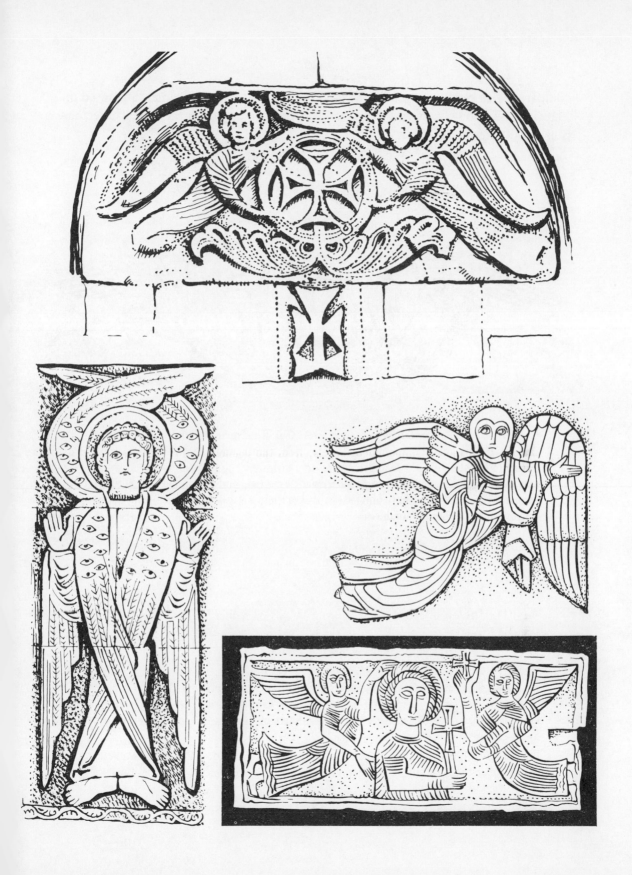

compared with medieval façades in stone such as that of Angoulême, illustrated on Plate 1; and it has been said to recreate the place of angels in the modern decoration of churches in the West.

60a. *Angels with a medallion* containing the Chi Rho surrounded by a wreath of victory, from a princely sarcophagus of the fifth century now in the Archaeological Museum in Istanbul. These angel supporters, with their naturalistic feathered wings and idealized faces, derive from pre-Christian 'Victories' and continued for centuries in many variations. The horizontal shape makes them a valuable decorative motif not only in sculpture but also in mosaic.

Plate 22: *The Trinity*: the symbolic tapestry behind the high altar in the Cathedral of the Holy Trinity at Chichester. Designed by John Piper and dedicated in 1966. The strong colours of red, blue, green and purple are shot through with accents of white and gold.

Plate 23: *The Cross and Crown as Symbol*

Liverpool Roman Catholic Metropolitan Cathedral of Christ the King: a symbolic pattern of crosses and crowns designed by William Mitchell and carved in deep relief in Portland stone facing for the dramatic front elevation. The large central Cross of Christ is flanked by two crosses of the thieves; that of the good thief has some enrichment while the other is left plain; they are linked together and entwined with crowns, symbols of the Kingship of Christ. Above are the four bells dedicated to Matthew, Mark, Luke and John. Behind is the soaring lantern tower marking the liturgical focal point of the High Altar to which the whole building is related. The stained glass by John Piper and Patrick Reyntiens depicts in abstract form and rich colour the Blessed Trinity. (*Photograph The Architects' Journal*)

Altar frontal by Margaret Kaye for the Epiphany Chapel in Winchester Cathedral, 1962. A contemporary design using traditional symbols with fabrics of different textures.

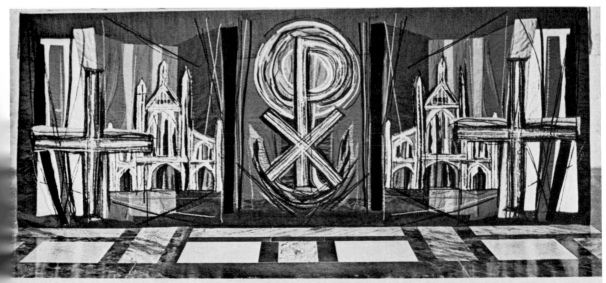

Plate 24: *Contemporary Embroidery*

Top: Altar Frontal by Pat Russell for St Edburga's Chapel in Pershore Abbey. The bold units of the design are worked in tones of blue, purple, deep gold and cream with touches of red.

Left: Cope by Constance Howard for St Marylebone Church, 1968, made of orange Welsh flannel with a rich design of crosses in gold and silver.

Right centre: Burse: part of a set of Festival vestments by Margaret Openshaw for St Andrew's Church, Cheddar, worked in coloured silks and gold on cream Thai silk.

Below: Burse: part of a Lenten array by Oenone Cave, worked in gold thread and gold kid on Irish linen.

Plate 25 (overleaf): *Lettering and Light*

Top: One of the eight great Tablets of the Word carved in Hollington stone by Ralph Beyer for Coventry cathedral. (*Photograph Architectural Press Review*)

Centre: Holy Water Stoup with Stars and Fish: the engraved line follows the gesture of the hand in making the Sign of the Cross, engraved freely with carborundum on glass by David Peace. The inscription reads: 'Wash you, make you clean, cease to do evil.'

Centre left: The Holy Spirit descending: the dove and the seven flames are embroidered in gold metal couching and silk applique on tweed by Anna Crossley, San Francisco, USA.

Below left: Curtains in the church: appliqued design of candles with the figures of the twelve apostles as the wicks. Worked by members of St Edmund's Church at Hayes, Middlesex, from a design by Heather Child.

Below right: Design for one of eighteen panels of symbols in sandblasted glass, by Heather Child for a pair of doors in St Matthew's Church, Bethnal Green.

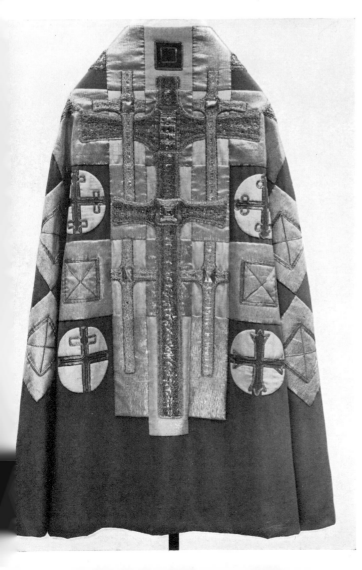

I AND THE FATHER
ARE ONE ✝ HE THAT
HATH SEEN ME
HATH SEEN
THE FATHER

Good and Evil

THE EXPERIENCE of innocent suffering and positive evil are two great enigmas with which the religions of the world have to come to terms according to their range of understanding. The still primitive tribesmen who believe thunder demons or rain spirits may be propitiated by acceptable rituals are not so far in mind from the western housewife who would not walk under a ladder or who touches wood when boasting modestly of her good fortune. The ancient East in the centuries before Christ was the home of a multiplicity of gods in human, animal and spirit forms or combination of these forms. By keeping on good terms with the appropriate deity the humble worshipper hoped to avoid natural disasters and to mitigate the human evils of war, oppression and injustice.

Anthropologists have done much patient research into the religious beliefs of primitive tribes in our own day and to the part played in their lives by a realization of a Power beyond them with which they can be in revitalizing contact. In the history of religion the peoples of Semitic origin have been outstanding especially in their apprehension of the One God. The stern and magnificent monotheism of the Jews was circled round with races serving multiple gods and the prophets of Judaism were necessarily fierce in protection of their precious revelation. This passionate vision of the singleness of God might be squandered if the Jewish people were not prevented from following the easier gods of neighbouring countries. In this view the distinctive revelation could be kept shining only by prophetic vigilance and outspoken condemnation of backsliders. Both Good and Evil were held to be in the hand of God and the true propitiation was to live the good life according to the law given by Moses. The need for the Law, which many Jews found burdensome and restrictive, stemmed from the fallen nature of Man and the origins of the fall were given poetic form in Genesis. The chronicle of events in Jewish history in the books of the Old Testament are told in terms of retribution when the leaders of Israel strayed from the path of right living, and rewards when they acted in accordance with God's will.

The Devil does not figure prominently in the Old Testament although the

serpent in the Garden of Eden is traditionally an embodiment. His most vivid appearance is in the Book of Job, given superb visual expression in the eighteenth-century illustrations of William Blake. This dramatic story shows God as giving Satan, who is his creature, permission to persecute Job to within a fraction of his life. God himself is delineated by the author of the story as being greater than all questions of human justice.

In New Testament times Jesus naturally inherited the current Jewish views of Satan and of Hell where the wicked endured the punishments they had deserved. In the parable of Dives and Lazarus it is because of his lack of simple human kindness that Dives is sentenced to such terrible punishment. In the parable of the tares and the wheat Jesus stressed the active malice of the Devil in human affairs. He saw the state of mental derangement in terms of possession of the soul by 'unclean' spirits, that is to say those hostile to the Kingdom of Heaven.

The Gospel accounts of Christ's lone temptation in the Wilderness can only have come from his own description to his disciples. Although skilfully different in kind each temptation is fundamentally to the same sin – that of Pride. In recounting this mysterious episode Jesus showed how swiftly the Devil tried to lure him to sin by appealing to this key weakness in humankind – of all sins the most damaging, separating us most wholly from the love and will of God. Illustrations of this story of inner conflict when rendered in visual terms such as those drawn on page 144 may seem simple to us, but the medieval mind would have found the imagery acceptable and compelling. The biblical proverb 'Pride goes before a fall' is true to our experience in everyday life. In orthodox Christian belief it was this Fall typified by Adam and Eve that brought death and sin into the world.

Adam and Eve and the Fall

The story of Adam and Eve has had an extraordinarily compelling influence on the subsequent development of Christianity and has been the inspiration for many works of religious art. Recounted in Genesis, the first of the books of the Old Testament, and possibly incorporating material and myths from earlier cultures than that of the Jews, it is told in unforgettable pictorial images and with extreme economy.

The literal interpretation of this single story has been an obstacle to the union of science and religion and the basic cause of the devastating rifts that broke out in

61. *Salvation Stories*

Drawing from a carving in low relief on the outside walls of the tenth-century Armenian church at Achtamar. On the left the Three Children in the Burning Fiery Furnace and on the right Daniel between two subservient lions licking his boots. The angel above is talking to Habbakuk who obediently flew in with sustenance for Daniel. Divine rescue stories were naturally popular with Christians living in dangerously turbulent times.

Below: The Hand of God rescuing Jonah from Leviathan: from an early medieval slab re-used in the pulpit in the cathedral at Traetto-Minturno. The decorative monster fills his triangle in a satisfying pattern.

the last century, when Darwin's account of the slow eons of evolution by natural selection was set against the satisfying simplicity of the Genesis story of the origin of mankind. This division of thought split educated people into opposed camps and the Church suffers still from the result of the division. In the changed outlook of our times it is hard to imagine how vehemently the fundamentalists hold to the literal interpretation of the Bible and in particular to the Biblical account of the origins of Earth and all the creatures that live on her, especially man.

If this beautiful and profound myth can be understood as a great work of art, a work of the distilled wisdom of a naturally religious race, it is much easier to see its abiding value as a symbol for our own time and still dynamic for artists working today. This vitality stems in part from the universal quality of the story. People who are not interested otherwise in Bible stories are nearly always familiar with that of Adam and Eve. It can most fruitfully be interpreted as a myth of exile from the paradisal innocence and freedom of childhood into the world of adult responsibility and sexuality with its ensuing duties, work and children. The nature of sin is more difficult to grasp; sex as such cannot be sin – according to the myth God himself created Adam and Eve and so made male and female beings. Surely the sin lies in the disobedience and in the Pride that would inflate man to think he could be as God and to desire it. The Oxford Dictionary of the Christian Church says: 'What the Biblical narrative teaches positively is that sin arose by free human choice and that all human life has been thereby radically altered for the worse, so that its actual state is very different from that purposed for it by the Creator.'

Christians inherited from the Jews the idea that the Fall of Adam and Eve brought death into the world and the result was sin and toil for all, typified by the tragedy of Cain who killed his brother Abel. The subsequent doctrine of Original Sin developed by St Augustine, laid great stress on the fallen state of man and so emphasized the essential need for the Redemption of the world by Jesus Christ. The rite of Baptism was seen as a necessary part of this redemption for all Christians.

When the historical authenticity of Genesis was called in question many in the Church feared for the whole theological edifice. It is for instance in Genesis that we find the famous quotation 'God made man in his own image.' It is no wonder that evolutionists have had a struggle to persuade orthodox Christians to their view. It would hardly be possible for an artist today to use the familiar story of the Fall without thinking about its symbolic meaning, no longer as illustration to either history or fable but as insight into a primary myth. In the last half century many writers and artists have been illuminated by the writings of Jung and his vision of

the archetypes from the racial subconscious, the home of images and myths. The work of psychologists has shown the extent to which the levels of the mind beneath the threshold of consciousness govern and influence the conscious life of activity and relationships. It is in these depths that myths and symbols are truly at home, from here they well up into the daylight as it were and are revealed in works of creative imagination.

Images of Salvation

Christian thought has usually seen Life as the arena for the struggle between the powers of Good and forces of Evil and Christian art has found forms and symbols in which to express this belief. It has always been more difficult to represent the forces of good in art compared with the drama of evil. It is a commonplace that in newspapers and on television today it is violence and disaster that make the headlines; good news tends to be thought less interesting and less worthy of comment.

The obvious visual idea of the forces of light against the forces of darkness is perhaps too simple, although at different times Christian communities have flooded their churches with light as the symbolic expression of the power of Christ – 'The Light of the World' – but at other times they have preserved a mysterious darkness in which candles and ikons shine like revelations of the faith.

The early Christians accustomed to living at risk saw their faith very simply in terms of salvation here and Hereafter. Death in martyrdom was no betrayal of the saving promise of Life with Christ because they were convinced that it led straight to happiness in Heaven with their risen Lord. It was even necessary for leaders to rebuke those enthusiasts who were too avid for martyrdom.

In the paintings in the catacombs, simple as they are, the subjects stress this faith and happiness. At this early period reinforced by the classical tradition with its restraint and moderation, pains and griefs were not considered as subjects for artists, not even the Crucifixion was rendered. The promise of Salvation was the theme of catacomb paintings: Moses striking the rock, Jonah, Daniel, Noah, the three Children in the Fiery Furnace and the sacrifice of Isaac were favourite subjects and continued to be so long after the Christian faith had become the State religion. A carving on the south wall of the tenth-century Armenian church at Achtamar, showing two of these salvation scenes in juxtaposition, is drawn on page 141.

[143]

62. *Devils in action*

Top left: The Temptation of Christ: from a thirteenth-century mosaic in St Mark's, Venice. Seated on rocks characteristically Byzantine in form Christ is being tempted by a little black devil suspended in front of him, against the gold background of the mosaic, the devil offers stones for bread.

Top right: St Michael weighing souls: from a fourteenth-century sculptured stone slab in Kildare Cathedral. The devil is usually shown pulling down the scale in a futile attempt to subvert divine justice. (After Romilly Allen.)

Bottom right: The Temptation of Christ: from an illumination in the thirteenth century Paris Psalter. The devil is shown in conventional medieval form with horns, tail, claws and leathery wings; his gesture is both threatening and persuasive as he points to the rocks saying, 'If you are the Son of God, command these stones to become loaves of bread.'

63. *Conflict*

Above left: Griffin attacking a deer: Byzantine marble roundel set into the outer wall on the north side of St Mark's, Venice. This can be seen as an allegory of the powers of evil attacking the soul, helpless unless it seeks salvation within the Church; or as a merely decorative variation of the ancient theme of griffins hunting.

Right: The Struggle: from one of the exceptionally fine carved early thirteenth-century stone bosses in the muniment room at Westminster Abbey. The centaur, a man with a lion's body, thrusts his lance into the scales of a winged dragon called an amphisbaena, whose dragon-headed tail is attacking the centaur's right arm. The energy and balance of the design repay observation.

Below left: 'Your adversary the devil prowls around like a roaring lion, seeking someone to devour.' Marble slab in the Byzantine Museum, Athens. As with the related design of the griffin, this hunting motif reappears in Christian guise as a subject suitable for decoration of religious buildings. In the Bible the lion may be a symbol of good as well as power for evil, so this subject can be interpreted in several ways: as the temptation of the strong to abuse their strength and attack the weak; or as a soul in mortal danger unless aided by the Church on whose wall the carving appears, but its survival as a popular theme is most likely due to the admirable pattern made by two figures in conflict.

[145]

The Anastasis and the Western variant of the scene, called the Harrowing of Hell, were also images of hope and faith in salvation; versions are shown on page 77 and page 153.

Warrior Saints

The very early believers did not encourage soldiers to become Christians as the profession of arms was deemed incompatible with the teaching of Christ. However when the ruling was relaxed warrior saints became celebrated heroes in the struggle against evil, such as St George, said to have been born in Cappodocia and martyred under Diocletian, later adopted as the patron saint of England. On page 149 is a rubbing from a fourteenth-century brass roundel showing St George elegantly horsed and armoured in contemporary style.

The depiction of St Michael the Archangel as a celestial warrior fighting the forces of evil is a popular subject in Orthodox and Western art in manuscripts and carvings. He is also shown as the guardian of souls in the balance of justice after death. A devil, according to the legend illustrated on page 144, grasps at the balance hoping to cheat unseen and so win the soul for Hell but St Michael's scales are not to be tipped by falsehood. Although a patron saint and Prince of the Church Militant he is no mortal being but captain of the heavenly hosts and conqueror of Lucifer.

Images of Doom and Judgement

In few subjects do we differ more from our medieval forebears than in our view of Hell. On the chancel arch or the west wall of most medieval churches there were great Doom paintings and frescoes showing the terrible fate of sinners after death. The struggle between good and evil expressed itself in terms of a profit and loss account in Virtue; with appropriate rewards and punishments. By medieval times the Day of Judgement had become a powerful symbol of the reckoning to be faced by all Christians and the theme lent itself to development in the visual arts. This particular vision was inspired by the passionate descriptions in Revelation – this, the last book in the New Testament demonstrates the spiritual range of the author's uniquely pictorial imagination and it had a profound effect on the thought of Christian scholars and artists thereafter.

Good and Evil

The iconography of this supernatural event shown in manuscripts or on façades, was worked out in great compositions of Christ as Judge, with the dead awakened from their tombs by angels with trumpets and rising up to be weighed in the balance and shepherded into groups of the saved and the damned. The celestial happiness of good souls in Heaven was contrasted with the terrible fate of sinners after death, thrust by implacable angels into the talons of devils and thence into the huge dragon-mouth of Hell. The imagination of artists feasted on the violence and contrasts of this apocalyptic scene and were meant to harrow the consciences of the beholders. The leaders of the Church really believed men might be driven by fear into virtuous living even when they could not be drawn by the desire for goodness itself.

Nowadays when as tourists we see such Doom paintings – at Torcello near Venice for example – it is hard to believe these pictures of devils at work were capable of altering men's lives for good. We ourselves tend to observe them in terms of the history of art or the history of belief and the minds of many people reject such an imposed virtue as being incompatible with the dignity of free will. We are also more cynical about motives and even impugn the validity of good works as stemming from guilt in the do-gooders' subconscious. We are not on the side of Shakespeare's maxim

'Assume a virtue, if you have it not.'

As a result of genuine contempt for dishonesty of intention have we given too much weight to the idea of the unconstrained expression of oneself in the impulses of the moment? May not a mind faced by responsibility need the fortifying framework of a code of right thought and action? It is not easy to imagine a painter grappling with these concepts – but music with its greater range of expression may well do so as in the poignant War Requiem by Benjamin Britten, written in the sixties.

Images of the Devil

The pictorial idea of temptation as Satan fishing for souls with the hook of damnation baited with the pleasures of pride or of the senses, is no longer current. He is seen less as an active agent and more as an impersonal force – the fact of evil rather than the acts of the Devil. One might have thought this would enable designers to visualize his power in abstract forms, but the climate of thought today would make

64. *Images of Conflict*

Left: Samson and the Lion: stone roof bosses of the thirteenth and fourteenth centuries in Exeter Cathedral. Above: from a boss attributed to William of Montecute in the presbytery; the lively action should be compared with the later boss (below) which is in the nave and carved by Digon. The movement has been transferred from the figure of Samson to his undulating hair and the lion's wavy tail. A winged griffin is biting the lion and the scene appears as in a tableau.

Above: David and Goliath: from a carving on a thirteenth-century roof boss. The curious bent elbow is a period mannerism, compare with the carving of the Expulsion in Lincoln Cathedral on page 119.

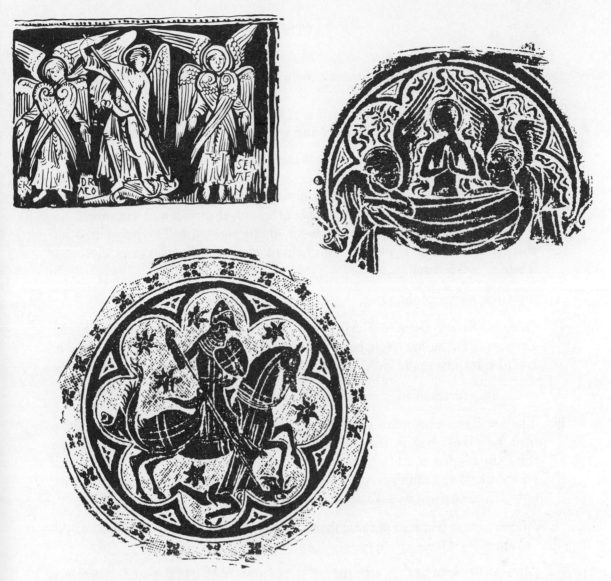

65. *Virtue Triumphant*

Top left: The Archangel Michael slaying a dragon between seraphim: detail from an eleventh-century silver reliquary, the Arca Santa in Orvieto Cathedral.

Right: A soul being carried up to Heaven by angels: from the medieval brass of Sir Hugh Hastings at Elsing in Norfolk.

Below: St George and the dragon: a roundel from the canopy of the tomb brass of Sir Hugh Hastings, who died in 1347. This elegant design is closely akin to the medieval seals with equestrian figures; the flowing horse trappings are drawn with delicate precision, and the dragon seems to be part man and part monster and certainly no match for the hero.

it hard to carry through such an image. Epstein's devil at Coventry is a poor match for his St Michael and Francis Bacon's nightmare images are outside the Christian tradition.

The distinguished nineteenth-century iconographer Napoleon Didron has much of interest to say about the nature and appearance of the Devil in Art:

Satan is alive wherever evil and suffering exist so that to write a complete history of the Devil we should deal with a great part of the history of the Universe; therefore we must confine ourselves to a certain limited treatment of the subject . . . Evil is either physical or moral, it gnaws and consumes the body or the soul of man, it demands his life or his virtue. The personification that has been made of evil through help of metaphor, concentrates these two kinds of evil in itself . . .

He gives the names of the Devil in the Western tradition as:

Dragon, Satan, Demon, Devil, Serpent, Asmodeus, Prince of the World, Zabulus . . . he has even been endowed with the glorious title Lucifer or Lightbearer just as the Greeks called their Furies the Eumenides or well doers.

From his description of representations these quotations are of interest:

The Devil was also endowed with the features of a lion, of a tiger, an eagle, a man, or a bull, to show that evil was angry as one, cruel as another, swift as a third, intelligent as a fourth, strong and indomitable as the last. Out of this combination and multiplicity of bizarre, heterogeneous, and impossible forms, a monstrous being was developed.

It is worth noting that four of these forms appear as the benevolent symbols of the four Evangelists. Of the visual imagery of Revelation Didron says:

Monstrosity is in fact the character of the Genius of Evil in the East. Therefore it is that in the Apocalypse which is a work altogether Eastern both in conception and execution, so much stress is laid upon the monstrous forms of its demons.

The dramatic manuscripts of the commentary on the Apocalypse made in Spain during the tenth and eleventh centuries also illustrate the imaginative sympathy between the Eastern author and the Western illuminators ten centuries later.

In addition to monstrous shapes the Devil of the Middle Ages was often depicted as a repulsive skeleton and came to be merged in the idea of Death,

although the skeletal representation of Death did not necessarily refer to the Devil. The Christian was concerned with life in this world and the continuing life of the soul in the next. Death was seen as part of the kingdom of the Devil. It was perhaps one of the deficiencies of medieval Christian iconography that its image of Death should be grotesque and terrible, as though death could come only as punishment for sinners and not in friendship, as the tranquil close of a strenuous life, and the gateway to a continuing spiritual illumination with Christ. The earlier art of the catacombs on the other hand breathes a classical dignity, the calm figure of the Orante, the emphasis on joyful Resurrection and the pictures on walls and gold-glass of the protagonists of salvation stories – such as Jonah, Daniel and Susannah – seem more balanced and genuinely Christian in outlook.

Beasts and Monsters

The strange animals from the East who also enriched the repertory of forms used by early Christian artists belonged to another tradition than that of the classical West.

As far back as Minoan times for example the savage griffin with his beaked eagle head, lion body and eagle's wings, exerted a compelling influence in the art and mythology of his homeland and in the Near East. In the absence of literary evidence we cannot know what supernatural force he represented to the Minoans, but the image of the griffin has been used on seals, bronzes, ivory-carvings, murals, textiles and decorative work for nearly four thousand years.

Some of the fabulous animals with Eastern origins may have represented power and authority rather than the blind forces of destiny or evil spirits. The lion is a case in point with a long and distinguished record of use in the art and crafts of many lands. In the Christian tradition he represents both the powers of good, with the wings of the symbol of St Mark, the first gospel-maker; and the powers of evil 'seeking whom he may devour'. In Romanesque cathedrals the lion guards the entrance and supports upon his crouching back the weight of the columns of the portal, as though he signified the weight of responsibility upon the holders of power. The carvers of the French Romanesque period have enshrined the most remarkable series of monsters, demons and fabulous beings in the whole history of Christian art. At hardly any time until our own have Western sculptors seemed so absorbed by tangible representations of the nightmarish. The imaginations of men

66. *The Faces of Evil* (left)

Two Devil Masks: stone corbels in the nave of Southwell Minster, probably early twelfth century. The expressions of gloom and disgust are forcefully rendered and underline the boredom one can imagine oppresses devils when not active in wrongdoing.

Centre: Early twelfth-century bronze door knocker from Durham Cathedral in the form of a demon-lion.

67. *Good and Evil* (opposite)

Top left: Romanesque Devil: carved stone capital of the twelfth century from the Abbey church of St Remi at Reims. The grotesque grimace is carved with all the linear vigour of the period. The emphasis on a mouth of jagged teeth is astonishingly close to paintings done by some schizophrenic patients today who have been encouraged to paint their fantasies as a healing therapy.

Right: St Michael and dragons: from the head of a thirteenth-century pastoral staff in Limoges enamels on copper in the Victoria and Albert Museum. St Michael is skilfully designed to fill the volute, while spearing one dragon in front he is being attacked in the rear by another and there are more round the knop and down the shaft.

Left: Head of Judas by Donald Potter in carved walnut, eighteen inches high. This pierced abstracted head with its mask-like quality has a sense of tragic power.

Centre: The Devil bound: from a carving on a Viking memorial stone at Kirby Stephen in Westmorland. The interlacing of Satan's bonds produces a compelling sense of restriction.

Below right: The Harrowing of Hell: from a medieval stone boss in the nave of Norwich Cathedral. This subject is less common in the Latin Church than in the Eastern Orthodox Church where it is shown as the rescue of Adam and Eve out of Limbo. The Dragon Mouth of Hell is typical in the West, especially in manuscript illuminations, and it can be a most effective visual formula for an otherwise difficult subject.

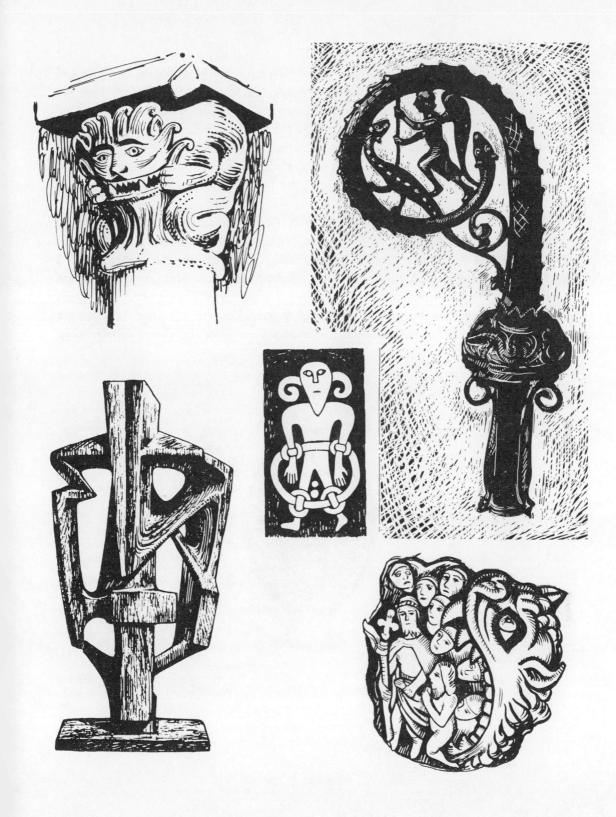

were awed by these demonic forces carved with such vigorous life on capitals and portals. The zest of the workmanship makes one think that they are less the terrible warnings they appear to be and more an actual expression of the artists' enjoyment in depicting violence, conflict and the grotesque. To take an example: the great marble lions and their agonized prey that carry the weight of the *pontile* in Modena Cathedral are instinct with a savage energy that outshines the vigour and strength of the Romanesque figures along the front of the *pontile* or those on the ambo.

The widespread use of exotic monsters in the decoration of churches during the early twelfth century led to the outspoken condemnation of no less a person than St Bernard of Clairvaux himself, whose seal, illustrated on this page, shows a hand brandishing an admonitory crozier. There is no doubt these vigorous forms add to one's sense of the dynamic quality of medieval Christianity. Too much emphasis on serene and peaceful images in ecclesiastical art may unwittingly devitalize the living image of the faith and remove it from the storm and stress of earthly life.

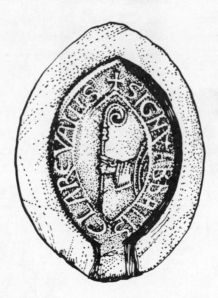

68. *Seal of St Bernard of Clairvaux* (Society of Antiquaries).

Forerunners and Followers

THE GOSPEL narratives laid stress on those events in the life of Christ which were said to be a fulfilling of prophecy. This view of his Messianic mission interpreted the main events in his life as having been foretold by the prophets of Jewish history and many events in that history were seen as symbolic parallels. The Gospels imply that Jesus himself saw aspects of his life as patterned in advance and foretold by the great seers of the Old Testament and say that he likened himself to Jonah and to the serpent raised by Moses in the wilderness to heal the sick. The Epistle to the Hebrews cites Old Testament texts to illustrate the author's homily on Christ the priest and king.

The Christian thinkers of the first centuries eagerly followed this trail of allegory and foreshadowing and Origen for example almost dissolved the literal words of Scripture into an exalted symbolism. The elaborate iconography of 'type' and 'anti-type' came into being. Devised in detail by theologians it was used by artists in the great scheme of decoration of churches that followed the Peace of the Church and the resulting uprush of Christian art. On the walls of the presbyterium in the sixth-century church of San Vitale the foreshadowing events in the life of Abraham are spaciously set out, opposite the companion symbolism of Abel and Melchizedek offering to God at their altars.

When St Benedict Biscop returned from his many journeys to Rome in the seventh century, he brought to his monasteries at Wearmouth and Jarrow artwork and pictures to hang in the churches and the Venerable Bede says they were placed so that a scene from the New Testament was opposite the parallel scene from the Old.

The most dramatic expression of the concept of the Forerunners in Christian art are the stained glass windows and the sculptured portals of medieval France. Even before the twelfth century the patterns of allegory had been firmly established by writers and preachers and incorporated into a grand iconographical plan. Chartres with its vast sculptured and windowed population of Forerunners and Followers is an excellent example to study, so too are the windows of Bourges and the cathedrals of Amiens and Reims.

It is difficult for us today to accept this view of history, our scepticism makes it seem impossible for the living artist to use these allegories in a way significant for our own generation. In medieval times the presence in a church of the painted and sculpted patriarchs and prophets added to the weight and dignity of the whole Christian faith. In those days the appeal to tradition and to authority was one of the most potent of all references; the concept of these heroes pointing forward from their remote antiquity to the future Messiah was held to be wholly convincing. One of the stained glass windows in Chartres given by Peter of Dreux shows the Evangelists riding on the shoulders of Isaiah, Jeremiah, Ezekiel and Daniel to illustrate that the men of the remote past supported the Gospel makers who in their turn illuminated the generations coming after. We spend much time and skilled manpower nowadays on digging up the physical past of old cultures and this pursuit of history is popular with young people. The fascinating archaeology of religious and spiritual ideas which can be discovered from the art and literature of the past unfortunately remains a more limited interest.

Prophets and Patriarchs

In the early books of the Old Testament it is the voice of Jehovah foretelling great events that established the authority of prophetic knowledge; such as the warning to Noah of the Deluge to come. In later books this supernatural foreknowledge of

69. *Forerunners.*

Top left: Adam and Eve: from the Albani Psalter in the Library of St Godehard at Hildesheim. The decorative miniature is in tones of deep blue, green and cold rose. It was made at St Albans in the twelfth century.

Below left: *The Tree of Jesse.* Drawing from a boss in the thirteenth-century Angel Quire at Lincoln. The design flows from the figure of Jesse lying at the bottom, the tree springing from his waist and dividing into two stems to frame the regal figure of David with the great harp upon his knees. Two forebears holding scrolls are emerging from the leafage on either side of King David. C. J. P. Cave says of these bosses: 'To my way of thinking they surpass all the figures that preceded them and they were never surpassed in later work.'

Right: The figure of Daniel is drawn from one of the five twelfth-century windows of the prophets in Augsburg Cathedral; each prophet carries the usual scroll inscribed from his work.

[156]

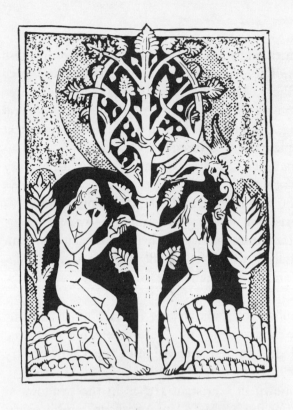

events is mediated through chosen men and women. It is Deborah the prophetess who foretells the downfall of Sisera. The major exponents of this dramatic fore-knowledge are Samuel, Elijah and Elisha. Their visions may take the form of pre-cognition-seeing exact events such as the dreadful death of Jezebel; or a general certainty of retribution for evil doing. Sometimes the grief of his prevision almost overwhelms the prophet as in the Lamentations of Jeremiah.

Of the three Major Prophets Isaiah, the first, was writing in the eighth century BC. His prophecies, expressed in unforgettable poetic imagery, influenced the Jews in their expectation of a Messiah who would come from the house of David.

Jeremiah, who followed Isaiah, was born about 650 BC, and in his writings on the New Covenant is held to illuminate the future quality of Christian life and thought, and his mourning for doomed Jerusalem, which fell in 586 BC, was seen to fore-shadow Christ's own lament for Jerusalem which was to be destroyed by the Romans in AD 70.

Ezekiel, the third of the Major Prophets, was writing in Babylon during the Exile after he had been carried away captive in 597 BC. He 'wrote as one overawed with the majesty and holiness of God.' His dramatic vision of the Valley of Dry Bones is an image of Resurrection.

The figure of Daniel is often shown in Christian art, as in the windows at Augsburg, as if he were a prophet, but the book of Daniel with its graphic salva-tion stories is not prophetic in the true sense and was assigned by the Jews to the Hagiographa.

Patriarchs is the name given to the antediluvian fathers such as Noah and particularly to Abraham, Isaac, Jacob and the twelve sons of Jacob who stand for the twelve tribes of Israel. David is described in Acts as patriarch and prophet and both the words may be used in a wide ranging sense. In the early mosaic schemes of decoration the figures of prophets and patriarchs were included to emphasize their role of forerunners. The Gothic artists carefully distinguished the patriarchs by differences of insignia or emblems, whereas the figures of the prophets were often rendered from similar cartoons and were only identified by the scrolls with quota-tions from their writings. By the sixth century the term Patriarch had become an ecclesiastical title for the bishops of the five Sees of Christendom: Rome, Alexan-dria, Antioch, Constantinople and Jerusalem and is in use today in the Eastern Church.

The Tree of Jesse

The symbolism of the Jesse tree is based on the renowned prophecy of Isaiah quoted from the Authorized Version: 'And there shall come forth a rod out of the root of Jesse, and a flower shall rise up out of his root. And the Spirit of the Lord shall rest upon him: the spirit of wisdom, and of understanding, the spirit of counsel, and of fortitude, the spirit of knowledge, and of godliness.' The rod was taken to represent the Virgin Mary and the flower to stand for Jesus himself.

The Tree of Jesse was a standard subject in medieval art and examples survive in carvings, manuscripts and stained glass, of which one of the most splendid is the Jesse window in Chartres cathedral. The medieval designer usually combined this prophecy with a visual form of the genealogy of the descent of Jesus from the royal line of David, which opens St Matthew's Gospel and which is recited on Christmas Day. The genealogical tree is usually represented as a luxuriant vine springing from the recumbent figure of Jesse, the father of David. The curling branches of the tree may end in vine leaves or formal foliage designed to frame a varying number of those prophets who proclaimed the coming of the Messiah and the kings of Judah of the line of David; 'the ancestors after the spirit and after the flesh' as described by Emile Mâle. Near the apex of the design the Virgin is shown holding the Holy Child; or she may appear singly, while above her is the figure of Jesus with the descending dove of the Holy Spirit; or he may be depicted encircled by the seven doves representing all Seven Gifts of the Spirit.

St John the Baptist

John is the great forerunner of Jesus Christ and heralds his coming by preaching repentance. He bridges the world of Old Testament prophets and the New Testament of the Incarnation. His recognition of the mission of Jesus preceded the baptism in Jordan which marked the beginning of Christ's ministry. John thus became the initiator of the sacrament of baptism in the Christian church and the follower in spirit of Jesus. He was beheaded at the instigation of Herod's revengeful wife, Herodias and her daughter Salome. The notorious scene of his death, with his head on a charger, has often been used in art.

John has become one of the most popular of all saints and patron of many trades and crafts concerned with wool, leather and tools.

70. *Patriarchs and Prophets*

This double page illustrates the medieval belief that the heroes of the Old Testament foreshadowed the sacrificial role of Christ. On the extreme left are Abraham and his son Isaac drawn from the thirteenth-century sculpture on the North Portal at Chartres; on the extreme right is St John the Baptist from the same portal. Next to them are

drawings from the dignified series of mosaics of the Old Testament prophets in St Marks, made in the same century.

Below are two recumbent figures with foliage. The carved patriarch on the left gazes across the great nave of Tewkesbury Abbey to the nude enchantress on the opposite corbel. Who is he, David perhaps?

[161]

71. *St Gregory the Great*: From a fourteenth-century mosaic in the Baptistery in St Mark's in Venice: which lovingly depicts the tools of the calligrapher. Gregory was elected Pope in 590 during a time of disorder and invasions and steered a difficult course with administrative wisdom and firmness. He has been called the Father of the medieval Papacy. After seeing the angelic blond Anglo-Saxons for sale in the slave markets of Rome he sent St Augustine with a team of missionaries to convert the English. He was a prolific author and letter writer and is famed for instigating the Gregorian chant; and for his profound description of himself while Pope as 'The servant of the servants of God'.

72. *Warrior Saints* (opposite)
Top left: St Michael and the Dragon, with the Dextera Dei and the Agnus Dei, from the early Norman tympanum at Hoveringham, showing strong Scandinavian influence in the dynamic linear rhythms of the main dragon and its convoluted subsidiary dragon-tail. 'Their tails are like serpents, with heads . . .' (*Revelation* ix.19).

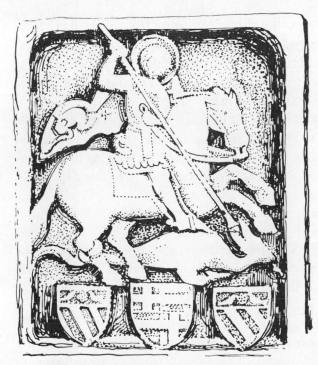

Bottom left: St George and the Dragon from the fifteen-century carved marble slab at Bodrum in Turkey. This traditional version of the saint shows him very well mounted, with flying cloak and diagonal lance delivering the coup-de-grace to the defeated dragon.

Right: St Theodore and the Dragon, from a painted ikon in St Catharine's monastery in Sinai. The saint is inspired by an angel and carries a cross-headed lance to pierce the serpent dragon. His apprehensive horse wears an amulet in the form of a cross – an early horse-brass perhaps.

He is usually depicted clad in a rough garment of camel hair and bearing a disc with a Lamb and a scroll with the words: *Ecce Agnus Dei*, 'Behold the Lamb of God'. He also carries a long cross-headed staff. In the art of the Greek Church St John Baptist may be shown with great wings since the Church translates literally the Old Testament text from Malachi: 'Behold, I will send my messenger and he shall prepare the way before me.' In this context the word messenger meant 'angel'.

Saints: *The Followers of Christ*

The first saints of Christendom were the disciples, called from their daily tasks to be the companions of the ministry of Jesus. At first they were puzzled and obtuse but gradually grew in perception and understanding, until, after the Passion and the illumination of Pentecost these ordinary working men became figures of power, faith and eventually, according to tradition, of martyrdom.

Closely associated with the Apostles were St Paul, an Apostle but not one of the disciples, and those two of the Evangelists, St Luke and St Mark who were not among the twelve chosen by Jesus. St Paul is the instigator of the idea of saints as being all those 'in Christ'. Later on the term 'Saint' came to have more exclusive meanings.

The sainted martyrs of the early persecutions were prized by the faithful as believers possessed by supernatural courage to suffer torture and humiliating death rather than betray their faith. This magnetic courage attracted others to the Christian way of life. The genuine reverence accorded to the place of martyrdom and the martyrs own tomb, began the cult which was to increase in popularity almost to idolatry until its zenith in the Middle Ages.

The martyrs were held to have qualified for the status of saint by virtue of a brave death for the faith. Other later individuals achieved this dignity in a slower variety of ways; by being men of ascetic holiness such as St Jerome; men of exceptional wisdom such as St John Chrysostom; or men of spiritual power and efficiency such as St Gregory the Great. Then there were those tireless missionaries who spread the gospel such as St Patrick and St Columba; those who truly lived the Christian life such as St Francis of Assisi, and those who encouraged the founding of religious Orders and the preservation of learning, such as St Benedict and St Bernard. Ordinary people of outstanding Christian quality could also become

saintly exemplars to humbler folk. Historically, the Saints divide into two further groups: firstly, the legendary characters whose romantic stories were edifying adventure tales for the illiterate and became desirable patterns for aspiration, such as St George, or a talisman for timid travellers such as St Christopher; secondly, true stories of exceptional human beings such as St Augustine of Hippo, St Clare of Assisi, St Joan of Arc and the great mystic – St Teresa of Avila. There are many books about saints, their lives, their emblems and their attributes and here we can touch but slightly on this 'great cloud of witnesses'.

The emblems of saints may be thought of as their recognition signs in art. In medieval works in series such as stained glass windows, the very similar figures, made perhaps from the same working drawings, can be identified by the objects or animals that have become their attributes. On page 166 is a sketch from a sixth-century mosaic of St Agnes with her lamb, one of a row of almost identical martyrs, she is said to be the first of any saint to have a pictorial emblem.

The cult of saints and their relics continued to increase in popularity until the early Middle Ages by which time its pristine innocent reverence had become an overemphasis on the sanctity of relics leading to superstitious miracle-mongering and credulity. The peoples' pilgrimages to the famed shrines of Christendom were the 'package trips' of the period. These were encouraged by the Church and greatly increased the income of those foundations with the tombs of martyrs and especially esteemed saintly relics. The layout and design of cathedrals was influenced by the need to plan for throngs of pilgrims to the shrines. The reaction against the cult of relics was one of the forces which engendered the Reformation.

Although it is of interest to sightseers today to understand the imagery of old churches, it might well be asked what part the depiction of saints and the lore of their emblems could have in the decoration of new churches. Their imagined presence is still a visual way of expressing the long tradition of the faith, 'the Communion of Saints' in fact. They are also a witness to the power of faith, a benison of holiness and a depth of experience. On another level they are a form of decoration which is relevant and non-controversial; an opportunity for varied colour and texture and for the work of craftsmen to enrich the building. The design of the figures may be stately and formal or full of lively movement. They may be rendered in engraved or stained glass, in glass mosaic, ceramic, embroidered on furnishings or the banners of patron saints; in new churches modern materials such as perspex, fibreglass, aluminium may be used with skill, wit and imagination to enhance the quality of the interior.

The figures of the patron saints of trades, guilds and craftsmen associated with

† SC͞A AGNES

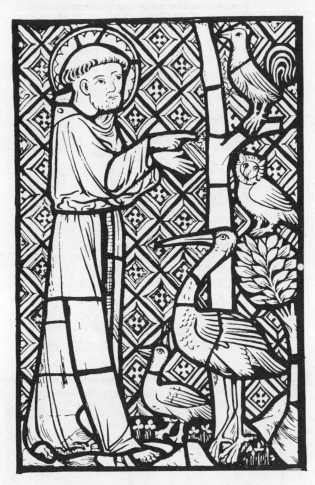

73. *Saints with their Emblems* (opposite)

Top left: St Peter with his Keys. From the mosaic in the dome of the sixth-century Arian baptistry in Ravenna.

Below left: St Ludger with his Church, from a woodcarving in the Friedensaal at Munster. This missionary saint worked under Charlemagne to evangelize the Saxons.

Right: St Agnes and her Lamb. From the sixth-century mosaic in Sant' Apollinare Nuovo, Ravenna. She is said to be the first of the saints to have an emblem.

74. *Aspects of Saintliness*

St Francis preaching to the birds: a detail from the fine series of fourteenth-century stained glass windows in the church of Koenigsfelden in Switzerland.

Stylite Saints. St Simeon was the first of the eastern ascetics to live on top of a pillar. This drawing is from a medieval mosaic in St Mark's, Venice, of Saint Alipio, a later stylite.

[167]

S. HI LAR ION.

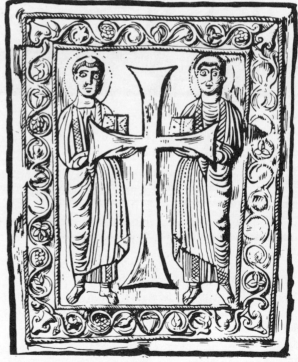

75. *Static and Ecstatic*

Left: St Hilarion: from a thirteenth century mosaic in St Mark's. The saint was a hermit in Palestine. The orans gesture is one of the most satisfying representations of prayer in art as in life.

Right: St Francis receiving the Stigmata: from the fourteenth century stained glass window at Koenigsfelden. The same gesture represents the awe of the saint before the vision of the Seraph.

Below: Two Apostles supporting a Cross: from a silver book cover in the sharp Syrian style of the sixth century; now in the Metropolitan Museum, New York.

76. *Holders and Upholders*

Left: St Philip, St Jude and St Bartholomew: from a twelfth-century Catalan carving now in the Victoria and Albert Museum. The characteristic Catalan sense of pattern transforms a simple group into a decorative whole.

Right: St Christopher: from the medieval stone carving on the outer wall of St Mark's.

Below left: Arms assigned to St James of Compostella: the long association of scallop shells with St James the Greater naturally finds expression in his armorial bearings. St Margaret of Antioch: the saint was reputed to have survived being swallowed by Satan and became by remote allusion the patron saint of women in childbirth.

[169]

the church may be a suitable choice of subject; as may local or regional saints. In the Anglican cathedral at Liverpool there are huge modern stained glass windows which among other subjects show famous Bishops of the Church; others are planned to depict parsons, musicians and scholars. A modern window to St Thomas of Canterbury by Moira Forsyth in the little Kentish town of Snodland is shown on Plate 28. This church also has an unusually full series of windows of the actual emblems of Saints designed by Hugh Easton.

The Apostles and their Emblems

The Apostles were the forerunners of the whole Christian Church. In the earliest works they were represented as sheep standing six on either side of Christ the Good Shepherd, the Agnus Dei, or the Throne. When they were depicted collectively in mosaics such as in the Baptisteries at Ravenna they carry crowns or scrolls and wear a nimbus; identifying names may be written beside each figure. In later medieval art the apostles came to be distinguished by their emblems:

St Peter the leader of the apostles, was a fisherman of Galilee, called to follow Christ and be a 'fisher of men'. Jesus gave him the title meaning 'rock' and said to him 'Thou art Peter, and upon this rock I will build my church', and conferred on him 'the keys of the kingdom of Heaven'. Peter was held to have been martyred upside down. The earliest surviving depictions show him as a stocky figure with white hair and a short white beard and large eyes; this version became established by tradition. His emblem is the crossed keys and more rarely an inverted cross.

St Andrew was another Galilean fisherman; the patron saint of Russia and of Scotland. His emblem is a cross saltire upon which it is said he was crucified.

St James the Greater was also a fisherman. He was the brother of St John, both were sons of Zebedee. He is to be distinguished from James the Less, the other disciple of the same name. With Peter and John he was chosen by Christ to witness the Transfiguration and the Agony in the Garden. In art he is usually depicted as a pilgrim and the 'scallop shell of quiet' became an emblem of pilgrimage in general and a badge of St James of Compostella in particular. He was the patron saint of Spain and of all travellers – especially to the Holy Land and his own enormously popular shrine in the great cathedral at Compostella.

St John the Evangelist was called the Divine, meaning the Theologian. He too was a Galilean fisherman and he and his brother James were known as 'sons of thunder'. Tradition has identified him as the disciple 'whom Jesus loved' and who leaned on his Master's breast at the Last Supper and to whom Jesus at the Crucifixion confided the care of his Mother; it was he who ran first to the tomb on the morning of the Resurrection, and he was the first to recognize the Risen Christ by the sea of Tiberias. His symbol as an Evangelist is an eagle with the Book and his own emblem a chalice with a snake emerging. In art he is depicted as the youngest and most physically beautiful of the Apostles. In old age he went to Ephesus and tradition says both he and the Virgin Mary lived there. He is credited with the authorship of the book of Revelation written on Patmos but this attribution has been questioned even by a writer as early as Dionysius of Alexandria, who died in 264.

St Philip came from Bethsaida and brought Nathaniel to Christ. Tradition says he preached in Phrygia and died in Hierapolis, the modern Pammukale in Turkey, still frequented for its healing springs. His emblem is a cross *botonny* flanked by two roundels.

St Bartholomew. His emblem is a butcher's knife commemorating his traditional martyrdom by being flayed alive. He may be the same person as Nathaniel, but nothing is recorded as certain.

St Thomas is called Didymus meaning twin; and in later literature is called Doubting Thomas referring to his first incredulity at the reports of Christ's Resurrection. When he did see him he cried 'My Lord and my God'. Strong traditions link him with the evangelizing of South India. His emblems are a spear and a carpenter's square.

St Matthew the Evangelist was a tax collector for the Roman occupation forces and was 'called' by Christ in Capernaum. He was also named Levi by Mark and Luke and is traditionally the author of the first Gospel. His symbol as an Evangelist is the man with wings and in art this is obviously difficult to distinguish from an ordinary angel figure. His emblem is money-bags.

St James the Less, son of Alphaeus. It has been said that he is the same person as James 'the Lord's brother' who looked after the early Christian group at Jerusalem and according to Josephus was there stoned to death. The author of the Epistle of St James may be the same person. His emblems are a saw and a fuller's club.

St Jude is also known as Thaddeus or Lebbaeus and tradition says he was the brother of James and perhaps the writer of the Epistle of St Jude. His emblem is a sailing ship signifying the Church whose message he spread on his missionary journeys. He is revered as an intercessor in times of extreme stress.

St Simon the Zealot; also called the Canaanean. His emblems are a fish and a book, as he was thought to be a great evangelizer.

St Matthias. After the Ascension lots were drawn to see who should fill the place of Judas Iscariot and Matthias was chosen. His emblems are an axe and an open book.

St Paul was called the Apostle to the Gentiles. He was not one of the early disciples of Jesus and began his association with Christians by persecuting them. An overwhelming vision of Christ on the road to Damascus converted him to becoming an ardent missionary to the Gentiles. His activities are graphically described in Acts and in his letters; his noble mind and exalted spirit helped to mould the organization and development of the growing Church. His emblems are the sword of his martyrdom and the Book of the Teacher. His appearance in art was established early as a shortish figure with a high balding forehead and long pointed beard, in contrast to St Peter with whom he often appears. Tradition says that they may have been martyred on the very same day in Rome, during the persecutions of Nero about AD 64.

A mosaic frieze of the Apostles robed in white and carrying their emblems, with their names in emphatic letters, circles the golden apse at Torcello, dated from the early twelfth century.

The Four Living Creatures

Symbols of the Evangelists

THE LIVING CREATURES which come to St John by way of the vivid imagining of Ezekiel are especially dear to artists, and have been so from early times until our own. Not only do they signify the Evangelists, but the quadruple animal, bird and human shapes combined with the wings of spiritual power, have not failed to fire the minds of designers in all the arts.

The four related but differing forms contrast with each other; the pride of the winged lion, the strength of the winged ox, the nobility of the eagle and the human dignity of the man-become-angel; all give variety within their common relationship. The graphic qualities of wings and forms, of gesture and movement, naturally appeal to artists seeking to express the dynamism of the Gospel message.

The four living creatures which have come to symbolize the four evangelists have two sources of inspiration. The first, from the prophet Ezekiel in the Old Testament, describes them:

> As I looked, behold, a stormy wind came out of the north, and a great cloud, with brightness round about it, and fire flashing forth continually, and in the midst of the fire, as it were gleaming bronze. And from the midst of it came the likeness of four living creatures. And this was their appearance; they had the form of men, but each had four faces, and each of them had four wings. Their legs were straight, and the soles of their feet were like the sole of a calf's foot; and they sparkled like burnished bronze. Under their wings on their four sides they had human hands. And the four had their faces and their wings thus: their wings touched one another; they went every one straight forward, without turning as they went. As for the likeness of their faces, each had the face of a man in front, the four had the face of a lion on the right side, the four had the face of an ox on the left side, and the four had the face of an eagle at the back. (*Ezekiel* i.4–10.)

The other Biblical source has been the more influential in Western art and comes from that strange poetical vision known as the Revelation of St John. The

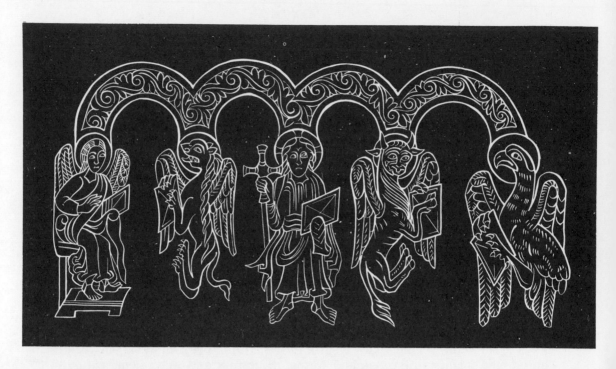

77. Christ in the centre of the Symbols of the Four Evangelists: detail from the eighth-century Canon Table illumination in the Evangelistary of Flavigny, now in the Bibliothèque Municipale at Autun.

78. *The Throne of St Mark in Venice* (after Garucci)

This carved marble cathedra is said to have come from Alexandria where traditionally St Mark had been Bishop, and to have been given by the Emperor Heraclius to the Bishop of Grado in the seventh century, when it may already have been antique. It is perhaps one of the earlier complete versions of the symbolic use of the Living Creatures. The low relief carvings blend Egyptian and classical mannerisms and are full of interest for designers and iconographers. The inside of the back of the chair shows the Lamb standing beneath the Tree of Life upon a hill from which flow four streams of Living Water, resembling roots of the Tree. On the sides and rear of the Throne the symbols of the Evangelists are displayed within rosettes of six wings against a powdering of stars, with palm trees and angels with trumpets. The wheelhead shows a pair of Evangelists on each side, carrying books and supporting a cross. The plaster copy in Grado Cathedral is easier to see and study than the original Throne which is now in the crowded Treasury of St Mark's.

[174]

The Throne of St Mark

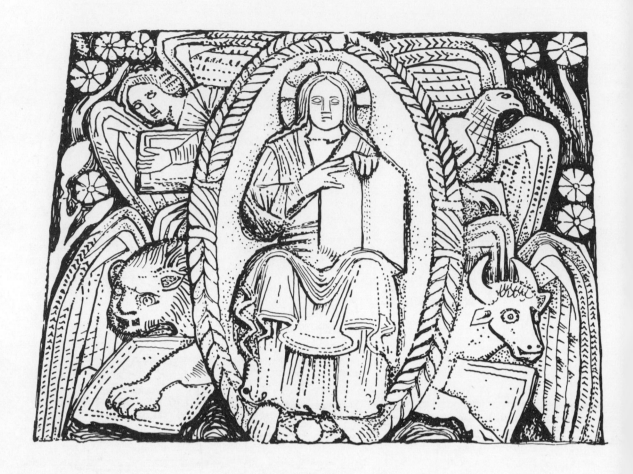

79. *Christ in Glory*: From the carving at the head of a grand seventh-century tomb at Jouarre. This tomb is reputed to be that of Agilbert, a distinguished Frankish ecclesiastic who became a bishop of England before returning to his native France. The design of this panel has unusual features: the four Living Creatures face outwards from the beardless Christ in a wreathed mandorla, flanked by long-stemmed starry flowers.

80. *The Symbol of St Matthew: the Man with Wings*

Left: From a Romanesque carving on an archway in San Leonardo di Siponto in Italy.

Right: From a thirteenth-century carved keystone in Magdeburg Cathedral.

Below: Emblems of St Matthew and St Mark, from one of the modern bronze fibre-glass panels in the main doors of Liverpool Roman Catholic Cathedral.

pictorial images and ideas from that work exerted a remarkable power in the Middle Ages over the conceptions of theologians and artists alike.

At once I was in the Spirit, and lo, a throne stood in heaven, with one seated on the throne: and he who sat there appeared like jasper and carnelian, and round the throne was a rainbow that looked like an emerald. Round the throne were twenty-four thrones, and seated on the thrones were twenty-four elders, clad in white garments, with golden crowns upon their heads. From the throne issue flashes of lightning, and voices and peals of thunder, and before the throne burn seven torches of fire, which are the seven spirits of God; and before the throne there is as it were a sea of glass, like crystal.

And round the throne, on each side of the throne, are four living creatures, full of eyes in front and behind: the first living creature like a lion, the second living creature like an ox, the third living creature with the face of a man, and the fourth living creature like a flying eagle. And the four living creatures, each of them with six wings, are full of eyes all round and within, and day and night they never cease to sing,

'Holy, holy, holy, is the Lord God Almighty,
who was and is and is to come!' (*Revelation* iv.2–8)

The way these symbols came to be represented in art obviously varies according to the source from which the description is taken.

The concept of celestial winged creatures, partly human or partly animal, was widely current in the religions of the Near East, the sphinx and the griffin being perhaps the most well known of many forms.

The Prophet Ezekiel would have been influenced by the composite winged animals in the monumental art of Assyria seen during his exile in the land of the Chaldeans. His description of the Living Creatures is difficult to interpret satisfactorily in the visual arts; his tetramorph has four faces, four wings, two hands and two feet. In the Rabbula Codex of the sixth century the tetramorph is depicted as a winged chariot bearing Christ at the Ascension. In the Christian East the version of Ezekiel seems to have been preferred in art, but the symbolism never became widespread. It is not surprising that the simpler version of St John has had a greater influence in the art of the West, in which the use of the symbols of the Evangelists became increasingly popular.

Early Christian thought delighted in finding types in the Old Testament to illustrate the doctrine of the new faith and in keeping with this habit of mind the fathers, particularly St Jerome, interpreted St John's living creatures as the

symbolic personifications of the four Gospel-makers. St Matthew, who began his gospel with the human ancestry of Christ, came to be signified by the face of the man. The lion signifies St Mark, the voice of the lion roaring in the desert – 'Prepare ye the way of the Lord'. St Luke, who began his gospel with Zacharius the priest at the altar, is figured by the sacrificial animal, the ox or calf. St John, the messenger of the Word of God, is fitly represented by the soaring eagle. Medieval commentators searching for satisfying parallels discovered other interpretations; such as the Man for Christ's Humanity and Incarnation, the Ox for his Sacrifice, the Lion for his Resurrection and the Eagle for his Divinity and Ascension. To the medieval mind, the eagle was considered the king of fowls, the lion the king of beasts, the ox the king of domestic animals and man the king of the visible world; they all attend upon Christ who is the King of all things visible and invisible.

It took time for these attributions to become firmly established but even after the tradition had crystallized the actual placing of the four creatures varied, those of St Matthew and St John being generally placed at the top of the composition and the lion and the ox below them. The right hand and left hand arrangement remains flexible.

In most of the early representations of the Living Creatures as symbols they are shown as winged heads or half figures. The huge depictions in the early mosaics in Rome and Ravenna show them as dream creatures of supernatural power floating on celestial clouds. Another and less common version renders the creatures with animal heads poised on human bodies and holding books in human hands. This bizarre conception recalls the gods of ancient Egypt, illustrated on page 61. The ornamental but naïve design of the creatures flanking the cross from the eighth century altar of Sigvald, now in the baptistery at Cividale, drawn on page 185, shows them in the guise of hippocampi holding explanatory inscriptions. A drawing of part of the tympanum at Moissac on page 82 shows the tightly knit design of the forms and the greater realism of their conception. In the West the Living Creatures are usually haloed and almost invariably carry scrolls or books. They appear in most forms of art: mosaics, frescoes, carvings, stained glass, manuscripts, ivory and precious metals. On the carved tympana of the Romanesque cathedrals of France they reached perhaps their noblest expression; inspired by the Apocalyptic vision of St John they accompany their Lord in attitudes of ecstatic adoration and yearning and they flank the mandorla of Christ in Majesty coming to judge the world. The same iconography is followed on a much smaller scale, but with equal dignity, in manuscript illumination, enamels and enriched Gospel bookcovers, on the latter the symbols were obviously particularly appropriate. More rarely in the

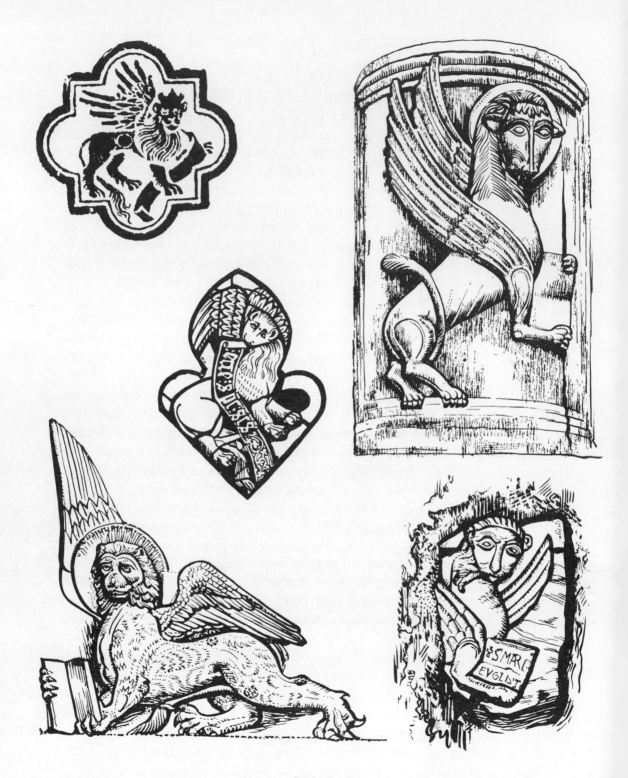

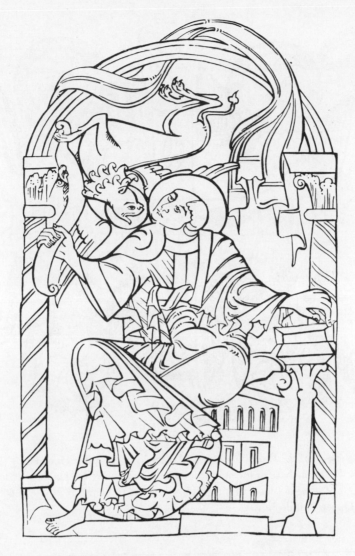

81. *The Symbol of St Mark: the Winged Lion* (opposite)

Top left: From the Chichele brass, late fourteenth century, at Higham Ferrers.

Top right: From a stone panel on the medieval pulpit in Grado Cathedral.

Centre: From a fourteenth-century stained glass window in Norwich Cathedral. The scroll shows the words *Ecce Spiritus Sanctus* in abbreviated form.

Below left: Carving from the bottom angle of the Rose window in the Romanesque Cathedral of Spoleto. The sculptor has enjoyed rendering textured fur and feathers.

Below right: From a damaged stone slab of the sixth or seventh century in the museum at Ravenna.

82. *St Mark* (above): From an eleventh-century Gospel painted at Corbie, now in the Bibliothèque Municipale at Amiens. The diagonal lines of the design and the fluttering drapery add a sense of urgency to the divine inspiration being imparted to the Evangelist by his apocalyptic symbol.

83. *The Symbols of the Four Evangelists*: Arranged in the angles formed by the arms of the cross. From the base of the sumptuous reliquary known as the 'Caja de las Agatas', on account of its agate decoration, which was given to Oviedo Cathedral by Fruela II and his Queen Nunilo in 910.

84. *The Symbol of St Luke: The Winged Ox or Calf* (opposite)

Top left: From the eighth-century Book of Kells in Trinity College Library, Dublin.

Top right: From a line drawing in the eighth-century Chad Gospels, Lichfield Cathedral.

Below left: From a high-relief carving on the medieval ambo in Grado Cathedral.

Centre right: One of four corner panels from a medieval brass at Higham Ferrers.

Below right: From the bible of William of St Carilef, eleventh century, Durham Cathedral Library.

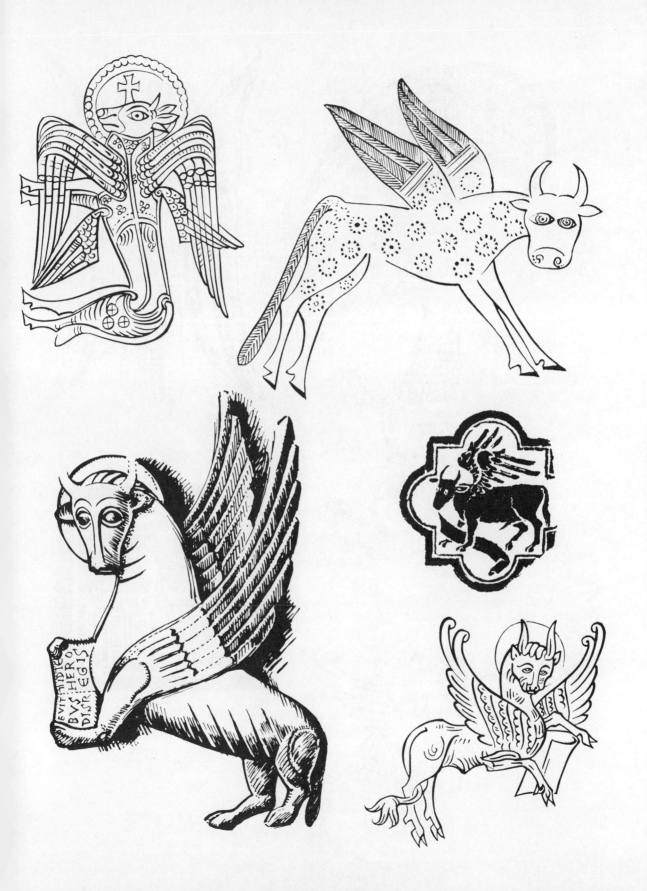

85. *The Symbol of St John: the Winged Eagle* (opposite)

Top left: Detail from a tenth-century Beatus manuscript in Madrid.

Top right: From the eighth-century manuscript book of Dimma in Trinity College, Dublin.

Centre left: From the '*imago Aquilae*' miniature in an early Gospel book at Corpus Christi College, Cambridge.

Right: Modern brass by Francis Cooper: detail from Bishop Trollope's memorial in Seoul Cathedral.

Below left: From the eleventh-century Carilef bible in Durham Cathedral Library.

86. *Symbols of the Evangelists* (above): From a low-relief Lombard carving in cream marble, now part of the eight-sided baptismal font of Callistus in the Baptistery at Cividale. According to the inscription it was a gift from the patriarch Sigvald in the eighth century. The panel is simply carved with little modelling but a strong sense of pattern. The four Evangelists are represented as half-figures derived from hippocampi, winged and without haloes, grasping their Gospel books with minuscule arms. Formal trees and pillars flank the cross while below, magical beasts confront the Tree of Life.

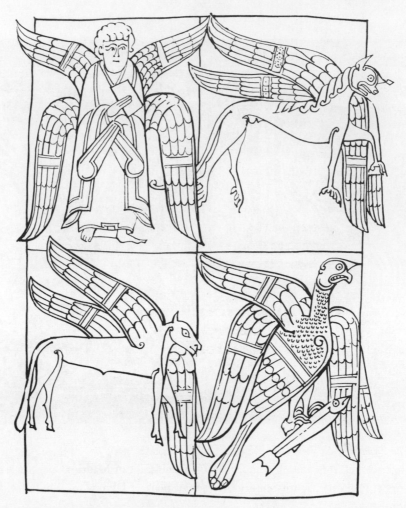

87. *Symbols of the four Evangelists* each with four wings; after the drawing in the ninth-century Book of Armagh in Trinity College, Dublin. The Celtic imagination has produced exceptionally powerful images of the Living Creatures in Gospel manuscripts, combining characteristic linear vitality with solemnity and grandeur equal to the verbal descriptions in St John's Revelation.

88. *Contrasting Styles* (opposite)

Top left: The Ox of St Luke: from a carving on an eighth-century screen panel on the font in the Baptistery at Cividale. Top right: The Eagle of St John: from the eighth-century Book of Kells. Centre left: Adaptation from the carved eagle on the sixth-century pulpit at Grado; the carvings are said to be medieval. Right: St Mark's lion from the seventh-century Irish manuscript Book of Durrow in Trinity College Library, Dublin. Below left: The eagle of St John from the eighth-century Echternach Gospels in the Bibliothèque Nationale in Paris. Below right: The eagle of St John from a panel at Cividale.

West the Creatures may be depicted turning outward from the figure of Christ, as on the seventh-century tomb of Agilbert at Jouarre in France, drawn on page 176 and thought to have been influenced by artists from the eastern Mediterranean, possibly fugitives from the Arab conquest.

In the frontispiece drawn for this book the Evangelists in human form are pictured writing at their desks accompanied and inspired by their symbolic creature. In the Lindisfarne Gospels of AD 700 the Living Creatures of St Matthew and St Mark are shown blowing horns to proclaim the good news. On page 181 a drawing from an eleventh-century manuscript painted at Corbie, shows the lion in a rushing ecstasy of communication with St Mark who is in the throes of composition.

To many people the use of these ancient symbols in new churches must appear irrelevant. But in all the fourteen centuries or so since the traditional link was forged between the Living Creatures of Revelation and the four Gospel Makers, there has been no comparable equivalent devised to replace their use as the essential symbols for the Evangelists and their Gospels, through whom the message of Jesus is carried out into the world.

It is perplexing to choose examples for comment from among the modern uses of these symbols. Two striking versions can be seen at Coventry Cathedral; one is on the mosaic floor of the Chapel of Unity designed by the Swedish artist Einar Forseth and carried out in coloured marbles. The other version can be seen spaced around the giant figure of Christ in the tapestry above the High Altar, which was designed by Graham Sutherland and completed in 1961. His creatures exhibit a characteristic gnarled anguish; their vitality is undeniable but this agitated conception conveys little of the dignity and power proper to the symbols of the inspired Evangelists.

Other modern interpretations can be seen in the Trinity tapestry in Chichester Cathedral, on the fibreglass doors of Liverpool Roman Catholic Cathedral and round the metal sculpture of Christ in Glory at Llandaff in the Theological College.

Benedicite Omnia Opera

O All ye Works of the Lord, bless ye the Lord : praise him, and magnify him for ever.

THE WRITER of the book of Daniel gave this song of praise to the Three Holy Children as they stood in the fiery furnace before King Nebuchadnezzar, and it has been sung since by centuries of Christians. The poetic sixteenth-century translation by Miles Coverdale is quoted here.

The Jewish poet of *Benedicite* saw the whole of Creation existing in terms of a symphony of praise to its Creator and all forms of his creation as relevant to praise God. The men of the twelfth and thirteenth centuries, also an age of faith, saw the world of nature as a mirror of the Divine. Emile Mâle writes:

In the art of the Middle Ages, as we see, everything depicted is informed by a quickening spirit. Such a conception of art implies a profoundly idealistic view of the scheme of the universe, and the conviction that both history and nature must be regarded as vast symbols . . . Further, it should be remembered that such ideas were not the property of the great thirteenth-century doctors alone, but were shared by the mass of people to whom they had permeated through the teaching of the Church. The symbolism of the church services familiarized the faithful with the symbolism of art. Christian liturgy like Christian art is endless symbolism, both are manifestations of the same genius.

89. *'Bright shoots of everlastingness'*
Trefoil crosses growing from a scroll over the arch of a ninth-century ciborium at Cavaillon Vaucluse. (After R. de Fleury.) Each side of the arch the scroll blossoms into eight little crosses; eight being the number of resurrection and renewal.

All the known works of God found a place in the enrichment of buildings for Christian worship. Until the Reformation, animals, plants, birds and fish abounded in mosaics and carvings and were used endlessly as symbols, emblems and appropriate decoration. In this section we aim to illustrate a small part of the variety of this historical use of natural forms. It is only within the last two hundred years that the life of most men has become oriented to living in mechanized towns. The images of an agricultural and rural economy are becoming less and less familiar to young people growing up in entirely urban communities. For the artist working in our own times the range of subjects has been extended in other directions and it is probably from these that a renewed vitality in design may unfold in the future. 'Cymatics' for instance is the name given by Dr Hans Jenny, the Swiss scientist, for his work in making differing vibrations of sound – in substances such as sand grains or water droplets – yield a visual equivalent that can be photographed. This is work with exceptional power 'to fertilize perception'. These intensely purposeful abstract patterns convey such richness of design and texture that they could be an inspiration to many, especially craftsmen in glass, embroidery and ceramics. The intricate world of the microscope, greatly extended by the electron microscope, is another field for research. The forms of the atoms, of mathematical equations and of solid geometry are relevant to be used symbolically in buildings for the worship of God; from the structure of crystals to the spiral of nebulae or unfolding bracken fronds, all these shapes can be seen as symbols of the expression of divine energy and join with men in the Benedicite.

The poet of Daniel divided his exhortation into the elemental parts of Air, Fire, Earth and Water; beginning with the Angels and Heavens, ranging through the Celestial Bodies, the Seasons, Night and Day and the natural forces of Wind and Weather. He continued with the Earth and its clothing of green things, its wells and rivers and 'all that move in the waters'. The birds and the beasts that live on the earth lead on to his closing adjuration to the 'children of men' and those worthy to praise the Lord.

From this comprehensive range of created things are drawn the subjects and sources of many simple emblems, profound symbols and picturesque allegorical

90. *Epitaphs and Emblems from the catacombs in Rome* (opposite)

Nearly all the Christian cemeteries date from after 313: these inscriptions are probably sixth century, they display a freshness and simplicity in which the anchor, fish, dove, vine and Chi Rho emblems intermingle with freely incised lettering. (After di Rossi.)

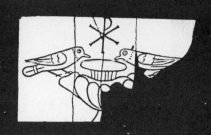

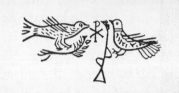

ornament in Christian art throughout history, and in this section we follow this sequence.

O ye Light and Darkness, bless ye the Lord

The paramount images of Light and Dark are obvious symbols for the forces of Good and Evil. The skills of architects, liturgists and craftsmen from the first centuries onwards have been drawn upon to serve and strengthen this imagery. Indeed some modern non-figurative artists working for the Church today have declared that in their view Light is the one and only appropriate symbol with which to represent Deity.

The use of the nimbus and mandorla in figurative art has long been a graphic way of attempting to express the spiritual radiance of the Holy. From the third millenium BC the nimbus or halo round the head has been used as an attribute of power, both the power of divine beings and the semi-divine imperial authority. Even the Christian Emperor Justinian and his actress wife Theodora wear large gold haloes in the mosaics in San Vitale consecrated in 547. In fact it was not until this sixth century that the use of the halo in Christian art became customary; the late antique representations of Christ show him without a nimbus. Once the use had become established the halo ensigned with the cross – of which three arms are visible – swiftly became the emblematic prerogative of Christ (or the Persons of the Trinity) and this identifies him even in the work of unskilled artists; such as the abrupt design on page 132.

Circular haloes are also shown behind the heads of angels, saints, martyrs and the Virgin Mary. The psychic perception of an emanation of holy light or aura subsequently gave way to haloes depicted as gold discs studded with jewels as

91. *Drawings from early Carvings* (opposite)

Left: From a stone carving of a Dove with cross from Qasr Ibrim in Nubia, a town Christianized in the sixth century. (Courtesy of Egypt Exploration Society.)

Right: Limestone slab in low-relief, a Coptic funerary stele now in the British Museum, probably seventh century. The bird as emblem or symbol of the soul flies upward carrying one cross in its wing tips and another with its beak. Soul birds were a feature of Coptic art and had developed from the ancient Egyptian belief in the nature of the human soul expressed by the ba-bird.

Below left: The *Victoria Agni*: the Lamb of God in the wreath of Victory over death. Detail from an ivory book cover of the early fifth century now in Milan Cathedral.

though they were earthly crowns of honour. Modesty perhaps led to the curious custom of square haloes being used for living persons represented in their life-times, as in the seventh-century church of St Demetrius in Salonika. The tri-angular halo is a later form and was reserved for the First Person of the Trinity. The aureole is a glory of golden light around the whole body and is an attribute of God the Father and Jesus Christ and the Dove of the Holy Spirit. In carvings the form of the aureole may have defined edges and appear almost as a wreath, echoing Roman triumphal art as in the drawing on page 132 from Cividale; the illusion of light is obviously easier to render in fresco and mosaic.

The mandorla or vesica, akin to the aureole, is an almond shaped oval of light with pointed ends usually formed from the overlapping intersection of two equal adjacent circles. It is used in scenes of the Transfiguration, Ascension, Last Judge-ment and Second Coming of Christ; and for the Assumption of the Virgin. In early versions of the Ascension the mandorla surrounding the figure of Christ may even be circular in form. The long oval is preferable in shape, it isolates and frames the figure with majestic power in such works as the fresco of the Anastasis in the Kariye Cami (the Church of the Chora) in Istanbul or the Transfiguration in St Catherine's Monastery on Sinai.

Gold as a Symbol of Light

The precious metal gold has long been used in art as an equivalent for celestial light and beauty. Its incorruptibility and worth strengthened the earthly parallel with transcendental heavenly things. The widespread use of gold glass tesserae in Byzantine mosaic decoration brought a glowing richness to the shimmer of sun or candlelight on vaults and domes. The figures on the walls were isolated from the ordinary world of light and shadow against an enduring golden background suggesting eternity. The Byzantines in particular were acutely conscious of the ecstatic quality of gold and gems in decorative art. The grounds of painted medieval altarpieces and manuscript illuminations are made of fine gold leaf and convey the same concept of transcendent glory as the gold tesserae of the mosaics. The use of gold for crosses, reliquaries, statues and church vessels was universal in the Middle Ages. The generous devotion of medieval minds would honour the house of God with the most splendid and sumptuous offerings embellished with enamels and set with jewels. We may think that they imagined him as an earthly potentate whose protection could be won by rich gifts, or we may believe they had a finer perception.

Our own material age is easily shocked by a display of gorgeousness in church decoration and this usually results in a denial of visual splendour in our places of worship. The pagan rite of libation, or the ritual pouring out to the deity of the natural gifts from Providence of water, wine and oil was transmuted in Christian worship into the enriching of churches. The most precious craftsmanship and finely worked materials were offered to the greater glory of God by the artists who made them and the donors who gave them.

> *O ye Heavens, bless ye the Lord.*
> *The Sun, Moon and Stars; Wind and Weather.*

The great celestial luminaries of the Sun and Moon overwhelm the capacities of graphic artists and perhaps this explains the rare appearances of the Sun and Moon except as mourning personifications in scenes of the Crucifixion. The stars on the other hand sing at the Creation in the poetry of Job, witness the Nativity in the Gospels and glitter in the Book of Revelation. Gold mosaic stars powder the blue vaults in Byzantine mosaics, signifying the Kingdom of Heaven in which the souls of the faithful shine like stars. The rich starry patterns in Galla Placidia's vault in Ravenna are illustrated on Plate 12, together with cloud and water patterns from related early mosaics. These add a sense of playfulness and ornament to the texture of the buildings, a sense lost in Romanesque art and found again in the lighthearted carvings of early and High Gothic.

> *'Be thou praised, O Lord, for our Brother the Wind,*
> *for the air and for the clouds, for serene and for tempestuous days.'*

St Francis's *Canticle to the Sun* from which these lines are quoted is itself a thirteenth-century Benedicite and characteristic of that time of flowering of art and faith. We lose much of delight by our current rejection of ornament and the vitality it can give to architectural surfaces by emphasis and rhythm and a modest symbolism. Many of the new materials which secular artists have found stimulating to develop could well be used in churches if the impetus were there.

> *O ye Wells, bless ye the Lord*

The significance of the Living Water in Christian symbolism is discussed in a previous section: included there is the allegorical fountain. The Fountain of Life

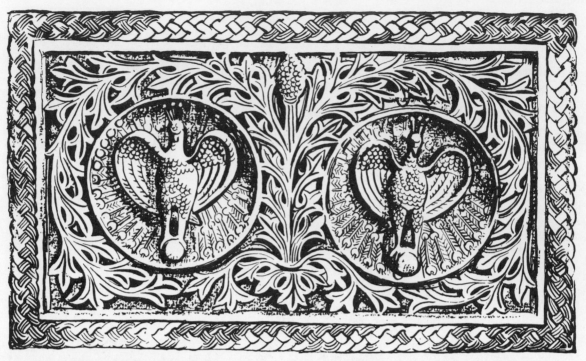

92. *Peacocks of Immortality*

Peacocks encircled by their tails, displayed standing on globes surrounded by acanthus foliage and a strapwork border: from a carved marble panel in St Mark's, Venice, rich in Byzantine slabs.

93. *Green Things* (opposite)

Top left: Tree of Life: from the carving on the Norman tympanum of Dinton church.

Top right: A fourth-century carving in low-relief on the soffit of a marble arch found near the palace of Galerius in Thessalonica and so possibly pagan in origin. The elegant vine scroll reminds one of similar carvings on British crosses.

Left: Vine scroll from a ninth-century carving on a shaft at St Felice, Cimitile.

Centre: Naturalistic vine carved on a fourteenth-century roof boss in Exeter Cathedral.

Centre left: Looped Cross Symbol in a roundel from the fourth-century mosaic floor of the basilica at Aquileia. This sign is found in many countries in the early Christian era.

Centre right: Fifth- and sixth-century Coptic slab: a section from a deeply cut vine frieze now in the British Museum.

Below left: Vine meander on a carved sixth-century slab; part of a repeat design. British Museum. The bold flat pattern of Coptic carvings is echoed in the strong contrasts of their accomplished textiles, many of which have been found preserved in dry desert sand.

Below right: Tree of Life: carved on the tympanum of the twelfth-century church at Kilpeck in Herefordshire. This is probably later work than the beakheads for which the church is famed.

[196]

was an early symbol of spiritual refreshment and of Faith, that virtue which is held to be necessary for salvation. The Fountain is an allegory of the Gospels, the four-fold spring from which flow the living waters of the New Testament. The concept is represented pictorially in a variety of ways; the simplest version shows four streams flowing from a hill on which stands the Cross or the Lamb. Elegant architectural compositions of great charm and fantasy such as those in the eighth-century Godescalc Evangelistary and the ninth-century Gospels of St Medard-de-Soissons at Aachen, show fountains with tall pillars rising from the basin to support curved canopies surmounted by the cross; all around harts, peacocks, swans and smaller birds are depicted refreshing themselves by the cool waters. A more mannered representation of the same theme is the carving on St Mark's, drawn on page 5 where peacocks drink from the vertically springing waters of a fountain. A spiritual meaning is given to this arcadian imagery by the words from the Book of Revelation: 'To the thirsty I will give water without price from the fountain of the water of life' and 'Let him who is thirsty come, let him who desires take the water of life without price.'

Of many allegorical fountains in art a particularly elaborate one can be seen in the mosaics at Daphni that illustrate the story of Joachim and Anna, parents of the Virgin Mary, another smaller one stands beside the Empress Theodora in San Vitale, and from another mosaic in St Mark's a drawing on page 105 shows an heraldically stylized fountain in the scene of Christ talking of the Living Water to the woman of Samaria.

94. *Birds and Beasts* (opposite)

Top left: Dove holding an ivy leaf: from a sixth-century Coptic textile; round the neck is a bulla showing the cross, and its breast is feathered with little crosses. (Ikon Museum in Recklinghausen.)

Top right: The hart with the serpent: from a fourteenth-century carved wooden misericord in Ely Cathedral.

Centre left: Daniel and the Lions: from the eighth-century carving on the base of the High Cross at Moone in Eire.

Centre right: Peacocks, crosses and trees on a terracotta lamp from Syria in the British Museum.

Below left: Peacock forming the illuminated initial Q; from a twelfth-century French manuscript in the Victoria and Albert Museum.

Below right: Detail from one side of the great Norman font of blue-black marble in Winchester Cathedral; showing a lion flanked by birds.

Benedicite Omnia Opera

O all ye Green Things upon the Earth, bless ye the Lord

The Tree is a powerful symbol of both life and knowledge; the evergreen suggests continuing growth and the life of a deciduous tree is an allegory of death and rebirth. So it is not surprising that the sacred tree has held an important place in myth and legend since ancient times. If the annual rhythm of winter and summer is one parallel of life and death; another is in the mysterious strength of fertility. A seed buried in the ground grows steadily upwards according to its nature into a great tree whose flowering branches are a shelter for nesting birds in spring, and in summer are a provider of welcome shade for animals and men, in autumn the fruits may well be sustenance for many creatures, while the fallen leaves of early winter enrich the soil with humus that other seeds may germinate when spring returns and sap rises. The dynamism of this green fertility is patient and purposeful and in sharp contrast to the aggressive hungry life of the animal kingdom. When its own life is ended the wood of the felled tree is raw material for many services to human beings. As a newborn infant Jesus was placed in a manger probably of wood, in adult life he may have followed St Joseph's trade as a carpenter, and it is on a cross of wood that he died.

95. *Emblems and Craftsmanship: Stars, Clouds, Vines and Flowers* (opposite)

Top left: Monstrance represented in flushwork at St Mary the Virgin, Woodbridge, Suffolk.

Top centre: Sacred Monogram on a thirteenth-century Limoges enamelled copper pyx in the Victoria and Albert Museum.

Top right: Pyx decorated with flowers and stars in enamelled copper, also thirteenth century; from the cathedral treasury of Esztergom, Hungary.

Centre left: Formal cloud pattern: from a medieval wooden roof boss in Blythburgh church, Suffolk. There are two wooden angels with widespread wings on each side of this boss, not drawn here. This formal pattern of clouds relates to an earlier stylization shown on Plate 12.

Centre right: Vine design on a French thirteenth-century iron hinge band, in the Victoria and Albert Museum. The tips of the delicate scrolls have been wrought into miniature leaves and bunches of grapes.

Below left: Leaved-cross, sword and hunting horn: adapted from a thirteenth-century incised tomb slab at Darley, Derbyshire.

Below centre: Roses: from a medieval roof boss at St George's Chapel, Windsor.

Below right: Interlace scroll springing from the chalice and surmounted by a cross: from a Byzantine sarcophagus in the church of San Donato, Murano.

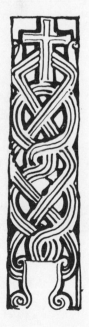
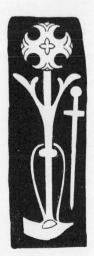

There are many elaborate legends relating to the wood of the Cross and one tells how a cutting from the tree of knowledge in the Garden of Eden grew into a tree from which derived the rod of Moses, a beam in the Temple of Solomon, a plank in the workshop of Joseph and the Cross of the Crucifixion.

To the Christian the new Tree of Life, the *Lignum Vitae*, is a symbol of salvation through the cross of Christ's Passion and Resurrection, depicted visually as a cross with the stem and arms representing the trunk and branches of a tree, the young shoots lopped close to the stem. The design is a convincing one, it appears on Byzantine ivories, on the tenth-century bronze doors at Hildesheim and it is a subject in Romanesque carving, manuscripts and metalwork.

According to another legend the wood became alive during the crucifixion. While Christ hung upon the cross it sent out shoots and blossomed from midday until Compline, after which it died with its Creator. The cross may be depicted with shoots growing from the stem or trunk and along the branches as from a living tree, or the arms may be shown as one branch of a felled tree with the shoots lopped and all facing in one direction, in other words a dead tree. Both renderings may allude to the legend of the Tree of Life.

The new Tree of Life on page 55 is drawn from the fifth-century mosaic in S. Clemente at Rome. It is a cross with growing branches, leaves, flowers and vine tendrils, planted upon the hill of Paradise Restored, from which flow four streams representing the four Gospels. The unity of Christ and the Church is expressed in

96. *Mythical Creatures in Ornament*

Top left: Mermaid: stone roof boss at Exeter Cathedral, probably thirteenth century. Although the mermaid has no official place in Christian tradition, carvings of this enchanting myth appear in the decoration of churches throughout Europe. Sometimes she has two tails – an ancient symbol with roots in the pre-history of the Near East; she is held to represent sensuality.

Top right: Gilt bronze ewer in the form of a kindly griffin, twelfth-century Mosan craftsmanship enriched with silver and niello. It was usual for such acquamanile to take the shapes of mythical beasts in this period. Victoria and Albert Museum.

Below left: Marble slab in the Byzantine Museum in Athens showing beaked griffin with trees. The flat pattern is finely ornamental; possibly seventh century.

Below right: Foliate Head: thirteenth-century roof boss in the Lady Chapel at Exeter, this Jack-in-the-Green figure was widely used in ornamental carvings in medieval churches.

the words: 'I am the vine, ye are the branches' and when the cross is composed of the leaves and branches of the vine it is an allusion to Christ as the True Vine.

The cross has been represented in manuscript illumination, enamels and stained glass in a variety of textures, sometimes quite literally as a rough tree trunk with bark upon it, more frequently as rounded and smooth, or of carpentered wood squared with a plane. The Passion cross is most often coloured as natural wood, but occasionally red to recall the blood of Christ, or green to symbolize the Tree of Life, or gold to signify glory.

The Venerable Bede tells us that the cross of the Passion was made of four woods: cypress, cedar, box and pine. In the Eastern tradition olive and palm are substituted for box and pine, and these woods had special significance for victory and martyrdom. In the Golden Legend it is related that the Cross was made from the Tree of Life, a branch of which had been planted by Seth on Adam's grave.

Related to the Tree of Life is a design originating in remote antiquity and still of interest to the artist today. It consists of a stylized holy tree between a pair of animals, birds or mythical creatures and is found in Assyrian art on small cylinder seals and monumental wall tiles. The technique of weaving encouraged the use of such confronted or addorsed designs which can be found in Sassanian, Coptic and Byzantine textiles. In Christian art peacocks confronting the Vine and the Tree of

97. *The Fish: Emblem of Christ*

Top left: Emblems of the Eucharist, the Host and the Fish, with a Seraph: from a carving by Albert Schilling on the great altar in St Michael's church, Hirzbrunnen, Switzerland.

Top right: Early seal stone. British Museum.

Centre left: Fish with the *PX* Monogram: coloured low-relief carving from the arch in the church at Kemijärvi in Lapland.

Centre right, above: The Anchor Cross with Fishes: incised carving from the catacombs in Rome.

Centre right, below: Weathercock in the form of a skeletal fish made in carved wood by Donald Potter.

Bottom left: Vigorous Coptic carving of a dolphin with a wreathed cross balanced on its nose and flanked by vines; this is probably sixth-century workmanship. British Museum.

Bottom right: Three Fishes: medieval roof boss from the north transept at Bristol Cathedral. This arrangement is known heraldically as 'tête à la queue'; it may also, if somewhat remotely, stand for the Trinity, as in the similar threefold design of hares from a boss drawn on page 45.

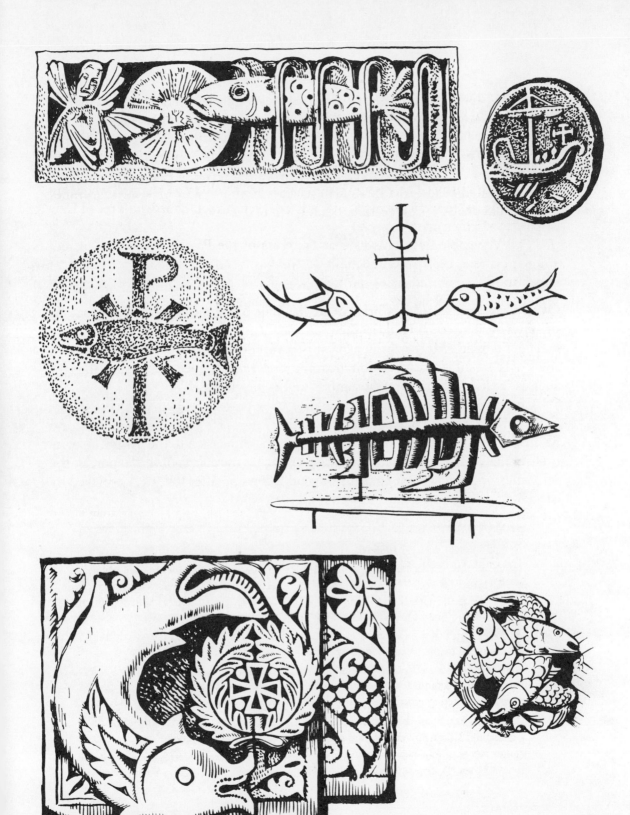

Life with doves pecking the grapes are closely related images. The intention may be simply decorative but the underlying spirit is one of worship and adoration.

Decorative heads surrounded by leaves and often with stems sprouting from their mouths can be found in many medieval churches, especially on carvings and bosses. C. J. P. Cave suggests that these may be a survival of pagan tree-worship. Similar foliated heads exist in Roman mosaics from classical pre-Christian times and may have been personifications of the spirit of the woods.

The Vine

Of all plant forms used in Christian art the Vine is the most universal. It may be merely a decorative motif and as such was widely popular in Roman wall decoration and floor mosaics. Much ornamental Christian art derived from classical sources and some of these subjects early acquired an allegorical significance in Christian thought such as the fish, the dove and the lamb as well as the vine itself.

Christ's own words: 'I am the vine, ye are the branches. He that abideth in me, and I in him, the same beareth much fruit, for without me you can do nothing,' and his institution of the Eucharist added the spiritual dimension to the natural associations of the vine. The communal vintage, crowning the efforts of the labourers, the resulting wine as a heartening drink of good fellowship after toil, were enriched by the new and deeper significance given in Christ's words.

98. *Confronted Creatures* (opposite)

Above: Lombard carving of the eighth century on a choir screen panel in Santa Maria in Trastevere, Rome. The unsophisticated carver has used the current repertory of Christian motifs – peacocks, vine, chalice, crosses and tree of life without grasping their structure but with a natural gift for arrangement.

Centre: From the sixth-century Egyptian carved stone tympanum of harts drinking at the vase with the tree of life, now in the Louvre.

Right: Confronted peacocks on the gold ring of Ethelwulf who was King of Wessex from 836 to 858 and the father of Alfred the Great. British Museum.

Below left: Eighth-century carved slab of peacocks drinking at the chalice. The geometrical stylization is clearly of a concept rather than a representation; as the child said 'I think and I draw my think', rather than 'I look and I draw my look'.

Right: Medieval bench end at Acton, Suffolk: quails (or partridges) among the poppied corn. Quails and manna sustained the wandering Israelites in Sinai.

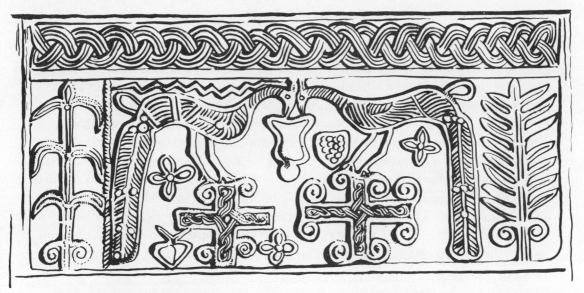

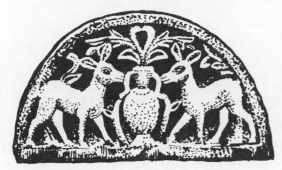

In Old Testament writings such as the Psalms the vine stands for the Jewish people as a whole. In Byzantine art the vine is often shown allegorically, springing from the cantharus – the two-handled vessel that was the earliest form of the chalice – and this design becomes a variation on the pagan theme of the Tree of Life; the lions and griffins of eastern ornament being replaced with the peacocks of immortality.

In the late seventh century the vine scroll appears in England on the great cross at Ruthwell and in the eighth century on Acca's cross at Hexham in Northumbria; it is thought to have come with artists from the Eastern Mediterranean. In its subsequent development it became a scrolling form, far removed from the plant's natural structure. The flexibility of the stem with tendrils, pendant bunches of grapes and indented leaves makes the stylized vine adaptable to many shapes and uses in the various crafts. Illustrations on Plate 11 and drawings on page 197 show a range of examples.

The Palm

The Palm was the sign of victory and later of martyrdom, the martyrs through faith being victorious over death. Edward Hulme writing in 1891 says: 'It was an ancient belief that the palm tree would always grow erect, no matter how it might be weighted or pulled aside, hence it was a favourite emblem in the Middle Ages of Triumph over Adversity.' In the description of the entry into Jerusalem the cheering populace seized fronds from the trees to wave and strew on the ground – hence the custom of giving the faithful palm frond crosses on Palm Sunday. On page 169 is a drawing of the carved slab on the outside wall of St Mark's showing St Christopher bearing the Christ Child on one shoulder with his great staff as a palm tree in the other hand, for legend says it flowered and fruited after his meeting with Christ. On

99. *Stone Carvings*

Top left: Eagle displayed between two budding trees within an ornamental frame: from a relief carving on a marble panel in Sorrento.

Right: Agnus Dei: from an early medieval low-relief carving in the Cluny Museum.

Centre right: Doves drinking from a chalice, symbolizing the soul and the Eucharist, from a later carving outside the sixth-century basilica of S Apollinare in Classe.

Below: Turkey-cocks and vines flanking the Chrismon: from a fifth-century altar panel in Ravenna.

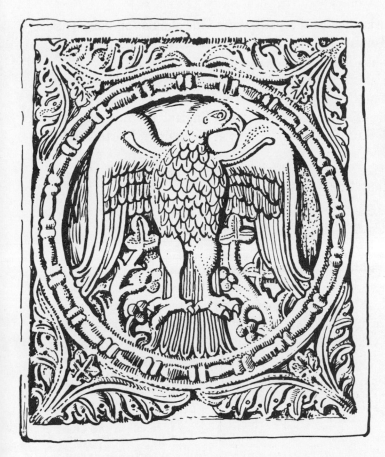

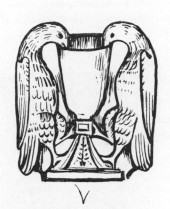

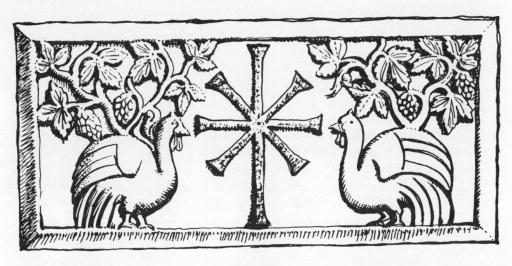

another carving from St Mark's on Plate 30, the symbolic palms of paradise flank the image of the Throne, and on page 166 is a drawing of a martyr beside a palm tree.

Paradise Garden

In the Paradise of early imagery flowers and plants and trees stress the vision of a pastoral heaven:

> *Where streams of living waters flow*
> *My ransomed soul He leadeth*
> *And, where the verdant pastures grow,*
> *With food celestial feedeth*
>
> (from Sir H. W. Baker's version of Psalm 23)

In medieval churches this tradition of sylvan imagery continued to blossom. On capitals and corbels, roof bosses, crockets, tympana and round doorways on mouldings and tombs, a wealth of leafy forms were carved and painted. Foliage twined in the borders of stained glass windows as on wooden bench ends, roodscreens and misericords. It has been said that in the twelfth century the Gothic carvers were in bud, in the thirteenth in leaf and in the fourteenth in blossom. In most cases the designs were imaginative rather than accurate in a botanical sense and were not so concerned with symbolism as with expressing the rising sap of life and faith and the delight of their creators. In English art the carved leaves of Southwell Minster are a notable example of this thirteenth-century prodigality. The present day use of plant and leaf is less wholehearted and more mannered. Stylized forms are used in ecclesiastical embroidery but the opportunities for ornament are restricted by both taste and cost today. In the nineteen seventies the increased concern with the problems of pollution and over population are making people more aware just how precious and vulnerable are 'the waters' and the 'green things upon the earth' and how great is the collective responsibility for their right use and conservation today.

O ye Whales, and all that move in the Waters

The Fish is one of the most familiar of the early Christian symbols and has a wide range of inner meanings. It is found in the catacombs, on early rings and gems and in Celtic manuscripts and sculptured stones. It became a symbol of Christ originating with the well-known acrostic in which the first letters of the five Greek

words for 'Jesus Christ, Son of God, Saviour' together form the word *IXΘΥΣ* meaning Fish.

Fishes figure in the miracles of Christ; many of the Apostles were fishermen, notably St Peter. The fish is also used to signify the human soul swimming to salvation through the waters of Baptism. Tertullian wrote of Baptism: 'But we small fishes, named after our great ICHTHYS, Jesus Christ, are born in water and only by remaining in water can we live.' In the early years of the Church the fish was a symbol of the Eucharist, arising from its imagery in the miracles of the Feeding of the Five Thousand and the Four Thousand.

The Vesica is a name meaning Fish given to the radiance of light round the figure of Christ, which is thought to be fish-shaped: or almond-shaped, when it is called a mandorla.

O all ye Fowls of the Air, bless ye the Lord
The Dove

The elegant and gentle dove so clearly demonstrates attractive qualities of form and nature that her exalted position as the Christian symbol of the Holy Spirit seems well bestowed. The symbolism originates from the Gospel account of the baptism of Jesus and the 'Spirit of God descending like a dove'.

In the Old Testament the dove appears in the story of Noah as a messenger of peace bearing the olive twig in her beak. God's anger is assuaged, the waters of the Flood recede and trees are in leaf again. In Jewish ritual doves were a prescribed offering in the Temple, and the olive branch remains an emblem of peace.

The dove has been seen more profoundly as an image of the Holy Spirit with Christ as the Ark, and the angry warrior's bow is reversed in the sky to become the great rainbow of God's promise to withhold his wrath against mankind. It is on this bow that Christ is seated in Majesty in the vision of St John.

The dove is also an image of innocence and constancy and of the Christian soul. Doves pair for life and their courting is visibly touching and affectionate. Seven doves together in Christian art represent the seven gifts of the Spirit. These are memorably shown in the stained glass of medieval French cathedrals. In the catacombs and in early Christian times the dove represents the human soul drinking from the chalice of the Eucharist or pecking the grapes on the Vine. The tomb of Theodotus drawn on page 113 shows this pastoral imagery and the doves on the tomb slabs from the catacombs on page 191 witness the same spirit.

The great difficulty of representing the Trinity or the Holy Spirit in adequate visual terms possibly led to the choice of the dove as being an acceptable image. But as a result the idea of peace and gentleness has perhaps been over-stressed in visual terms and the true power and strength of the Holy Spirit working in the lives of men thereby diminished.

The Eagle

The eagle was taken to be the king of birds and was believed to be able to gaze straight at the sun without injury and to cure itself of blindness by soaring upwards towards heaven until the film on its eyes had been burnt away by the sun.

The eagle is one of the four Living Creatures of the Book of Revelation and became the symbol of St John the Evangelist. It is also an emblem of spiritual power and aspiration. The striking form of the eagle makes it of wide service to the artist and craftsman. The lectern in English parish churches is commonly in the form of a fine brass eagle with outspread wings holding the Bible – so symbolizing the carrying of the Gospel message to all and witnessing the opening words of St John's Gospel: 'In the beginning was the Word.'

The Peacock

This decorative bird was used in art before the Christian era and was sacred to Juno the consort of Jupiter in the Roman pantheon. It was a widely popular subject in Byzantine art and is found on mosaics and carved on marble chancel slabs, sarcophagi and tombstones. It came to symbolize immortality of the soul and resurrection from the analogy that when it sheds its splendid tail this plumage is brilliantly renewed. The eyes in the tail were held to signify foresight and its flesh was held to be incorruptible; it was even eaten roasted.

The design of two confronted peacocks drinking from a chalice is found in many forms. Speaking particularly of the eleventh-century marble carving at Torcello, most likely brought from Constantinople, Gervase Mathew says:

The exact mathematics of the composition, the tactile value of the surface, the balanced rhythm of the figures could satisfy Byzantine sense perception, but it

could also satisfy another form of *aisthesis* – not beauty experienced only by the senses but Beauty apprehended through senses by Mind. When contemplated it conveyed a cluster of connected truths; the Christian had put on incorruption by drinking from the spring of living water and by partaking in the Eucharist. By so doing he had received the pledge of immortality and by so doing he had pledged himself to drink of the Chalice that Christ drank of and to be baptized with that with which He was baptized.

The Cock

The cock is inseparably linked with St Peter's denial of Jesus and his subsequent repentance; it is thus an emblem of the Passion and later of penance. The piercing cock-crow at day's dawning scattered the fears of the night and made the bird an appropriate choice for weathervanes. From many church towers and steeples gilded cocks in wrought iron and copper watch over the landscape. The design of such weathercocks may vary from natural form to extreme geometrical stylization.

The bird as an emblem of vigilance and light has also acquired a patina of legend as Shakespeare says:

> *Some say that ever 'gainst that season comes*
> *Wherein our Saviour's birth is celebrated,*
> *The bird of dawning singeth all night long;*
> *And then, they say, no spirit can walk abroad* . . .

O all ye Beasts, and Cattle, bless ye the Lord
The Lamb

The symbol of Jesus as the Lamb of God stems from the saying of John the Baptist in the first chapter to St John's Gospel: 'Behold the Lamb of God who takes away the sin of the world.' The death of Jesus on the Cross was seen as a sacrifice for mankind in the symbol of the sacrificial Lamb of the Jewish Passover. It was held that Isaiah had prophesied the Crucifixion with the words: 'Like a lamb that is led to the slaughter'. The Book of Revelation with its passionate verbal imagery strengthened the concept of Jesus as the heavenly Lamb of God – the apocalyptic Lamb with the Book sealed with the seven seals signifying Christ as the Judge at the end

of Time. The Lamb with blood flowing into a chalice from a wound in the breast stands for Christ crucified. This image inspired the great altar piece 'The Adoration of the Lamb' by Van Eyck, put up in St Bavon at Ghent in 1432; it is one of the undisputed masterpieces of religious painting in Europe. At one time the form of the Lamb was used instead of the figure of Christ on the Cross but this was forbidden in the late seventh century as inducing to idolatry. The Lamb bearing the cross-emblazoned banner (the Agnus Dei) was a sign of Victory and Resurrection. This image has always been a favourite symbolic device of craftsmen and designers. The depiction of the Agnus Dei on a disc is a particular attribute of St John the Baptist and among other saints it is also the emblem of St Agnes.

The Ram figures in Old Testament story as a sacrificial animal, especially the Ram 'caught in a thicket' who was sent as a substitute sacrifice for Isaac.

In early mosaics and carvings lambs are used to signify the Apostles; the illustration on Plate 30 is a noble example of this idea. The lamb was also used on sarcophagi as an image of the faithful Christian soul.

The Lion

The lion, an obvious example of power and courage, is traditionally the king of beasts. In Christian art and literature he plays a double role; at one time standing for the forces of Good and at another for the powers of Evil, as in the opening words of Compline, the divine office which close the prayers for the day:

'Brethren, be sober, be vigilant, for your Adversary the Devil, as a roaring lion, walketh about seeking whom he may devour; whom resist, steadfast in the faith.'

As one of the Living Creatures in the Book of Revelation the winged lion became widely known as the symbol of St Mark the Evangelist and in the same book the lion is used as a figure of Christ: 'Behold, the Lion of the tribe of Judah the Root of David, hath prevailed to open the book, and to loose the seven seals thereof.'

On page 231 is a drawing from a window illustrating the fable of the lion and cubs as a type of the Resurrection.

Lions were believed to sleep with their eyes open so made appropriate guardians for the doors of churches. However, when the pillars of Romanesque portals rest on the carved figure of a lion he represents the power of evil overcome by the might of the Church. A lion fighting a dragon represents good overcoming evil but when the lion has a man or a lamb in his claws he himself stands for the powers of evil.

Confronted lions guarding a tree are found in Romanesque carvings and echo the earlier Persian motif of the sacred tree or 'hom' and its guardian beasts.

The lion is an attribute of St Jerome and few who have seen the paintings by Carpaccio in San Giorgio degli Schiavoni in Venice will forget his three beguiling pictures of the Saint and the lion.

The Hart

One of the most evocative early images is that of the hart drinking, derived from the forty-second Psalm: 'As the hart panteth after the water brooks, so panteth my soul after thee, O God.' Confronted harts drinking from streams and from the chalice appear in fifth-century floor mosaics in North Africa. In mosaic in the mausoleum of Galla Placidia in Ravenna they are depicted with sensitive realism drinking natural water from a rushy pool set against a celestial blue sky. A little Coptic lunette of this subject is drawn on page 207. In the mosaic at S Clemente in Rome drawn on page 55 the harts are shown drinking from four streams standing for the four rivers of Paradise as well as for the four Gospels from which the faithful derive refreshment. The related image of the Fountain of Life is found in examples as distant as Ottonian and Ethiopian manuscripts.

The hart was believed to be the natural enemy of the serpent and the fantastic natural history of the Bestiary described him as able to pursue his enemy into cracks of a rock and there snuff or blow him out and trample him to death, on page 199 is a drawing of this from a medieval misericord at Ely. Having destroyed the poisonous serpent the hart sought a stream to assuage a supernaturally consuming thirst and was revitalized by the water – hence the parallel with the Christian idea of Baptism.

The Donkey

Although no specific symbolism attaches to the homely donkey he has a place in Christian art. From the Old Testament comes the perceptive donkey of the prophet Balaam – who saw an angel and rebuked his master.

The donkey on which Mary rode to Bethlehem and which bore the Holy Family on the flight into Egypt is a necessary invention of artists. The donkey figures most

notably and authentically in the Entry into Jerusalem – and speaks in G. K. Chesterton's poem:

> *. . . for I also had my hour ;*
> *One far fierce hour and sweet :*
> *There was a shout about my ears,*
> *And palms before my feet.*

Donkeys in Jerusalem used to have thick coats in which darker fur down the spine and across the withers could clearly be seen as a cross – naturally held to commemorate the honour of that day.

Bestiary Beasts

From ancient times moral and supernatural qualities were attributed to animals real or magical. The Physiologus, a Natural History book dating from early in the Christian era and probably originating in Alexandria, embodied many of these traditions from the East. From this work similar books called Bestiaries were derived and were popular all through the Middle Ages. A selection from the many symbolic creatures in the Bestiaries would include the Peacock, the Phoenix, the Pelican in her Piety and the Mermaid and such composite fabulous beasts as the basilisk and amphisbaena.

Bestiary animals were frequently treated as images of Christ, or of the Devil, or of the Virtues and Vices. The fables were a fruitful source of inspiration to artists who preferred them to genuine observation of nature. Each description ends with a moral discourse, for example the mermaid is a symbol of the lure of the senses. In representations of Christ Triumphant, held to be prophesied in the ninetieth Psalm, he is shown treading down the lion and the dragon, the adder and the basilisk. St Augustine understood these fabulous creatures as four aspects of the Devil overcome by Christ after the Resurrection. The Antichrist is signified by the lion, the Devil by the dragon, Death by the basilisk and Sin by the adder.

Among the more significant of the creatures from the Bestiary are the following:

The Unicorn: The mythical creature is described as too powerful for man to tame and with a horn so long and sharp that it pierced everything it touched. According to legend if a pure virgin sat alone in a forest the great creature would come and lay its head in her lap, thus becoming a prey to the hunters; and from this legend it

100. *The 'Homme-Arcade'*: Example from the tympanum of the West front of Chartres, *c.* 1150, showing the Apostles. The presentation of rows of prophets, saints or apostles within niches or arcades became a standard medieval motif, linking the figures with their architectural framework in a satisfying relationship of strongly decorative value.

became a remote emblem for Christ, born of a Virgin. Behind the legend lies the image of the rhinoceros, unknown to medieval writers; and the 'horns' which sold at a great price on account of their supposed power to detect poison were the spiral horns of the narwhal. The elaborate symbolism of the Unicorn is little understood or used in art today although in heraldry it is a familiar beast.

The Pelican in her Piety: The Bestiary said that the pelican slew her importunate young and then restored them to life with blood taken from her own wounded breast. This was held to symbolize Man's redemption from the Fall through the blood of the Redeemer. Medieval artists unfamiliar with real pelicans illustrated the fable with birds of many forms. A modern version from the doors of Cologne Cathedral is drawn on page 231.

The Phoenix: According to classical legend this mythical Arabian bird lives for five hundred years and then builds a pyre and burns itself to ashes from whence a splendid young phoenix rises and on the third day flies away to live another five hundred years. The obvious parallels led to its adoption as a Christian symbol of the Resurrection. It is found in the art of the catacombs and in the ninth-century mosaics in Rome. A drawing from the floor mosaic at Daphni is shown on page 231. The endearing imagery is still alive today although better known as an emblem of insurance.

The Griffin: A fabulous creature with ancient Greek or Scythian origins, frequently used as a sinister decorative monster without specific allegorical meaning.

O ye holy and humble Men of heart, bless ye the Lord

A carving from Chartres on page 217 illustrates 'the Glorious company of the Apostles' as the *Te Deum* describes them; but the singer of Benedicite had all holy men in mind.

In the fellowship of the Church the figures of Apostles, Saints and Martyrs were used to decorate the walls and windows, the façades and portals to show that these great ones were joined in fellowship to the worship of the congregation. The figures of workers too, of carvers and masons, men reaping corn, scribes at their desks, children at school, vintners with casks, all kinds of people who make a community were also included in the decoration of medieval churches; this emphasis on the interdependence of crafts and trades, work and prayer, might well inspire artists afresh in the different patterns of communities today.

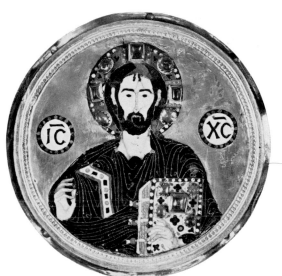

Plate 26: *Much in Little*

Top left: Early Christian gold glass depicting the youthful Christ of classical tradition, about two inches square. (*Photograph British Museum*)

Top right: Christus: low-relief carving on a five-inch shale pebble by Arthur Pollen.

Below left: Verger's Wand in silver: made by Dunstan Pruden for Llandaff Cathedral. The three bishops are part of the arms of the diocese.

Below right: Roundel of Christ: in jewelled gold and enamels from the Pala d'Oro in St Mark's, Venice; a sumptuous altarpiece of tenth to fourteenth century workmanship. The iconography of this small work is similar to that of the huge mosaics of Christ Pantocrator at Cefalù, Monreale and Daphni and conveys the same majestic dignity within its three inch circle.

Plate 27: *Symbolism of Hands*

Top left: Detail of the Eucharist panel from a stained glass window by Moira Forsyth in the Roman Catholic Church at Brixham. The Hand showing the wound is surrounded by the Crown of Thorns, the spear and the emblems of Wheat and Vine. The Cross appears above the altar on which stands the Chalice with the Host and in front there is a section of the Rainbow which springs across the five lights of the window.

Right: The Hand with the Dove of Peace: sculpture above the portal of the Methodist Church in Kingsway, London.

Below left: The Hand of Christ nailed to the Cross: one of a set of Stations of the Cross in ceramic by Donald Potter for St Matthew's Church, Bethnal Green.

Right: The Flames of the Spirit: carving in stone over a doorway in the twentieth century Cathedral of the Holy Spirit at Guildford.

Plate 28: *Saints and Emblems in Glass*

Opposite, left: St David: Abbot and Bishop of the sixth century and patron saint of Wales. Engraved glass panel by John Hutton at Coventry Cathedral. St David's emblem the dove is perched on his shoulder.

Opposite, right: St Thomas à Becket: stained glass window by Moira Forsyth in Snodland Church, Kent. The halo of the twelfth century martyr is vivid scarlet and his robes gold and silver tones. The figures of the pilgrims can be seen in the background going towards Canterbury Cathedral. The arms of the Archbishop show his three Cornish choughs impaled with the arms of the Province of Canterbury.

Above: Holy Eucharist window, one of a series of the Seven Sacraments in the church of St Ambrose, Speke, near Liverpool, by Gounil and Philip Brown.

Plate 29 (overleaf): *Skill and Simplicity in Design*

Top left: The Ascension: in the frame on either side are Seraphim and symbolic figures for two of the four rivers of Paradise. Detail from an eleventh-century ivory book cover now in Munich Library. The mannerism of the figures and trees is characteristic of the ivories of this school. Designers of nativity plays could well gain ideas from the formal arrangement of the seraphs' wings. (*Photograph Bayer*)

Below left: Cross from a tenth century ivory triptych in the Louvre. This panel is from the back of the Harbaville ivory, a work of exceptionally sensitive craftsmanship. The cross stands in a Paradise garden and bears five formal roses alluding to the wounds of Christ. The sky is powdered with twenty-four stars; the earth is carved with trees and flowers and fruiting vines. Two cypresses bowing to the cross are wreathed with different species of vine twining opposite ways, in which tiny birds are pecking the fruit. In the roots of the tree on the left live a family of minute lions, while on the right a hare is nibbling a blossom. Although of a very different scale and scope this work breathes the same spirit as the pastoral mosaics in Ravenna, of some four hundred years before.

Top right: Coptic memorial limestone slab, seventh century, in the British Museum, showing an orant standing in an arch between palms, within an ornamental border of crosses and sunwheels.

Below right: The Lamb of the Apocalypse: modern carved relief behind the altar at Möhlin near Basle, by Albert Schilling.

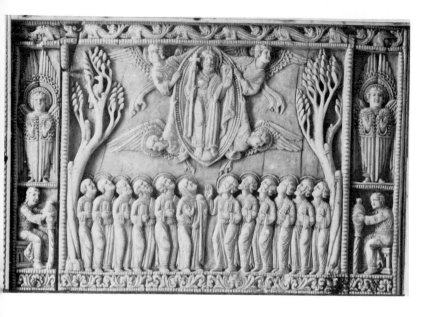

Plate 29 : caption overleaf

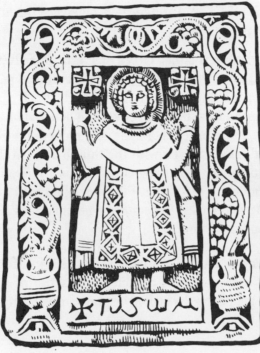

101. *Prayers*

Right and left: Vine patterns from carvings on ninth-century shafts at Cimitile.

Top: Immortal soul: from a carving on a late medieval tomb slab; from Llanvihangel in Wales.

A saint in the gesture of prayer from a ninth-century silver-gilt buckle found in the tomb of a child at Mikulčice, Czechoslovakia.

Below: The Abbot Pachomius in prayer. Coptic carving from Egypt of sixth to seventh centuries. British Museum. St Pachomius was born in the third century and was the first hermit to organize monks and nuns into communities with written rules; his work influenced both St Basil the Great and St Benedict.

This is the standard early Christian attitude of prayer with palms held outward and elbows bent. M. D. Anderson says that 'the posture with hands joined was unknown alike to pagan antiquity and early Christianity; it appears in the eighth century but did not become common until the twelfth century.'

Benedicite Omnia Opera

The Gesture of Blessing

The giving and receiving of blessings as a symbol of the favour of God plays an important part in Old Testament story. In the Gospels Christ is described as repeatedly blessing the food which he ate with the disciples: in the Beatitudes his benediction extends to all 'holy and humble men of heart'.

The depiction of Christ with his hand raised in the beautiful gesture of blessing is universal in Christian art. The distinguished nineteenth-century iconographer Napoleon Didron writes:

> The gesture of benediction is either Greek or Latin; it is always given with the right hand, the hand of power. In the Greek Church it is performed with the forefinger entirely open, the middle finger slightly bent, the thumb crossed upon the third finger, and the little finger bent. The movement and position of the five fingers form, more or less perfectly, the monogram of the Son of God.
>
> The Latin benediction is given with the thumb and two first fingers open; the third and the little finger remaining closed. This arrangement of the fingers appears to be symbolic . . . and that the three open fingers signify the three Divine persons. The two closed fingers are emblematic of the two natures of Christ, the human and the divine.

Blessing is used today as an integral part of the Liturgy: formal blessings are regularly given at the close of services to convey the sense of spiritual good bestowed from God to the people by the bishop or priest in authority.

The Ship as an Emblem of the Church

In the familiar Old Testament story of Noah all living creatures found refuge from the flood in the ark. To Christians the ship became an early symbol for the Church. The mast and yard arm formed a simple cross above the ship which stood for the Church of Christ afloat on the troubled seas of life, carrying the faithful to salvation under the sign of the Cross. Sometimes St Peter, the Founder of the Church, is at the helm, in reference to his mention of Noah's ark in his first Epistle. In early representations the ship of the Church is merely a floating chest but the image, however simple, remains one of Salvation. The main body of a church is still called

the nave from the Latin word for ship. The World Council of Churches uses as its current emblem a ship afloat encircled with the Greek word *OIKOYMENE*, showing the world-wide mission of the Church.

Personifications

In the Middle Ages the Church was personified as a crowned female figure holding a cross, or a chalice, or a church. Usually she would be opposed to another female figure signifying the Synagogue, represented blindfolded and with a broken banner falling from her hands or a crown tumbling from her head; well-known examples include the figures on Antelami's panel of the Crucifixion at Parma and the noble gothic carvings on the south portal of Strasbourg Cathedral. The use of Personifications for other abstract subjects – such as Virtues, Vices or Beatitudes – was of practical use to sculptors and designers, but would hardly be acceptable as symbolism in our time.

102. *Ship symbol used by the World Council of Churches*, surmounted by the Greek word *OIKOYMENE* meaning the whole inhabited world. The ecumenical Church is the whole Church throughout the world.

The Church in Work and Time

Labours of the Months

DECORATIVE FIGURES representing the pastoral work of men in different seasons became a familiar subject in medieval art, especially in manuscripts and in sculpture. Examples can be found on doorways in many French and Italian cathedrals and for ordinary people coming in and out of the building they visibly linked the life of daily work with the praise and prayer of the Church.

The later developments of the Labours, as in the fifteenth-century manuscript – the Très Riches Heures of the Duc de Berri, stressed the activity of the figures among crops, hills and distant views; this feeling for figures in a country setting led in its turn to the discovery of landscape painting for its own sake.

The subjects of the Labours in different parts of Europe vary according to the climate and the local crops. January shows two-headed Janus facing the Old and New Year, or people warming their wintry feet. February shows a man digging, pruning or fishing and in northern France he may still be warming his feet. March

103. *The Church in Work, Learning and Time*

Left: *The Labours of the Months*: These fine Romanesque examples are carved on the archivolts of the central door of St Mark's in Venice and reveal Byzantine influence with Western characteristics. Shown here are July as a man harvesting or haymaking; August as a youth drowzing in a chair with a fan in his hand; September as a peasant carrying a basket of grapes.

Top right: Carved wood misericord from a medieval series of the Labours of the Months once at the church of St Nicholas in Kings Lynn, now at the Victoria and Albert Museum.

Below: Grammar: one of the seven Liberal Arts from the twelfth-century carvings on the Royal Portal at Chartres. In medieval times the influence of the Church extended to all aspects of the life of ordinary people. The activities of learning, of work and of the cycle of the seasons were all thought suitable subjects for the artist to use in enriching great church buildings.

in Italy may be blowing a horn or drawing a thorn from his foot or pruning trees; in France he may be dressing or digging his vines. April is considered as the most beautiful of all the months and is sometimes shown as a king. He may carry boughs or flowers and in France perhaps an ear of corn. May is a horseman, sometimes with a sickle. In French manuscripts a knightly train of aristocratic sportsmen is usual. June shows a man mowing or reaping with scythes and July reaping or threshing. In the thirteenth century sheepshearing begins to be an important activity. August is generally a cooper with a cask in Italy, or a man gathering fruit; in France still a harvester or thresher. September always represents the vintage with grapes gathered or trodden. The later months are shown by a variety of activities; October tasting wine or filling casks or sowing. November may be ploughing with oxen; feeding swine or killing hogs or pulling up turnips. December may be cutting wood or killing hogs, baking cakes and feasting.

Although the labours of most people today are urban and so not linked with the seasons and thus with particular months, the idea of the dignity of labour as worthy decoration for churches is still valid, especially perhaps for stained or engraved glass. The difficulty for designers is to make the actions of modern man at work appear to be representative. Whereas a medieval man in the act of digging could symbolize all men from Adam onwards earning his bread by the sweat of his brow, the same is not so true today. Yet more than formerly it is necessary to emphasize the relation between worship and work.

Medieval man accepted the necessity for work, there was no alternative for him, life was hard and leisure rare. Today we have in too many ways submerged creative delight in productive effort, the richness and meaning it can give to life however hard. For people working in factories at repetitious and boring jobs there is little sanctity in labour and their true interests must largely depend on their leisure activities. Man is a naturally creative being and when this power is frustrated his whole inner structure is distorted and his capacity for living and loving is diminished. More is at stake than the survival of early Christian symbolism. If men cannot rediscover their own springs of reverence for life of plants and creatures, reverence for the health of lakes and rivers, for the well-being of the soil which supports our corn and cattle, or reverence for the quality of air in our cities then the survival of mankind is in question:

'where there is no vision, the people perish.'

The Christian Calendar

The Worship and Feasts of the Church follow an annual pattern which primarily commemorates and symbolizes the sequence of Christ's life and Passion and secondly the anniversaries of saints and martyrs. Those feasts which always occur on the same date such as Christmas and Epiphany are known as immovable feasts; the others which occur on the same *day* of the week but a different date are termed movable feasts, the most important being Easter and Pentecost. Sunday is the day of rest and the commemoration of the Resurrection each week.

The nine major seasons of the Christian or Church's Year are: Advent; Christmastide; Epiphany; Septuagesima; Lent, which includes Holy Week; Easter; Ascensiontide; Whitsuntide; Trinity season. The phrase 'tide' means 'in the octave' or the eight days during which the observance of certain major feasts are continued.

Advent is the season of preparation for Christ's coming at Christmas and his Second Coming to judge the world, and it begins the Church's Year. Advent Sunday is the fourth Sunday before Christmas.

Christmas Day is the feast of the Nativity, the Birth of Jesus and a Holy day among all Christians. It is always celebrated on December 25 so the day of the week changes each year. The twelve days from December 25 to Epiphany are known as Christmastide.

Epiphany is the feast commemorating the coming of the Magi or Wise men and this is held to symbolize the manifestation of Christ to the Gentiles. The Epiphany season is from January 6, Twelfth Night, to Septuagesima.

Septuagesima Sunday begins the pre-Lent season seventy days before Easter, as the name implies. It is the third Sunday before Lent begins, the two following Sundays being Sexagesima, sixty days before Easter and Quinquagesima, fifty days before Easter.

Lent, the period of forty days before Easter, commemorates Christ's conquering of temptation in the wilderness. It is the season of penitence, fasting and self-denial. In Roman Catholic countries a period of Carnival with feasting and dancing precedes Lent. Shrove Tuesday, so-called for the 'shriving' or confessing of the faithful on that day is immediately followed by Ash Wednesday. Lent begins on Ash Wednesday so-called from the medieval practice of placing ashes of mourning on the forehead. The last two weeks of Lent are called Passiontide during which Christ's suffering

and death are commemorated. Passion Sunday is two Sundays before Easter Day and is followed by Passion Week, leading to Palm Sunday which commemorates the Triumphal Entry into Jerusalem, it is marked in some churches by the use of palm decoration and small crosses made from palm fronds. Holy Week follows Palm Sunday, the Thursday is called Maundy Thursday which marks the day on which Christ washed the feet of the disciples, it also commemmorates the Last Supper and the institution of the Eucharist.

Good Friday in Holy Week, the Friday before Easter Day, commemorates the Crucifixion of Christ. It is so-called 'good' because of Christ's redemptive sacrifice.

Easter Sunday celebrates the Resurrection of Christ and symbolizes the Christian faith in life after death. It falls on the first Sunday after the first full moon following the Spring equinox on March 21. Other movable feasts and holy days not observed on fixed dates, depend on the date of Easter which is the most important feast of the Church's year. The period from Easter to Ascension day commemorates the forty days Christ spent on earth after his Resurrection.

Ascension Day, Holy Thursday, the fortieth day after Easter, commemorates the Ascension of Christ as told in the first chapter of the Acts of the Apostles. It is the last of Christ's appearances on earth after the Resurrection.

Whitsunday, also called the Feast of Pentecost, celebrates the coming of the Holy Spirit to the Apostles. Pentecost is a Greek word meaning fiftieth and the first Pentecost took place fifty days after the Resurrection; Whitsunday was the Anglo-Saxon name for Pentecost. In the Roman Catholic Church the Sundays between Pentecost and Advent are reckoned after Pentecost.

Trinity Sunday, the first after Whitsunday, honours the Three Persons of the Trinity, the Father as Creator, the Son as Redeemer, the Holy Spirit as Sanctifier. The period from Trinity Sunday to Advent Sunday is the longest season in the Church's Year.

All Saints' Day, November 1, is the Holy day on which all martyrs and saints are remembered, it is also known as All Hallows Day and the previous evening as Hallowe'en, a date for celebrations.

All Souls' Day, November 2, is a Holy day commemorating all those who have died in the Christian faith.

Feast of the Circumcision, January 1, according to Jewish law this ritual took place eight days after birth and at the ceremony the infant Jesus received his name.

104. *Signs of the Zodiac* from San Miniato al Monte in Florence. These Signs were
often used in conjunction with the Labours of the Months to depict the passing of time
and the seasons of the year. This floor, one of the most beautiful of medieval zodiac
designs, in dark green and white marble, is thought to have been laid in the thirteenth
century. The church is richly paved with a variety of animal and abstract patterns. The
Zodiac signs are: Aquarius, Pisces, Aries, Taurus, Gemini, Cancer, Leo, Virgo, Libra,
Scorpio, Sagittarius, Capricorn.

[227]

Candlemas, February 2, an early name given to the feast of the Purification of the Virgin Mary, an alternative name for this feast is the Presentation in the Temple. It commemorates the declaration of Simeon recorded in St Luke's Gospel that Jesus is 'a light to lighten the Gentiles'. Traditionally tapers and candles are blessed and carried in procession on this day.

In the Eastern Orthodox Church the Liturgical year is based on Easter and falls into three parts: the ten weeks before Easter; the Paschal Season of Easter; the rest of the year.

The Signs of the Zodiac

In Christian medieval art the twelve signs of the Zodiac as symbols of the celestial pattern of the annual seasons are often depicted with the Labours of the Months. This combination underlines the medieval sense of unity between man's earthly work and the rhythm of the heavenly bodies. The twelve signs and the twelve months did not correspond exactly but the images were commonly understood to represent the month in which the sun was in the sign.

Although the Zodiac stems from pre-Christian origins its use as a decorative calendar was common with medieval carvers and was considered astronomical rather than astrological. The Church has always taken a firm stand against the popular practice of astrology in attempting to forecast the future from the stars; but an interest in the astrological qualities of the luminaries and planets and their inter-action with the lives of men was fairly general among educated people in the Middle Ages. Carvings of the Zodiac are found all over Europe; in Italy the earliest perhaps is carved on the Sagra di San Michele in Val di Susa; there are outstanding examples at Piacenza, at Lucca and in the baptistry at Parma. Illustrated on page 227 is the marble floor at San Miniato at Florence; the primitive energy of the pagan symbols of the Zodiac have been transmitted into a lacey bower inhabited by sprites.

Categories

CLASSIFICATION MAY seem a dry subject but it can be a most helpful aid to inspiration. A craftsmen may need to plan a series of designs, perhaps for a set of objects or windows or hangings. A pageant-master might need a group of appropriate persons for a mystery play or a procession. An art teacher in a primary school may need ideas for group painting projects. One can imagine many such situations in which the useful list at the right moment will be a godsend. Here is a brief selection from those many categories that could prove of value to the artist, or to the donor of a gift to his church.

The meaning of Numbers

A sense of the inner significance of numbers has been common to most epochs and cultures. The medieval Christian mind carried this cult to extremes and allied it with a passion for symbolic symmetry. Four has been taken to stand for the material world. The four elements of Earth, Air, Fire and Water come at once to mind, as do the four points of the compass and the four seasons. In the New Testament the Evangelists are four and so are the legendary Rivers of Paradise. It is the number of the cross, the square and the cube.

Three has been held to be the number of the spiritual world. It is the number of the Trinity and for the threefold concept of man as body, mind and spirit. It has beginning, middle and end and so may be regarded as complete, a concept attributed to Pythagoras. The many triple windows of the Middle Ages were in honour of the Trinity. The combination of these two symbolic numbers 4 and 3 makes seven, combining the worlds of matter and spirit; seven was regarded as the perfect number. The Old Testament is full of significant sevenfold happenings such as Balaam's sacrifices, Pharaoh's lean and fat years, the circuits of Jericho or the bonds

of Samson. In later times among other examples in this section there are the seven sacraments and the seven gifts of the Spirit.

Eight was thought to be the number of the dispensation with the coming of Christ, particularly the number of regeneration at Baptism and so medieval fonts were often made with eight sides.

'Nine for the nine bright shiners' stands for the nine orders of Angels; ten is the number of the Ten Commandments; and twelve is most renowned as the number of the twelve Apostles; thirteen is considered unlucky because thirteen people sat down to the Last Supper and one betrayed his Master.

Forty is particularly significant in biblical description and is held to represent trial or testing such as the forty days of the deluge, the forty years the Israelites spent in the wilderness, the forty days Moses spent on Sinai. Jesus was tempted during his own forty days in the wilderness – and so we have the forty days of Lent in commemoration. One could continue with many examples of significant numbers in Bible story and exegesis.

Good design depends on proportions which may be judged by eye but are numerical at root; most artists find it is easier to compose with odd numbers such as three, five and seven than with four and two, and we nearly all have our 'lucky' numbers, whose invisible presence gives harmony to our work.

105. *Emblems of Christ*

Above left: Fish and Anchor: carved on the seven-sided travertine font at Guildford Cathedral by Alan Collins, mid-twentieth century. The letters spell 'Fish' in Greek and stand for 'Jesus Christ Son of God Saviour'. Both the fish and the anchor were symbols of the faith in early times when the threat of persecution led to the choice of secret and obscure signs.

Above right: Pelican in her Piety: a detail from the modern bronze doors of Cologne Cathedral. The Pelican according to medieval tradition wounded her breast to feed her young; this was taken to be an image of Christ's redemptive sacrifice and is still used with this meaning.

Below left: Lion breathing life into its young. From a thirteenth-century window in the Ritterstiftskirke at Wimpen im Tal; the medieval bestiary elaborated the symbolism of the Lion as a type of the Resurrection. It was believed that lion cubs were born lifeless but after three days were raised by the lion breathing into their mouths.

Right: Phoenix: detail from a sixth-century floor mosaic from Daphni, now in the Louvre. An aureole with sun's rays encircles the head and rosebuds fill the background. According to pre-Christian legend the phoenix rises anew from its ashes every five hundred years, and it thus became another emblem of the Resurrection of Christ.

Categories

Old Testament

Emblems of the Patriarchs

In the Old Testament the name Patriarch is given to the fathers of the human race described therein, especially to Abraham and his descendants Isaac, Jacob and his sons whose names were given to the twelve tribes. Not all the Patriarchs have specific emblems in Christian art, the identifying emblems are most frequently associated with them in medieval carvings and stained glass windows. Noah holds an ark or a dove with olive twig. Abraham holds the knife of sacrifice or his son Isaac. Moses holds the tables of the Law and his brother Aaron a rod or a censer. Amos who was called from his sheep to be a prophet holds a shepherd's crook. Daniel is accompanied by lions and David by a harp. Jonah is associated with a ship or a whale. Elijah may be in the chariot in which he went up to heaven, or hold a scroll.

The Prophets

The Major prophets are Isaiah, Jeremiah and Ezekiel; Daniel may be shown with these in Christian art as a fourth. The twelve Minor prophets are the authors of the shorter prophetic books: Hosea, Joel, Amos, Obadiah, Jonah, Micah, Nahum, Habakkuk, Zephaniah, Haggai, Zechariah, Malachi. In the visual arts the prophets are usually presented as a series of venerable and grave men in middle life carrying scrolls with identifying quotations from their works.

Stories of Deliverance

Among the most popular in all periods are: Noah and the animals in the ark; Abraham and the sacrifice of Isaac, told in the book of Genesis; Moses and the Israelites crossing the Red Sea, and Moses and the Water from the Rock told in the book of Exodus; and the fall of Jericho from the book of Joshua. David and Goliath comes from the first book of Samuel. Jael and Sisera, Samson and the lion and Samson and Delilah come from the book of Judges. The Three Children rescued from the Fiery Furnace, and Daniel in the lion's den are told in the book of Daniel.

From the Apocrypha come the stories of Esther and Susanna and the Elders; the latter was a favourite at a period when false witnesses might cost Christians their lives, and was used in gold decoration on the glasses found in the catacombs.

New Testament

The Magi also called the Three Kings

The wise men from the East were the first Gentiles to recognize Christ and so symbolize all Gentiles who believe in him. Their gifts of gold, frankincense and myrrh were held to be symbolic of Christ's Kingship, Priesthood and Passion. In the sixth century the names of Gaspar, Melchior and Balthasar are first mentioned and they were revered as saints during the Middle Ages. The subject of the Adoration of the Magi has been immensely popular in the art of all Christian countries.

The Twelve Apostles

Apostle is the title given in the Gospels to the twelve chief disciples of Christ. When they are shown together their number is always twelve but the same persons are not always included. According to the Roman Canon of the Mass the apostles are thirteen in number: SS Peter, Paul, Andrew, James the Great, John, Thomas, James the Less, Philip, Bartholomew, Matthew, Simon, Jude, Matthias. St Jude is usually left out to admit St Paul. When the Evangelists who were not disciples are included, Simon and Matthias are left out. In the Greek Church the apostles most usually represented are: SS Matthew, Philip, Mark, Paul, Peter, Luke, Andrew, Thomas, Simon, Bartholomew, James the Great, John.

The Four Evangelists

St Matthew: symbol, a man with wings. St Mark: symbol, a winged lion. St Luke: symbol, a winged ox. St John: symbol, an eagle. For illustration and a more detailed account of the symbols of the four Gospel Makers consult the section on The Four Living Creatures.

106. The winged ox and lion adapted from the Carilef Bible, Durham.

The Beatitudes

The Beatitudes are 'Christ's promises of coming blessings' and 'describe the qualities of Christian perfection', In the Sermon on the Mount recounted in St Matthew's Gospel there are eight blessings of a spiritual nature: 'Blessed are the poor in spirit, . . . Blessed are those who mourn, . . . Blessed are the meek, . . . Blessed are those who hunger and thirst for righteousness, . . . Blessed are the merciful, . . . Blessed are the pure in heart, . . . Blessed are the peacemakers, . . . Blessed are those who are persecuted for righteousness' sake.' These were personified in medieval art as maiden figures.

Seven Gifts of the Holy Spirit

Wisdom, Understanding, Counsel, Fortitude, Knowledge, Piety, Fear of the Lord.

From the book of Isaiah: 'And the Spirit of the Lord shall rest upon him, the spirit of wisdom and understanding, the spirit of counsel and might, the spirit of knowledge and the fear of the Lord.' The gift of Piety is added in the Vulgate text. These gifts are traditionally represented in art by seven doves. The great Jesse window at Chartres is a medieval example. The east window at Guildford Cathedral by Moira Forsyth is a fine modern use of this imagery.

107. Emblem of the seven gifts of the Spirit.

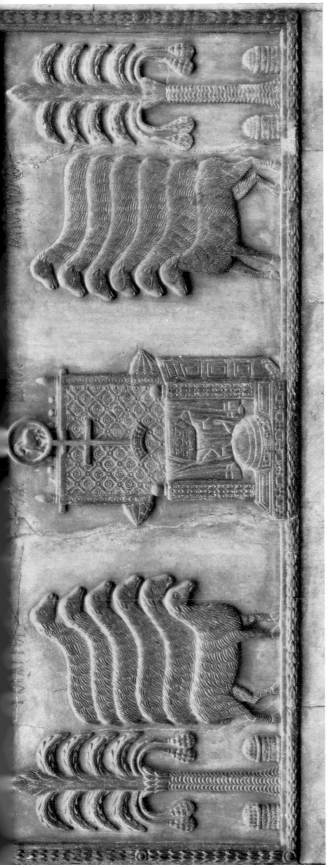

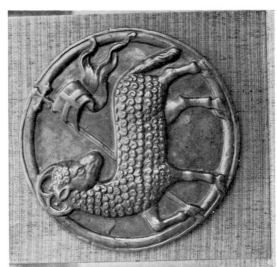

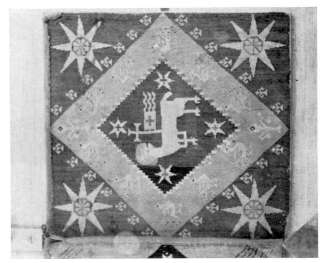

Plate 30 : caption overleaf

Plate 30: (overleaf) *Agnus Dei : The Lamb of God*

Above: The Lamb of God enthroned between the symbols of the Apostles, flanked by palms and baskets. Seventh century low relief carving on the outer north wall of St Mark's, Venice probably brought there from Constantinople. (*Photograph Alinari*)

Below left: Ivory Crozier: twelfth century Italian craftsmanship showing the struggle between the symbols of Good and Evil. British Museum.

Centre: Burse: thirteenth century embroidery in coloured silks on linen. The Lamb of God stands on a field of stars, fleurs-de-lys and peacocks. Victoria and Albert Museum.

Right: Agnus Dei: fifteenth century Florentine bronze plaque in the Victoria and Albert Museum.

Plate 31: *Cross and Chalice*

Left: The Cross of Force, designed by David Maude-Roxby. This modern processional cross was inspired by a series of dreams and is dedicated to all astronauts. It is of oak inlaid with symbolic medallions carved in perspex, chosen to show the unfolding of the Holy Spirit in the Old and New Testaments and the place of man and his planet in Space.

Right: Chalice, designed by Reginald Hill in eighteen carat gold. The gift of HRH the Duke of Edinburgh to the Archbishop of Canterbury at the time of the Coronation. Twelve stems of wheat symbolize the Body of Christ and the twelve Apostles. Three stems bind the ribbed knop symbolizing the Holy Trinity.
(*Photograph Goldsmiths' Company*)

Below right: Pectoral Cross in silver made by Dunstan Pruden for St John's Abbey, Collegeville, Minnesota. The Lamb of God on the Book with the Seven Seals.

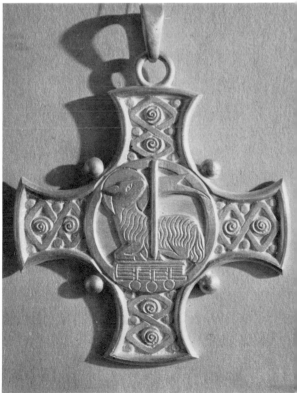

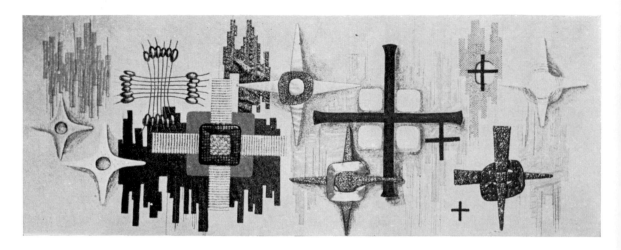

Plate 32: *Crosses and Craftsmanship*

Above: Altar Frontal designed by Beryl Dean for St Margaret's Church, King's Lynn. An abstract design of overlapping crosses in gold, metallic yarns and fabrics on an off-white ground of watered silk.

Right: Bronze lamp on the stairway to the crypt of Worcester Cathedral with rayed bronze background throwing rosy white light against the Norman stonework; one of a series designed by Jack Penton.

Left: Abyssinian Processional Cross in silver, given to Westminster Abbey by the Emperor of Ethiopia. (*Photograph the Dean and Chapter of Westminster*)

Below: Altar Cross in silver: a modern interpretation of a Celtic cross for a church in Northern Ireland designed and made by Gerald Benney, 1965. (*Photograph Goldsmiths' Company*)

Plate 33 (overleaf): *Tabernacle, Pulpit, Lectern, Altar Frontal*

Contemporary examples of the use of emblems.

Top: Tabernacle with Fish symbol in blue ceramic by Count Janusz Lewald-Jezierski for the chapel of Corpus Christi College, London. The keyhole is in the eye of the Fish.

Pulpit mosaic with cross and doves in shades of warm and cool greys by Peter Paul Etz for the church of St Canisius, Mainz.

Centre right: Symbol of St John: cast bronze eagle surmounting the lectern in Coventry Cathedral by Elizabeth Frink.
(*Photograph by permission of the Provost and Chapter*)

Below: Embroidered Altar Frontal with peacocks, from the Lutheran Church in Cleveland, USA.

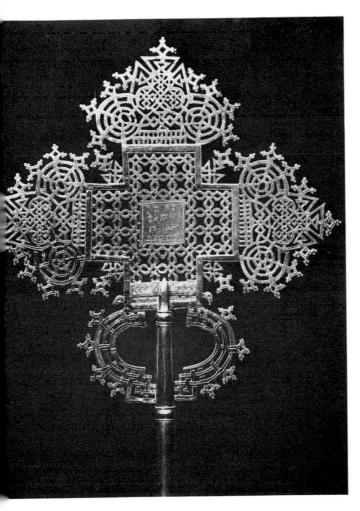

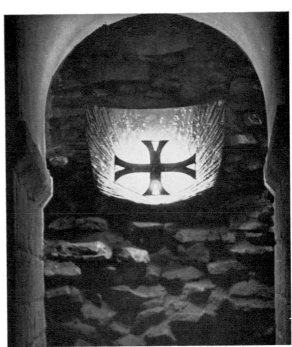

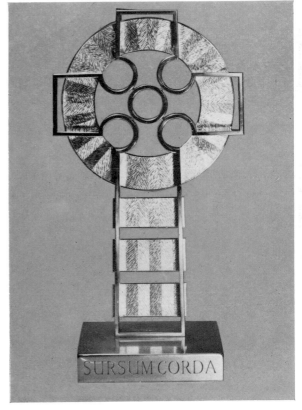

Categories

The Fruits of the Spirit

From the letter of Paul to the Galatians: 'The Fruit of the Spirit is love, joy, peace, patience, kindness, goodness, faithfulness, gentleness, self-control; against such there is no law.'

Seven Churches of Asia

Ephesus, Smyrna, Pergamum, Thyatira, Sardis, Philadelphia, Laodicea. These are the churches in Asia Minor which are addressed in the first chapter of the Book of Revelation. With the opening of Turkey to tourism more people are visiting the varied and beautiful ruins of these historic places.

Early Church and the Early Middle Ages

The Fathers of the Church

These were very early bishops and writers of authority on doctrine, who were appealed to by later writers from the fourth century onwards, in support of the orthodoxy of their teaching: St Athanasius, St Basil of Caesarea, St Gregory Nazianzen, St Gregory of Nyssa, St John Chrysostom, St Cyril of Alexandria; in the ninth century St John of Damascus was added.

The Doctors of the Church

The title of Doctor of the Church was conferred in the West on four outstanding men all saints and theologians, who lived during the fourth, fifth and sixth centuries; St Gregory the Great (*c.* 540–604), emblems a cross and a dove; St Ambrose (*c.* 334–397), emblems a beehive or a scourge; St Augustine of Hippo (*c.* 354–430), usually holds a heart as his emblem; St Jerome (*c.* 342–430), emblems an inkhorn and a lion. The number of doctors was increased during the Middle Ages. Recently the Roman Catholic Church has included St Teresa of Avila as the first woman Doctor of the Church. In the Eastern Church the Doctors are held to be: St Athanasius, (296–373), St Gregory of Nazianzus (329–389), St Basil the Great (*c.* 330–379), St

John Chrysostom (347–407). These are often shown in Byzantine mosaics wearing magnificent robes. Their likenesses are depicted according to a fixed tradition, there are examples at Palermo in the Cappella Palatina and in St Mark's, Venice.

The Seven Sacraments

The Book of Common Prayer defines a sacrament as 'an outward and visible sign of an inward and spiritual grace'. With memorable brevity St Thomas Aquinas echoing St Augustine calls it 'the sign of a sacred thing'. The Roman Catholic Church upholds seven sacraments: Baptism, Confirmation, Eucharist, Penance, Anointing of the Sick, Ordination, Matrimony. Most of the Reformed Churches hold that the two sacraments of Baptism and Eucharist as 'ordained of Christ the Lord in the Gospel are necessary to salvation'. The Quakers and the Salvation Army have no sacramental observances but hold that the Christian life should be sacramental. Each sacrament is held to be a symbol of spiritual reality in material form and exhibits the principle of the Incarnation – the union of God and man. 'The right matter, the right form and the right intention' are necessary for the sacrament to convey grace but the recipient must himself be rightly disposed.

Emblems are used to represent the sacraments on medieval fonts. In East Anglia, for instance at Salle, the carved emblems are: Baptism: a chrismatory (casket for holy oils); Confirmation: a mitre; Holy Communion: an altar; Penance: a rod; Ordination: a chalice; Matrimony: a musical instrument to stand for harmony; Extreme Unction: a soul rising from a shroud. The modern emblems of the sacraments carved on panels in the Roman Catholic church at Leatherhead, by John Skelton, are: Baptism: Candle, Chi-Rho, Water; Confirmation: the Dove; Holy Eucharist: Chalice and Host; Ordination: a pair of hands; Marriage: rings interlocked and a cross; Penance: crossed keys; Anointing the Sick: candles flanking an altar.

The Seven Corporal Works of Mercy

These are giving food to the hungry; drink to the thirsty; clothing to the naked; harbouring the stranger; visiting the sick; ministering to prisoners; burying the dead. This list is based on Christ's words reported in St Matthew's Gospel. These actions lend themselves to figurative designs.

[236]

Categories

The Seven Virtues and Seven Vices or Deadly Sins

The four natural or Cardinal virtues are: Justice, Prudence, Temperance, and Fortitude, mentioned in the Wisdom of Solomon: 'And if anyone loves righteousness, her labours are virtues; for she teaches self-control and prudence, justice and courage; nothing in life is more profitable for men than these.' The three Theological virtues named by St Paul are: Faith, Hope and Love.

To these seven Virtues are opposed seven Vices or deadly sins: Pride, Covetousness, Lust, Envy, Sloth (*Accidie*), Greed or Gluttony, Anger. The idea originated from the Psychomachia of Prudentius, thought to have been written about 400 AD, which pictured in vivid verse the inner conflict of vices and virtues. It inspired subsequent medieval carvers in their figurative images of the Virtues and Vices symbolizing the good and evil qualities in mankind. These became a usual subject for sculpture on doorways and capitals in European cathedrals. In Romanesque carvings on this theme the Virtues appear as heroic maidens engaged in battle in which each victorious Virtue transfixes her opponent Sin. In later developments the female figures of the Virtues holding shields which display appropriate emblems – such as Justice with her balance – are carved above little scenes depicting the corresponding Vices; at Chartres for example Humility sits enthroned above the scene of Pride tumbling headlong from his horse, while at Amiens Fortitude is shown opposed to a lively scene of Cowardice dropping his sword and fleeing from a rabbit.

These personifications offer fascinating costume subjects for use in modern pageants and morality plays. Children in particular enjoy interpreting the Vices and the Seven Deadly Sins either in art or acting and mime with masks of their own design.

The Seven Liberal Arts

This was the name given to the group of sciences which in medieval times was the basis of secular education, they were: Grammar, Rhetoric and Dialectic, these three were called the *Trivium*; Arithmetic, Geometry, Music, Astronomy; these four were called the *Quadrivium*. Personifications of the Liberal Arts are found in medieval art, notably in a series carved on the portals of Chartres Cathedral; on page 223 is a drawing of Grammar as a stern schoolmarm from the doorway on the West front.

Categories

Founders of Religious Orders

St Benedict (480–547) founder of the Order of Benedictines: father of Western Monasticism, his emblems are a broken cup and a raven.

St Bernard, Abbot of Clairvaux (1090–1153), founder of the Cistercian Order: his emblem is a beehive.

St Bruno (1033–1101), founder of the Order of Carthusian monks.

St Francis of Assissi (1181–1226) founder of the Friars Minor, the Franciscans: he is often depicted in art receiving the stigmata or preaching to the birds.

St Dominic (1170–1221) founder of the Order of Preaching Friars, the Dominicans: his emblems are a star and a dog.

St Ignatius of Loyola (*c.* 1491–1556) founder of the Society of Jesus, the Jesuits.

The Order of Cluny was founded in the tenth century. Later St Odo (927–942) extended its influence widely in Europe.

The Seven Champions of Christendom

The following patron saints are the traditional Seven champions of Christendom:

St George of England: a red cross on a white ground.

St Andrew of Scotland: a cross saltire gold on a blue ground.

St David of Wales: a dove

St Patrick of Ireland: a shamrock and snakes.

St Denis of France: he carries his severed head, witness to martyrdom.

St James of Spain: a scallop shell

St Anthony of Padua (Italy): the lily, the flowered cross and a book.

Soldier Saints

St George One of the most generally famed of soldier martyrs and patron saints. The facts of his life are unknown and replaced by ample legends. His badge is a red cross on a white ground and he is shown in art on horseback with a lance thrust through a recumbent dragon – from whose jaws he is said to have rescued a princess. He may have been chosen as patron saint of England about the time Edward III founded the Order of the Garter in 1348, under his patronage.

St Theodore Tradition says he was a Roman soldier and he became one of the warrior saints of the East. He is shown on horseback in combat with the obligatory dragon. One of the great pillars in the Piazzetta in Venice shows him with his dragon already vanquished; he was the original patron saint of the city before St Mark.

St Demetrius He was another early martyr of whom little fact is known. He is said to have been a deacon but legend made him a warrior saint and his popularity was widespread in the East.

St Michael the Archangel This is the paramount angel champion in the struggle against the Devil. In art he is shown fighting a dragon with a lance usually on foot. He can be identified by wings but can also be confused with the warrior saints of mortal origin whose windblown cloaks may be mistaken for angelic wings.

Collective emblems for classes of Saints

Martyrs hold a palm, a crown, a sword.

Sainted hermits hold a T shaped staff and a rosary.

Sainted pilgrims wear a hat with a cockle shell, and hold a scrip or wallet and a palmers staff.

Sainted monks or nuns are depicted in the habits of their Orders.

Founders of churches and monasteries hold model buildings and wear the habit of their Order.

Sainted Bishops and Abbots wear a mitre and hold a crozier or pastoral staff.

Sainted Popes wear the triple tiara, a cope and pallium and hold a triple cross.

Royal Saints wear a crown.

Dedications and Patron Saints

It is customary for churches and sacred buildings to be dedicated to the Trinity, to Christ the King, to the Virgin Mary, to All Saints, or to a particular Saint. In remote country regions the chosen Saint may be so local that his name is known only through the dedication. This wide subject can barely be touched on here – a list is given in Francis Bond's book *Dedications of English Churches* showing the relative popularity of saintly patrons.

It is perhaps more surprising that institutions such as the craft guilds chose a particular patron, but many of the medieval Guilds – the early forerunners of today's

trade unions – began as religious brotherhoods, just as the foundation of great hospitals with saintly names – St Bartholomew's and St Thomas's – was also religious. St John Baptist, for example, was one of the most popular of all guild patrons for trades and crafts involving wool, leather, sharp tools and even candlemaking. St Catherine of Alexandria was another popular patron; a martyr, whose association with a spiked wheel caused the carmen to adopt her emblem on their arms, and wheelwrights and mechanics to claim her as their patron saint. She is also patron of students and philosophers on account of her learning and eloquence. St Peter is the patron saint of the Fishmongers – one of the Great Twelve of the City Livery Companies of London. His keys appear in the Company's arms and fishmongers were called Petermen in the fourteenth century. St John the Evangelist is the patron saint of the writers' craft and of newspapermen; his eagle emblem appears in the arms of the Scriveners' Company holding an inkhorn and penner. The Stationers' Company have in their arms the same eagle emblem but with a nimbus, and also the Dove of the Holy Spirit, source of wisdom and truth.

Orders of Angels : The Angelic Hierarchy

Although the orders of Angels are not of much relevance to designers today, the appropriate knowledge helps to interpret medieval art. The form and dress of angels and their attributes depends on their place in the hierarchy. The origin of orders stems from the Epistles of St Paul to the Ephesians giving five ranks, to which were added Angels and Archangels and the Seraphim and Cherubim of the Old Testament.

Writing about 500 AD, in the 'Celestial Hierarchy', the mystical theologian Dionysius the Pseudo-Areopagite explains how the nine choirs of angels mediate between God and man; they are divided into three Orders:

> Seraphim, Cherubim, Thrones,
> Dominions, Virtues, Powers,
> Principalities, Archangels, Angels.

According to Dionysius the Seraphs are 'all wing', they stand nearest to God and are aflame with perfect love; Cherubs are 'all eyes' and are filled with perfect knowledge; these express the two most intense aspirations of the human soul. Thrones 'sustain the seat of the Most High'; the second order are Regents of the stars and elements; the third execute the will of God in relation to man.

Categories

In art the appearance of celestial beings in the nine orders is not fixed, but Seraphim and Cherubim usually have six wings and these may be strewn with eyes. Thrones are represented as scarlet wheels with wings and sometimes with eyes. At different times these angelic beings have been depicted in various roles; dressed in armour as the warriors of heaven, or in robes as judges carrying such emblems of authority and power as books, scrolls, crowns and sceptres. The Archangels alone have acquired definite characteristics, attributes and names. Those mentioned in scripture are Michael, Gabriel, Raphael and Uriel. The Nine Orders are carved in detail over the south portal at Chartres, and they appear on the west front of Wells Cathedral.

The Emblems of Christ

Throughout this book the emblems of Christ are referred to in the text. The Cross, the Chi Rho, the Lamb and the Fish are those most frequently depicted. In addition the Lion, Eagle, Phoenix, Pelican and Unicorn are used as emblems of Christ in an indirect manner.

The use of coloured eggs as Easter gifts – tokens of the Resurrection – was general throughout medieval Christendom.

The Instruments of the Passion

The cult of honouring the emblems of the Passion, shown individually and separated from the relevant scenes of the Crucifixion, was a development of medieval piety. Their use in stained glass, carvings and embroidery became widespread from the thirteenth century and they were esteemed as a focus for private devotions, petitions for deliverance from temptations and for forgiveness, such as that symbolized by the cock that crowed to St Peter. In folk art and folklore there are many examples of their use.

The instruments are often shown grouped on either side of the Cross or the Sacred Monogram; the number of objects vary but usually they are: the Crown of Thorns; the nails; the pillar, cord and scourges; the seamless robe; the dice; money-bags and thirty pieces of silver; the ladder, reed and sponge; a lance and sword; pincers and hammer; the veil of St Veronica; a cock and lantern. In later medieval art the five wounds of Christ are among the emblems of the Passion.

Christ of Pity

This is the name given to the figure of Christ depicted showing his wounds and is associated with the Emblems of the Passion. The image recalls the legend of St Gregory who had a vision while celebrating Mass. Subsequently these images became very popular especially when lavish indulgences were granted to those who said prayers before them. Fifteenth-century woodcuts show the Christ of Pity within a border containing the instruments of the Passion and objects associated with it. M. D. Anderson says that 'it was probably the Stigmatization of St Francos in 1224 which gave the greatest impetus to the cult of the Five Wounds'.

These Wounds as well as the Emblems of the Passion were often displayed heraldically as charges upon shields held by angels; alternatively figures of angels hold the instruments themselves. The finest existing series in England are the sixteenth-century carved and painted roof bosses in the choir vaulting of Winchester Cathedral.

In a medieval stained glass window at St Nicholas church, Sidmouth, a shield is blazoned with the two hands and two feet of Christ and in the centre the heart, above each wound is a small gold cross and under the hands an inscription with the words 'Wel of Wisdom' and 'Wel of Mercy', under the feet 'Wel of Grace' and 'Wel of Ghostly Comfort' and under the heart 'Wel of Everlasting Life'.

Today the use of the emblems of the Passion is limited mainly to ecclesiastical embroidery, the most appropriate being in the Lenten array. But the nails and the crown of thorns have stimulated designers of metal work and silver. The striking modern wrought-iron screen in the shape of the Crown of Thorns at Coventry Cathedral is an example; this was designed by Sir Basil Spence and made and given by the Royal Engineers. It stands as the gate to the Chapel of Christ in Gethsemane and through the Crown can be seen the mosaic figure of the kneeling angel with the symbolic Cup of Christ's Passion.

The Stations of the Cross

The devotion to the Way of the Cross probably originated with pilgrims returning from the Holy Land who having followed in Jerusalem the Via Dolorosa, the traditional route from Pilate's house to Calvary, wished to recall at home the Way of the Cross as an aid to prayer.

Catholic churches are furnished with a series of pictures or carvings showing incidents on the journey of Christ from Pilate's house to the entombment. These are designed for devotional purposes and are usually fixed to the walls of the nave or aisles. They may also be placed out of doors along a way leading to a church or a shrine. The Stations of the Cross may be an elaborate and conspicuous feature in a church, although plain wooden crosses are all that is actually required to signify the Way of the Cross. The number and choice of incidents depicted varied at different times until the eighteenth century when they were fixed at fourteen. The incidents which the Stations now represent are:

1. Jesus is condemned to death. 2. Jesus receives the Cross. 3. Jesus falls the first time under the Cross. 4. Jesus meets his Mother. 5. Simon of Cyrene is made to bear the Cross. 6. Veronica wipes the face of Jesus. 7. Jesus falls the second time. 8. Jesus meets the women of Jerusalem. 9. Jesus falls the third time. 10. Jesus is stripped of his garments. 11. Jesus is nailed to the Cross. 12. Jesus dies on the Cross. 13. Jesus is taken down from the Cross. 14. His body is laid in the sepulchre.

The Stations of the Cross have inspired art of high quality and in different media. On Plates 3, 20 and 27 are examples from a modern series in ceramic, distinguished by restraint and simplicity. The series of low-relief carvings made by Eric Gill, the sculptor, for Westminster Cathedral are familiar to Londoners.

The Emblems of the Blessed Virgin Mary

The great devotion to the Blessed Virgin Mary in the Middle Ages linked many flowers with her name of which the Lily, emblem of purity, and the Rose were the chief; olive and cypress trees were also associated with her name. The five petals of the rose were seen both as the Five Joys of Mary and the five letters of her name 'Maria'; references to the rose in the Scriptures reinforced the symbolism, for example the words from Ecclesiasticus: 'Listen to me, O you holy sons, and bud like a rose growing by a stream of water; send forth fragrance like frankincense, and put forth blossoms like a lily.' The medieval devotion of the Rosary perpetuated the rose symbol and established the use of the white rose for the Joyful Mysteries, the red for the Sorrowful Mysteries and the gold for the Glorious Mysteries.

Among her emblems the crowned 'M' is an attractive form and is found carved on medieval bench-ends and bosses; an example in flush-work is shown here. The badge of the wing-enclosed heart, sometimes pierced with a sword and displayed on a shield is known as the *Arma Virginis* – the Arms of the Virgin; it refers to the words from St Luke: 'And a sword will pierce through your own soul also'.

Among the many Old Testament prefigurations of the Virgin are the Tower of David, the Fountain Sealed, the Garden Enclosed, Gideon's Fleece, the Rod of Jesse and the Burning Bush; these became names or types of the Virgin and in this form may appear in medieval carvings, stained glass and manuscripts.

The Rosary may be thought of as a string of beads, but it was originally founded as a devotion to the Fifteen Mysteries of the Blessed Virgin Mary and the beads represent prayers.

The Five Joyful Mysteries are: the Annunciation; the Visitation, the Nativity, the Presentation in the Temple, the finding of the Christ Child in the Temple.

108. *Emblems of the Blessed Virgin Mary*

Top: Crowned Monogram. The MR stands for Maria Regina, a fifteenth-century design from the church of St Mary the Virgin at Woodbridge, in the local flush-work of dark blue flint set in white stone. Refined and precise decoration was achieved with this laborious craft throughout East Anglia.

Two Cyphers of the Virgin

The Pierced Heart: from a medieval roof boss in Bristol Cathedral. This emblem refers to Simeon's prophecy in the Temple. The encircling wings express loving care.

The Winged Heart: from a medieval roof boss in Bristol Cathedral.

Crowned letter M: signifying Mary as Queen of Heaven, from a painted medieval roof boss from Congresbury, Somerset.

The Five Sorrowful Mysteries are: the Prayer and Agony in the Garden, the Scourging at the Pillar, the Crowning with Thorns, the Carrying of the Cross, the Crucifixion and Death of Christ.

The Five Glorious Mysteries are: the Resurrection, the Ascension of Christ into Heaven, the Descent of the Holy Ghost to the Apostles, the Assumption, the Coronation of the Blessed Virgin Mary in Heaven and the Glory of all the Saints. The traditional *Seven Sorrows* of the Blessed Virgin Mary are: the prophecy of Simeon, the flight into Egypt, the loss of the Holy Child, meeting Jesus on the way to Calvary, standing at the foot of the Cross, the taking down of Christ from the Cross, His Burial.

Later medieval artists represented the Seven Sorrows by a figure of the Virgin standing with seven swords radiating from her heart like the rays of light from an aureole.

109. Initial M of the 'Magnificat' from the ninth-century Corbie Psalter now in the Bibliothèque Municipale, Amiens.

110. Peacock sculpted in low-relief, about twelfth century, now in the Archaeological Museum in Istanbul. The popularity of peacocks in Byzantine designs obviously owes much to its symbolism, but from the artist's point of view probably even more to the scope for variation of line and texture given by this elegant bird. Sometimes the drawing of one feather can deputize for the whole ceremonial tail.

The Liturgy and the Crafts

MUSIC, SCULPTURE, painting and works of fine craftsmanship have all been expressions of Christian worship since early times and it is still important that the works of craftsmen should be appropriate to their function and to the part of the church for which they are intended.

Ecclesiastical design may well be symbolic, and traditional iconography can usefully be studied and absorbed in order to achieve a sound understanding of symbolism. Ideally a designer's work for the Church should be the product of close collaboration between architect, artist and clergy. Gifts as diverse as stained glass, plate and embroidery are still individually presented to a church; they can make a useful and equally enduring memorial, in place of the more usual marble tablet on a wall: but no work may be put up in a church without a faculty – the name for a dispensation or licence given for this purpose.

In the Anglican Church a faculty must be granted by the Chancellor of a Diocese, to cover the work of artists and craftsmen intended for a church and for all additions and alterations. In the Roman Catholic Church the scope of Christian art is formulated in the Encyclical Letter of Pope Pius XII on the

Sacred Liturgy and in the Constitution on the Sacred Liturgy of the Second Vatican Council, especially Chapter VII; these make clear that an understanding of the background and doctrine of the Catholic Faith should be known by artists employed by the Church. In the Nonconformist Church the decision on what is placed within a church normally rests with the trustees or the local committee.

Ecclesiastical Embroidery

Vestments, altar linens, furnishings and palls have long been a field where the use of embroidered symbols and emblems is particularly appropriate. In fact one of the most famous periods in English art was during the thirteenth and fourteenth centuries when the ecclesiastical embroidery known as *Opus Anglicanum*, prized at the time all over Europe, reached its greatest perfection. In the Syon Cope and the Butler Bowden Cope, to take only two examples now in the Victoria and Albert Museum, scenes from the life of Christ and the Saints are combined with intricately designed arcading, vine-scrolls, angelic figures, emblems and coats-of-arms, superbly worked in silks. The finished effect is as densely textured and rich in detail as the manuscript illumination on vellum of the period. Today the taste in ecclesiastical design, in sympathy with much modern art, is toward the abstract. There is little demand for pictorial representation but formal symbols, bold stylized lettering and geometric pattern are used, in association with exceptionally rich and varied textures and materials.

Vestments worn by the officiating clergy are seen by the congregation as part of the action and ritual of the services of worship. As such they form one essential group of objects that may be designed and decorated by embroiderers. The other group of objects is static in effect: these are the altar linens, hangings and accessories in the church building, and the two groups should combine together to form a decorative whole. For the sense of unity, so vital a part of Christian faith, can best be served by artists and craftsmen when they collaborate with architect and priest to bring this sense of wholeness into the scheme of decoration, a scheme in which ecclesiastical embroidery may often play an important part. Unity in this context does not mean devising a monotonous colour scheme throughout the building. Variety and balance of the colours and the scale of decoration is certainly as important as harmony. It can be very dull when all the kneelers in a church have been patiently worked in the same two colours, without enlivening variety.

The Altar, the Lord's Table, or the Holy Table as it is called in the Eastern Liturgy, is the most important symbol in Roman Catholic and Anglican church buildings. Basically the altar is a block of wood or stone, sometimes supported on four columns. Many altars have beauty of form and are intended to be veiled only with a fine textile or antependium to express homage and reverence. The altar of Melchizdek in the sixth-century mosaic in San Vitale is shown covered with a cloth and furnished only with the bread and wine. Famous frontals in precious metals survive – the ninth-century beaten silver altar-frontal in S Ambrogio at Milan for instance, and the golden antependium from Basle Cathedral now in the Cluny Museum.

For more than a thousand years the priest celebrated the Mass from behind the altar and facing the congregation; then in the twelfth century a change took place, the priest moved to the front of the altar, which was placed against the east wall of the Sanctuary. As a result the laity came to be spectators rather than participants in the celebration of the Holy Eucharist. In this position the altar became enriched with a retable, or later a triptych, and these were often of great splendour and beauty; one of the most remarkable being the Romanesque retable from Lisbjerg now in the Copenhagen National Museum, and another the fifteenth-century triptych at Ghent showing 'The Adoration of the Lamb' by Van Eyck. From the time of the early Christian persecutions it was customary for the altar to contain a holy relic, and by the thirteenth century the altar often had a reliquary actually placed upon it.

The Liturgical Movement in this century has brought about a widespread general interest in the Liturgy and a more active participation by the laity. The earlier custom of the priest celebrating the Eucharist facing towards the people from behind a free-standing altar is gaining ground. There is new thinking today about the purpose and function of altar-hangings and vestments; their style, shape and ornament. The design of a frontal to suit the placing of the altar is obvious, a free-standing altar seen from all sides needs different treatment from one placed against a wall.

By the choice of apt symbol, good design and imaginative use of the Liturgical colours, attention can be drawn to the altar – the focal point of worship in the church. The work of skilled and sensitive embroiderers is needed to achieve this high aim. However it should be remembered that it is not the frontal or the embroidery that must command attention but the altar itself.

The development of modern craftsmanship has encouraged the revival of fine handweaving, notably in Germany, Switzerland and Spain where vestments are

being made from specially woven materials which depend for their distinction on their line, texture and colour rather than on surface decoration. As silk and wool are better for such weaving than man-made fibres, the initial expense, the cleaning and the upkeep of these beautiful garments are factors which must be considered. Today the cope is the most suitable vestment for richness of decoration and the use of symbols. There is scope also for embroiderers to make dignified designs for the stole, maniple, burse and veil; and on a larger scale there is splendid opportunity for the relevant use of symbols on altar frontals, pulpit falls and banners, as well as on the smaller accessories such as kneelers, runners, alms-bags and cushions. It is perhaps not too high a claim to say that some ecclesiastical embroidery made in England today can hold its own with the medieval *Opus Anglicanum*.

Liturgical Vestments

'Liturgical vestments, the distinctive dress worn by the clergy, have their origins in early Christian worship'; they developed from the everyday clothes worn by Roman citizens at the time of Christ. The principal vestments were established by the tenth century and apart from minor additions they are still in current use, but their shape and enrichment has naturally varied with the style and taste of the period.

Processional vestments are generally worn in cathedrals and great churches on ceremonial occasions when the cope is the principal vestment.

Vestments worn in celebrating the Eucharist have been endowed with special significance, they are the Alb, Amice, Girdle, Stole, Chasuble and Maniple, also the Dalmatic and Tunicle if they are in use.

Alb: an ankle-length, sleeved garment usually made of white linen and bound at the waist by a *Girdle* or cord which as part of the Eucharistic vestments represents the cords which bound Christ at the Passion. The alb may be decorated with apparels at the cuffs and the lower front hem.

Amice: this is a white linen neck-piece covering the shoulders and worn with the alb; it may have an apparel which encircles the neck like a standing collar. It was originally a hood to cover the head and neck symbolizing the helmet of salvation.

Apparel: this is a decorative panel, usually embroidered, which is applied to the alb, amice and other vestments.

Chasuble: the principal vestment worn by the priest for celebration of the Eucharist, it derived from the Roman woollen cloak. Medieval chasubles were large and conical or oval in shape, without sleeves and with an opening in the centre to go over the head of the celebrant. The chasuble is usually made of silk or linen and decorated on the back with orphreys often in the shape of a cross. It represents the seamless robe placed on Christ after the Scourging.

Cope: this is the principal vestment worn for ceremonial occasions. It is a long semi-circular sleeveless cloak of rich material which envelops the other vestments. The front edges are usually decorated with embroidered orphreys. At the back of the neck there is a hood, triangular or shield-shaped but which is no longer used to cover the head. The cope is fastened across the chest by a rectangular piece of material, a metal brooch or clasp called a *Morse*.

Dalmatic and Tunicle: these are basically the same calf-length, sleeved tunic with narrow strips of contrasting material applied from shoulder to hem and known as *Calvi*.

Maniple: this is a narrow strip of material worn over the forearm, derived from the napkin carried by court officials in classical times, it signifies the Washing of the Disciples' feet and hence service. It has recently been abolished in the Roman Catholic Church.

Mitre: this is a double-peaked head dress of silk, usually embroidered and sometimes jewelled, it has two lappets pendant from the back. The mitre was low and simple in form until the thirteenth century after which time it increased in height and grandeur.

Orphreys: these are decorative bands, often embroidered, applied to a cope or chasuble; they are not an integral part of the garment but were generally used to cover the seams.

Stole: this is a long narrow piece of embroidered silk worn like a scarf round the neck and falling to the knee. It is a sign of the priest's authority.

Surplice: this is substituted for the alb on many occasions.

Episcopal insignia consists of the mitre, ring, gloves, stockings and sandals, pastoral staff or crozier; to these an Archbishop adds the pall and the cross-staff carried by his chaplain.

In the Eastern Church the principal vestments are similar to those in the West but differ in shape.

Altar Linen

Altar linen is a collective term for the cere-cloth, altar cloth or fair linen, corporal, chalice veil, purificator and pall, and the burse; these collectively are sometimes called the Fair Linen.

Cere-cloth: this basically covers the altar; it may be made of unbleached coarse linen and waxed, and lies beneath the fair linen.

Altar cloth: this is a long linen cloth which covers the top of the altar and hangs over the ends, it is often embroidered with five crosses.

Corporal: a linen napkin embroidered with a cross which is laid on the altar over the fair linen and the communion vessels are placed on it.

Veil: a textile covering for liturgical objects such as the chalice and pyx, the material usually matches the burse.

Purificator: a linen napkin used to cleanse the chalice after the celebration of the Eucharist.

Pall: the communion pall is a small square of card or metal covered with white linen and placed over the chalice.

Burse: a square pocket, a kind of purse, which holds the corporals, the linen chalice veil and the purificators (the cloths used in the celebration of the Eucharist).

Altar Hangings

Altar hangings consist of the *Antependium or Frontal*, a cloth usually of silk or damask which hangs in front of the altar reaching to the floor, often decorated with orphreys and enriched with symbols.

Superfrontal: a cloth of silk or of lace which covers the altar and hangs over the frontal for about ten inches.

Dossels and Riddels are the curtains which may hang behind and on either side of the altar.

Pulpit Fall or *Antependium*: this is a cloth which hangs from the front of the pulpit or lectern and which may be decorated with appropriate devices.

Liturgical Colours

The traditional colours used in the Liturgy have symbolic meanings and their sequence is of medieval origin. Many cathedrals and the more wealthy churches possessed sets of vestments and altar frontals in the appropriate colours for every season in the Church's Year, others used a finer set for festivals and a plainer one for all the other seasons. Today it is usual to observe Feast days and Seasons by changes in the colour of vestments and altar hangings.

In the Eucharistic vestments the appropriate colour is generally used for the stole, maniple and chasuble, also the chalice veil, burse and altar hangings. The exact shade of the colour is a matter of choice and such factors as the style and decoration of the church should be taken into consideration. The standard sequence of colours prescribed in Roman service books, with minor variations, is as follows:

White or cream or gold for festivals such as Christmas, Easter, Ascension and sometimes on Saint's days.

Red symbolizing fire and blood, at Pentecost and on the feasts of martyrs.

Green, the colour of nature, signifies God's provision for man's needs. It is generally used after Epiphany until Septuagesima and after Trinity Sunday until the eve of Advent Sunday.

Purple or violet or blue signifies preparation or penance, so is used for Advent, Vigils, Ember Days and Passiontide.

Black was formerly used in the Roman Catholic Church for Good Friday, All Souls' and Requiem Masses, but is discontinued. The Church is now more aware of cultural differences; for instance in Japan black signifies joy and white is for mourning.

This colour sequence is known as the Western use and is followed by some churches in the Church of England, while others prefer one of the older English usages. Westminster Abbey has followed its own traditional sequence for centuries.

The Eastern Church has no definite colour sequence. From Easter to Ascension-tide white is used at all services including funerals and more sombre colours at penitential seasons.

Liturgical Objects

These are the various objects used in the ritual of the services of the Church. They all serve a practical purpose and may have symbolic form and meaning. They lend themselves to decorative treatment and their design and ornament naturally reflect the style of the period in which they were made.

In early times and those of stringency, these objects were simple and serviceable but with the growing wealth and power of the Church the most sumptuous materials and embellishments were used for princely examples of liturgical objects, such as chalices, patens, reliquaries, crosses, candlesticks, gospel-book covers and the like. To our eyes these may appear overloaded with jewels and ornament but in their own day this richness was to honour Christ as well as to show the wealth and generosity of the donor and the imaginative skill of the craftsman. Today we prefer simplicity of form, functional shape and little enrichment. Over the centuries many of these precious medieval objects in gold and silver have been melted down and the jewels sold, but much still remains in cathedral treasuries, especially in France and Italy, and in the national museums of all Christian countries. Those who are interested in symbols and emblems in ornament will find this field a rewarding study.

The work being done today is a mirror of the range of taste and style characteristic of modern craftsmanship. Examples in ceramic and glass of a new intensity of colour is a contemporary trend and counterpoints the austerity of some modern church interiors. The warmth of bronze furnishings and the popularity of gold embroidery on altar frontals and vestments is linked perhaps to this desire for areas of colour and brightness to contrast with plain surfaces. A list of liturgical objects on which symbols and emblems can be aptly used may be helpful in this context.

Some of the chief liturgical objects are: Chalice, paten, tabernacle, ciborium, pyx, monstrance, processional cross, altar cross and candlesticks, and censers.

Chalice: the drinking cup, usually of silver or gold in which the wine is consecrated at the Eucharist. The early form was the two-handled cantharus seen in mosaics and carvings, which was sometimes of glass. Elaborate early Byzantine chalices of onyx and agate survive. In the West the twelfth- and thirteenth-century chalices with their shallow bowls, broad base, round knop and simple decoration were wholly satisfying. Later Gothic examples became top heavy and over elaborate. Today there is a return to simple unencumbered outlines and well balanced proportions.

Paten: the round shallow plate on which the bread is consecrated at the Eucharist

and from which it is administered. The early patens were made of glass and may well have been decorated in the gold leaf technique. Later they were made of silver and gold. An exquisite Byzantine example in the treasury of St Mark's, Venice, is of carved alabaster with inlays in enamels and jewels. The paten today has become smaller in scale since the use of wafer bread became usual. In the Eastern Church this plate is called a discos and is larger, more concave and may have a central foot.

Tabernacle: a place for keeping the consecrated elements of the Eucharist in safety; therefore usually a cupboard with a lock. In medieval times the tabernacle was shaped like a tower and stood on the altar, or as a dove suspended on chains above the altar. On Plate 33 is a modern example in symbolic form; the eye of the fish is the keyhole.

Ciborium: a lidded vessel, usually of precious metal, resembling a covered chalice in which the consecrated bread is reserved when placed in the tabernacle.

Pyx: a small round box usually of silver for carrying the consecrated bread to the sick.

Monstrance: a vessel devised in the middle ages for carrying the Host in procession and still in use today. The early monstrances of precious metals and crystal resembled portable shrines or caskets decorated with symbols and ornament. Later the monstrance came to be shaped like the sun in splendour with golden rays springing from a circular glass disc in which the Host is visible for veneration, it then becomes a Eucharistic symbol in itself.

Cruets: these twin containers for wine and water are usually of precious metal, glass or crystal and the lids may be surmounted by a cross.

Ewer or Acquamanile: the ewer is for water for the hands and may be simple in shape. The medieval acquamanile were made in the forms of fabulous beasts, such as the example drawn on page 203.

Crosses: Altar crosses vary widely in their design, scale and elaboration. Modern design tends to simplification and the cross may be isolated against a plain surface, but in many churches the existing background is an elaborate reredos or retable and the form of the cross may not easily be seen. In Roman Catholic churches it has been obligatory since the sixteenth century to have a crucifix on the altar during the celebration of the Mass.

A processional cross is carried in front of the choir or during an ecclesiastical procession. The form gives scope for dignified design on an impressive scale. An elaborate Abyssinian example in Westminster Abbey is illustrated on Plate 31. Some

interesting modern crosses have been made for new churches and cathedrals. At Coventry the cross carved from perspex by Leslie Durbin, and given as a memorial to the R.W.V.S., bears the symbols of the Lamb, the four Evangelists and St Michael modelled and chased in gold.

A pectoral cross is normally a personal possession for private devotion, but these crosses have become a sign of Episcopal office and it is the custom for a bishop to wear one on a long cord round the neck. Medieval pectoral crosses were sometimes made in the form of small reliquaries.

Crozier: the pastoral staff of a bishop and a symbol of his authority. The early forms were shaped like a shepherd's crook; in the middle ages the crozier-head, retaining the symbolic crook became a vehicle for complex figurative design in ivory and metal work. The silver crozier designed for Coventry by Sir Basil Spence embodies the Crown of Thorns set with a crystal engraved with the dove of the Holy Spirit. The crozier made for the Bishop of Guildford by Dunstan Pruden is in the form of St George fighting the dragon.

Church Wardens' Staves: the symbol of office of the Vicar's Warden and the People's Warden. The ornamental top to the staff is an opportunity for the use of appropriate emblems and ecclesiastical heraldry.

Thurible or Censer: a vessel with a cover, hung on chains in which incense is burned. Incense is a mixture of gum resins and spices, it is burned ceremonially in services of worship, the fragrant smoke being a symbol of prayer.

Reliquary: ornamental container for holy relics, usually made of precious metal often elaborate in shape and symbolism. Reliquaries were made in enormous numbers during the middle ages when the veneration of relics was at its height and pilgrimages to shrines of saints were a popular enthusiasm. The pilgrims naturally wanted to see the small revered relics, so transparent containers of crystal were mounted on stands which lent themselves to a rich display, and encouraged donations to the church from the pilgrims.

111. Peacock bronze lamp from the Dumbarton Oaks Collection, USA.

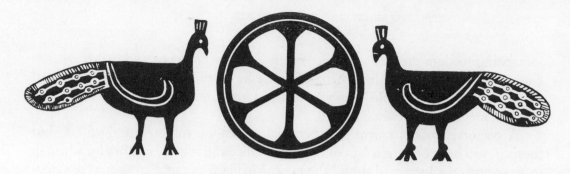

List of Books

THE AUTHORS express their gratitude to the many writers on Christian art and history without whose works this present book could not have been made. It would not be practical however to list all the books consulted, a brief selection is given here and the bibliographies in many of these will lead a student on to further reading.

Reference Books

The Revised Standard Version of the Bible, published by Nelson, has been generally used in quotations although certain familiar poetic phrases from the Authorized Version are essential to the understanding of some visual symbolism.
The Apocryphal New Testament, translated by M. R. James (Oxford 1926) gives the source material for many legendary scenes used by medieval artists.
We have consulted the *Oxford Dictionary of the Christian Church* (London 1957) as our principal dictionary of fact and theology. *The Larousse Encyclopaedia of Byzantine and Medieval Art* and *The Larousse Encyclopaedia of Ancient and Medieval History* (Paul Hamlyn, London 1963) are commendable. *The Penguin Dictionary of Saints*, Donald Attwater (London 1966) and *Saints and their Attributes*, Helen Roeder (Longmans, London 1955) are full of helpful information.
Among early English poems mentioned in the text, which may be of interest to the reader are: *Piers the Ploughman*, William Langland, translated by J. F. Goodridge (Penguin Classics, London 1959) and *The Earliest English Poems*, translated by Michael Alexander (Penguin Classics, London 1966).
Also in paperback are *The Early Church*, by Henry Chadwick (Pelican History of the Church, Volume I, London 1967) and *Early Christian Writings*, translated by Maxwell Staniforth (Penguin Classics, London 1968) which give a vivid historical background to our subject.

112. Chrismon with confronted peacocks from a panel in the south transept of St Mark's, Venice.

List of Books

Symbolism

The earnest Victorians found the subject of Christian symbolism of particular interest as well as the related subject of Christian archaeology. Among the books of this period worth seeking out are: *Early Christian Symbolism in Great Britain and Ireland before the Thirteenth Century*, by J. Romilly Allen (London 1887); Napoleon Didron, *Christian Iconography*, translated by Margaret Stokes (London 1907); F. Edward Hulme, *Symbolism in Christian Art* (Allen & Unwin, London 1910); Louisa Twining, *Symbols and Emblems in Early Christian Art* (Murray, London 1885); *Sacred and Legendary Art*, by Mrs Jameson (London 1848).

In our own century the single most illuminating book on the subject of medieval symbolism is: Emile Mâle, *Religious Art in France of the Thirteenth Century* (Paris 1902; first published in English by Dent, London 1913; in paperback as *The Gothic Image*, Fontana, London 1961).

Among more modern works with emphasis on the visual aspects are: M. D. Anderson, *The Imagery of British Churches* (Murray, London 1955); George Ferguson, *Signs and Symbols in Christian Art* (Galaxy Books, London 1966); Gerard de Champeaux and dom Sebastien Sterckx OSB, *Introduction au Monde des Symboles* (Zodiaque, Paris 1966).

For general reading: Anthony C. Bridge, *Images of God* (Hodder, London 1960); Dr Gilbert Cope, *Symbolism in the Bible and the Church* (SCM Press, London 1959); F. W. Dillistone, *Christianity and Symbolism* (Collins, London 1955); Stephen Spinks, *Psychology and Religion* (Methuen, London 1963); Dr Hans Jenny, *Cymatics* (Basel 1967).

Art History

It is in this rich field that it is hardest to make a brief selection. Among the many admirable *Series* of histories of art easily available, we would list the following:

from 'The Pelican History of Art' (Penguin Books, London)
 Margaret Rickert, *Painting in Britain: The Middle Ages*, 1954
 Lawrence Stone, *Sculpture in Britain: The Middle Ages*, 1955
 John Beckwith: *Early Christian and Byzantine Art*, 1970

from 'Art of the World' (Methuen, London)
 Andre Grabar, *Byzantium*, 1963
 Paolo Verzone, *From Theoderic to Charlemagne*, 1967
 Marcel Aubert, *High Gothic Art*, 1964

[257]

from 'The World of Art Library' (Thames and Hudson, London; Praeger, New York)
 John Beckwith, *Early Medieval Art*, 1964
 David Talbot Rice, *Art of the Byzantine Era*, 1963
 Andrew Martindale, *Gothic Art*, 1967
from 'The Oxford History of English Art', (Oxford University Press, London and New York)
 David Talbot Rice, *English Art 871–1100*
 T. R. S. Boase, *English Art 1100–1216*
 Peter Brieger, *English Art 1216–1307*
 Joan Evans, *English Art 1307–1461*
from 'Landmarks of the World's Art', Paul Hamlyn (London)
 Jean Lassus, *The Early Christian and Byzantine World*, 1967
 Peter Kidson, *The Medieval World*, 1967

Of individual works, early Christian art and history are admirably surveyed by F. van der Meer and Christine Mohrmann in their *Atlas of the Early Christian World* (Nelson, London 1966).

For the Early Christian and Byzantine periods the following:

F. van der Meer, *Early Christian Art* (Faber & Faber, London 1967)

David Talbot Rice, *The Beginnings of Christian Art* (Hodder, London 1957)

Eduard Syndicus, *Early Christian Art* (Burns & Oates, London 1962)

Michael Gough, *The Early Christians* (Thames & Hudson, London 1961)

Gervase Mathew, *Byzantine Aesthetics* (Murray, London 1963)

Philip Sherrard, *Iconography of a Sacred City* (OUP, London 1969); *The Greek East and Latin West* (1959)

Francoise Henry, *Irish Art in the Early Christian Period to A.D. 800* (Methuen, London 1965); *Irish Art during the Viking Invasions, AD 800–1020* (1967); *Irish Art in the Romanesque Period, AD 1020–1170* (1970)

T. D. Kendrick, *Anglo-Saxon Art to 900* (Methuen, London 1949)

For the medieval period in addition to the *Series* already mentioned:

Henri Focillon, *The Art of the West: Romanesque* (Phaidon, London 1963)

Henri Focillon, *The Art of the West: Gothic* (Phaidon, London 1963)

Ernst Kitzinger, *Early Medieval Art in the British Museum* (London 1963)

Francis Bond, *Dedication and Patron Saints of English Churches: Ecclesiastical Symbolism, Saints and their Emblems* (OUP, London 1914)

List of Books

Arthur Gardner, *English Medieval Sculpture* (Cambridge University Press 1951)

F. H. Crossley, *English Church Craftsmanship* (Batsford, London 1941)

C. J. P. Cave, *Roof Bosses in Medieval Churches* (Cambridge University Press 1948)

David M. Lang, *The Georgians* (Thames & Hudson, London 1966)

George Henderson, *Gothic* (Penguin Books, 1967)

George Henderson, *Chartres* (Penguin Books, 1968)

Among books which include modern work in this field:

Winefride Wilson, *Christian Art since the Romantic Movement* (Burns & Oates, London 1965)

Iris Conlay and Peter F. Anson, *The Art of the Church* (Burns & Oates, London 1963)

Christianity and the Visual Arts, edited by Gilbert Cope (Faith Press, London 1964)

Eric Newton and William Neil, *The Christian Faith in Art* (Hodder, London 1966)

Most of the Christian symbols and imagery which have been described in this book, but not illustrated through lack of space, can be found reproduced in 'Landmarks of the World's Art'.

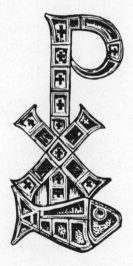

113. Chi Rho and Fish Symbols made in ceramic by Count Janusz Lewald-Jezierski for the main doors of Corpus Christi College, London.

Index

Index

Index

Hodigitria 88
Holy Ghost 112
 Descent of the 245
Holy Cross Day 26
Holy Land 85, 170
Hope 237
Hospital, St Bartholomew's 240
 St Thomas's 240
Host, The 116, 204, 236, 254
Hoveringham 162
Howard, Constance *Pl. 24*
Hulme, Edward 208
Hutton, John 134, *Pl. 19, 21, 28*

IC 20-1
ICHTHYS 12, 13, 210-11, 230-1
Iconoclast rule 26
Iconography defined xvii
Ignatius of Loyola, St 238
IHC 20-1
IHS 20-1, 22, *Pl. 25*
Image defined xvii
Imagery of British Churches 130
Incarnation, The 67, 87, 101, 159
Incense 101
Inkhorn 235, 240
Isaac 50, 52-3, 143, 158, 161, 214, 232
Isaiah 86, 100, 156, 158, 232, 234
Israel 44, 124
 Twelve Tribes of 158
Israelites 104, 206
Istanbul 122, 124
Ivy 198

Jack-in-the-Green 202
Jacob 124, 158. Sons of, 158
Jacob's Well 105
 Ladder 124
Jael 232
James (the Greater), St 26, 58-9, 78, 79, 169, 170, 238
James (the Less) St 170, 171
 Epistle of 171
James of Compostella, St 169, 170
James, M. R. 94
Jamtland 24
Janus 222
Jarrow Monastery 155
Jehovah 156
Jenny, Dr Hans 8, 190
Jeremiah 156, 158, 232
Jerome, St 178, 215, 235
Jerusalem 11, 38, 158, 171, 208, 242
 the New 86, 88
Jesse 159

Jews 14, 60, 122, 124, 139, 142, 158
 as the vine 208
 exile of 158
Jezebel and Anna 93, 94, 198
Joan of Arc, St 165
Job 195
John, St 26, 43, 55, 58-9, 76, 78, 79, 102, 105, 108-9, 132-3, 170, 171, 173, 178, 179, 212, 240, *Pl. 20*
 eagle of, 51, 184-5, 186-7, *Pl. 33*
John the Baptist 2, 98, 104, 126, 159, 160-1, 164, 214, 240
John Chrysostom, St 164, 236
John of Ephesus, St 28
Jonah 3, 67, 70, 104, 108, 110, 141, 143, 151, 155, 232
Jordan River 102, 105, 159
Joseph, St 86, 88-9, 93, 98-9, 100, 200
 Dream of 124-5
Joseph of Aramathea 76
Josephus 171
Jouarre 176, 188
Judas Iscariot 74, 152-3, 172, *Pl. 16*
Jude, St 169, 172
 Epistle of 172
Judge of Mankind 64
Judgment, The Last *see* Day of Judgment
Judith 48
Julian of Norwich 48
Jung, Carl 2, 8-9, 67, 142
Jupiter 212
Justinian, Emperor 52-3, 78, 192

Kaeppelin, Philippe *Pl. 3*
Karima Aly *Pl. 15*
Kariye Cami 62
Kaye, Margaret *Pl. 23*
Kelibia 106
Kelloe 14
Kemijärvi 204
Keys of St Peter 39, 58-9, 60-1, 166-7, 170, 236
Kiev 103
Kildare 144
Kilpeck 196
Kingdom of God 102
Kingdon, Jonathan *Pl. 17*
King's Lynn 222, *Pl. 32*
Kirby, Stephen 152
Knife, butcher's 171
Koenigsfelden xv, 167, 168
Konigsdorf 94
Kurbinovo 120, 127

Lamb of God 2-3, 164
 and Flag 3
 symbolic 26, 56, 75, 83, 165, 166-7, 174, 213, 214, 241, 255, *Pl. 29*
Lambeth Palace 83
Lang, David 136
Langland, William 48
Launcells 68
Lazarus, Rising of 70, 71
Leatherhead R.C. Church 236
Labbaeus *see* Jude, St
Legend, The Golden 204
Lent 80, 225-6, 230
Levi *see* Matthew, St
Leviathan 141
Lewald-Jezierski, Count 259, *Pl. 19, 33*
Libraries:
 Amiens 245
 Autun 174
 Bodleian 83, 94, *Pl. 19*
 Durham Cathedral 182
 Munich iv, *Pl. 29*
 of Paris (National) 60, 79, 186
 Pierpoint Morgan (New York) 14, *Pl. 16*
Lichfield Cathedral 98, 152
Liebana, Abbot of 82
Life of Constantine 14
Lily 34, 100, 238, 243
Lincoln Cathedral 92, 119, 130, 156
Lindisfarne Gospels 13, 24, 188
Lion 7, 80, 145, 151, 198, 214-15, 230-1
 -winged 173, 179, 188, 208, 214, 216, 233, 234, 235, 241, *Pl. 29*
Lisbjerg 248
Liturgy, Divine *see* Eucharist
Liverpool Anglican Cathedral 36, 170
 R.C. Cathedral 111, 177, 188, *Pl. 23*
 Church of St Andrew, Speke *Pl. 28*
Llandaff Cathedral 188, *Pl. 26*
Llanvihangel 219
Loaves *see* Bread
London 134, *Pl. 20 see also under* Museums and Westminster
Longinus 76
Lorraine, Cross of 18
Louvre 28, 206, 230, *Pl. 10, 39*
Lucca 228
Ludger, St 166-7

[265]

Index

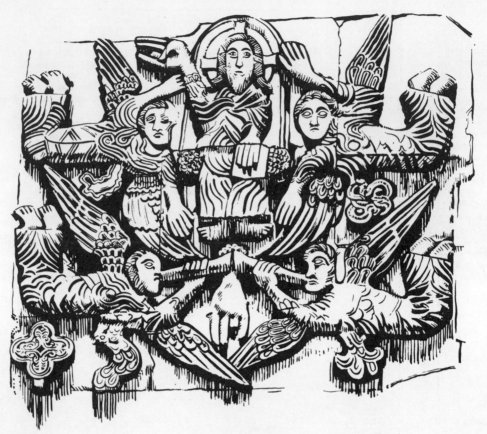

114. The Second Coming.